TO WESTERN
SCOTTISH WATERS
BY RAIL AND STEAMER TO THE ISLES

TO WESTERN SCOTTISH WATERS

BY RAIL AND STEAMER TO THE ISLES

ROBERT N. FORSYTHE

AMBERLEY

In 2009, the National Railway Museum purchased the majority of the Forsythe Collection and most of the items featured in this volume can be studied in their Search Engine archive at York.

First published 2000
This edition published 2010

Amberley Publishing Plc
Cirencester Road, Chalford,
Stroud, Gloucestershire, GL6 8PE
www.amberley-books.com

Copyright © Robert N. Forsythe, 2000, 2010

The right of Robert N. Forsythe to be identified as the Author of this work has been asserted in accordance with the Copyrights, Designs and Patents Act 1988.

ISBN 978 1 84868 505 5

British Library Cataloguing in Publication Data.

A catalogue record for this book is available from the British Library.

Typeset in 9.5pt on 12pt Sabon.
Typesetting by FonthillMedia.
Printed in the UK.

To Fiona
without whom none of this would have happened

CONTENTS

Colour plates are located between pages 96 and 97

SUMMER TOURS
IN THE
Western Highlands and Islands of
SCOTLAND

By the Steamers of
David MacBrayne, Ltd

R.M.S. "COLUMBA," "IONA," etc.

FOREWORD

I am delighted as Managing Director of Caledonian MacBrayne to be invited to contribute to a book on the grand history of the cruises and ferry services of Western Scotland. It is a history which is ongoing, as new ships come into service and new routes continue to offer more variety and reliability to the people of the Highlands and Islands as well as the tourists who flock to the area. This year (2000) will see the delivery of a replacement for the *Lochmor* as well as the introduction of a new vessel ploughing between Uig, Tarbert and Lochmaddy in place of the *Hebridean Isles*.

The scenery of Scotland's western seaboard is breathtaking and, whatever the weather, the best way to see it is still from the deck of a Caledonian MacBrayne vessel. While the puffers and paddlers may be gone, the spirit of service and professionalism continues and the timeless beauty of the lochs and islands is as enchanting as ever.

If the scenes presented in this book pique your interest, I should like to invite you, on behalf of all my staff and crews, to join us on our historic routes through the most beautiful scenery on Earth.

John Simkins

Captain John Simkins
Managing Director, Caledonian MacBrayne

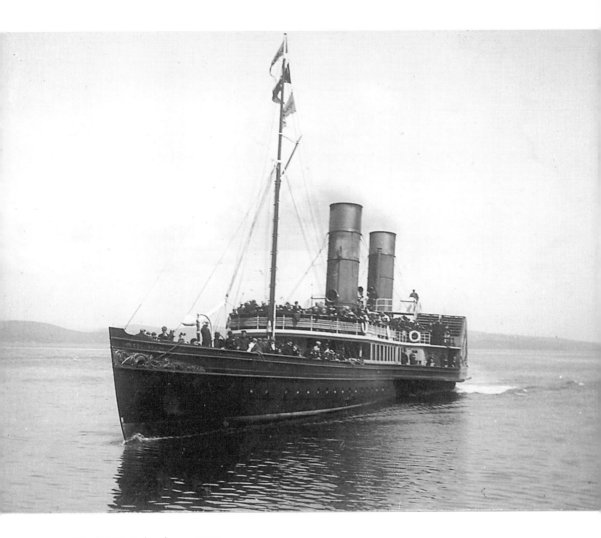

The RMS *Columba*, *c.* 1895.

ACKNOWLEDGEMENTS

Items reproduced are from my own collection, that of my parents-in-law and that of Campbell McCutcheon. Where relevant they are reproduced with thanks to the British Railways Board and Caledonian MacBrayne Ltd. I wish to express my gratitude for help offered by my parents-in-law, Mr and Mrs McMurray, both of whom were railway folk, to Campbell McCutcheon at Amberley Publishing, to Mr Neil Sinclair for reading the manuscript and to Mike Blair at Caledonian MacBrayne.

PREFACE

Illustrated investigations of Western Scottish shipping are not a new idea so the public may wonder what fresh nuance this publication can offer. Some time ago, I was professionally involved in the subject, having been the Curator of the Scottish Maritime Museum at Irvine between 1986 and 1989. One of my specialisms has been the study of transport publicity literature. As a subject, it is frequently neglected by those, whether in libraries, museums or archives, who ought to have regard for it. Within this volume, three themes are woven together. One uses old picture postcards to reach back into the ancestry of the subject. The story then moves from the glory days of the Caledonian Railway to the creation of Caledonian MacBrayne in the 1970s, using as a vessel the colourful and inventive publicity output of some of the principal companies involved. Much rarely seen material will be presented. Using some of our own photography taken since 1973, the opportunity to set this history into its more recent context will be taken as well as the chance to enjoy the remarkable vistas of rock, sea and sky that an interest in Western Scottish shipping inevitably allows.

Some of the lesser-known byways of the subject like the cargo steamer (the famed Puffer), vessels on isolated inland lochs, or the secondhand railway car ferries purloined from the Isle of Wight (and in another case the cruise vessel that was once a Tilbury-Gravesend Thames ferry) receive their due. Railway money had, from the mid-nineteenth century, been a key force in the subject and this integrated approach is clear in the chosen publicity material including, as it does, an excursion from London to Staffa. A separate section will consider the two key railway lines to the West Coast running from Glasgow to Oban and Mallaig.

Note on MacBraynes
The niceties of English grammar do not appear always to have been followed in the shipping industry. Mr David MacBrayne had his company named after him and it should therefore be MacBrayne or MacBrayne's. However, many items of publicity are labelled MacBraynes prior to the 1973 transition to Caledonian MacBrayne. The buses too were labelled MacBraynes. This anomaly is difficult to avoid in our own text.

A BRIEF CHRONOLOGY

1812 PS *Comet* – first steamer on the Clyde.

1840 Railway opened from Glasgow to Ayr and Ardrossan – the first to reach the Firth of Clyde.

1851 Foundation of David Hutcheson & Co. – ancestors of MacBraynes.

1873 First railway into Western Highlands opens to Strome Ferry.

1878 Creation of MacBraynes.

1880 Railway opens to Oban.

1889 Caledonian Steam Packet founded.

1901 Launch of first turbine passenger steamer: TSS *King Edward*.

1923 Scottish railways grouped into LMS or LNER.

1928 Coast Lines and LMS buy MacBraynes.

1948 The nationalised British Railways formed – owns the Clyde fleet.

1953 Last new steam paddler entered service: PS *Maid of the Loch*.

1954 A.B.C. ships arrived – start of car ferry revolution on the Clyde.

1969 Scottish Transport Group acquire MacBraynes and Caledonian Steam Packet.

1973 MacBraynes and Caledonian Steam Packet amalgamate to form Caledonian MacBrayne.

1975 PS *Waverley*'s first season as a preserved steamer.

1981 PS *Maid of the Loch*'s last operational season on Loch Lomond – the end of state-owned steamers.

2000 Caledonian MacBrayne announce the end of Clyde cruising.

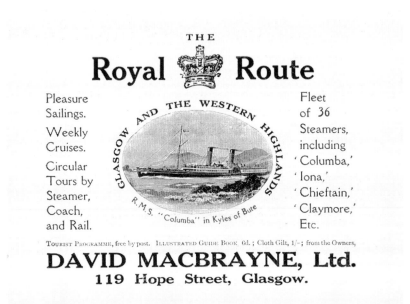

1

A VIEW BEYOND MEMORY

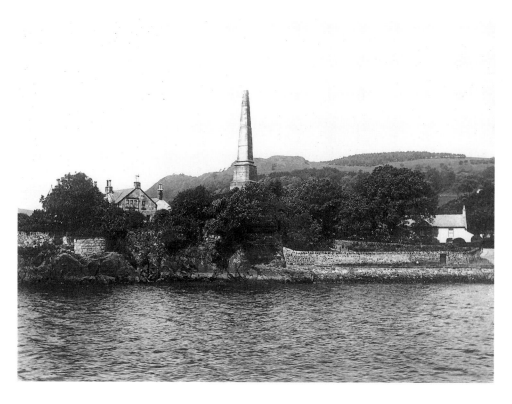

There are several shrines to the inception of the steamers on the Clyde. This one is still familiar a century after this image was taken. It is the Henry Bell Monument on the north bank of the Clyde at Dunglass near Bowling. This was erected in 1839 to commemorate Bell (1767-1830) who is regarded as the effective father of British commercial steam shipping. In 1812, he had introduced the paddle steamer *Comet* onto the Clyde between Glasgow and Greenock. From the outset, publicising the initiative was important and newspaper advertisements from that year exist.

The original vessel is no longer, but a replica was made for the 150th anniversary in 1962 and one of the 1812 vessel's engines and its first steam cylinder survive.

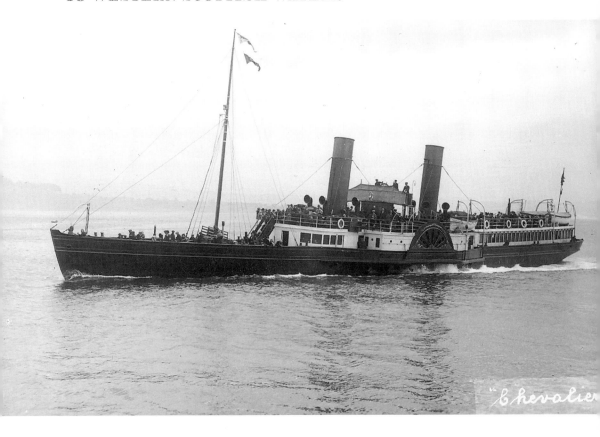

Between 1812 and 1866, when the PS *Chevalier* was launched, vessel design evolved rapidly. By then, the main design elements which would be recognisable in the last paddlers like *Waverley* (1947) and *Maid of the Loch* (1953) could be identified. *Chevalier* was built for one of the contemporary big names, David Hutcheson, and was a miniature version of their famous *Iona*. She was built for the burgeoning tourist trade out of Oban. Her long life ended with a shipwreck off Barmore Island, Loch Fyne, in 1927. Fortunately, no one died.

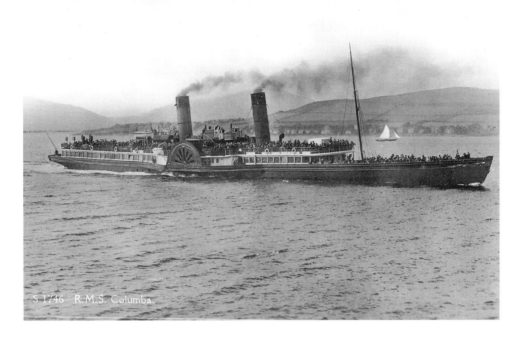

S 1746 R.M.S. Columba.

To render a complex story simply: by 1870, a now extensive steamship network operated on internal routes in the West of Scotland. These were run by a large number of competing companies with, as yet, some quite limited railway involvement. One personality stood out: David MacBrayne, a distinctive individual who was ninety-three when he died in 1907. Having held high office as a partner in the predecessor company of David Hutcheson, in 1878, he was enabled to operate on his own account and so the company's ships dominated services west and north of Kintyre with some routes in the Firth of Clyde.

Tradition was to become a strong force in these shipping services. Names of favourite ships were often reused. The second *Columba* will feature later in some detail (see p.59ff). She has lived up to the illustrious precedent of the earlier vessel. Comments like 'the finest and most famous steamer that ever sailed on the Clyde' or 'it is doubtful if any ship of this type ever attained as much prestige' reflect the regard of those who knew the first *Columba*. Built in 1878, her *forte* (of which more later) was the so-called Royal Route which MacBraynes worked from Glasgow via Ardrishaig, Oban and Fort William and thence the Great Glen to Inverness. The stimulus to her construction was the palatial 1877 PS *Lord of the Isles* built for a competitor. *Columba*, equipped even with her own on-board post office, so making her RMPS *Columba*, worked the first element of the route from Glasgow to Ardrishaig. This took her down the Clyde, through the Kyles of Bute and up Loch Fyne, a stunning journey, even today. She did this job for some fifty-eight seasons but, owing to her large 2,000 passenger capacity, had the benefit of leisurely winters in lay-up.

Columba was not the only steamer with an on-board post office, even the tiny *Fairy Queen* on Loch Eck was so equipped. Something to watch out for are surviving franks from these vessels on used postcards.

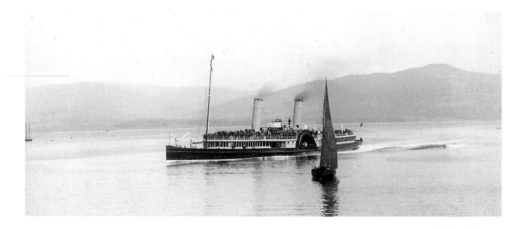

The most unusual feature of the PS *Ivanhoe* (1880) cannot be seen in the photograph. She was built for the specially formed Firth of Clyde Steampacket Co. Ltd as a teetotal excursion vessel running from Helensburgh. Alcohol only appeared after the Caledonian Steam Packet Company took her over in 1897. She lasted forty years. The two owners were linked by Captain James Williamson. He was captain of the steamer and secretary and manager of the first-named company. This association helped to bring him prominence on the river, enabling him to become influential in the 1889-founded Caledonian Steam Packet Company (a subsidiary of the Caledonian Railway). Williamson was a member of an influential 'steamer' clan with brothers and father all on the water. More will be heard of them.

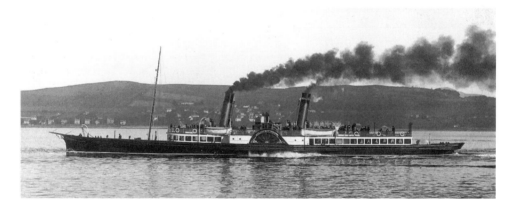

PS *Grenadier* (1885) was a MacBraynes vessel. She illustrates a practice still used in recent times. She switched routes according to the season between the Firth of Clyde and the West Highlands. In winter she could be found running to Loch Fyne, while most summers Oban was her base. Staffa and Iona were often her destinations and the publicity will reveal how sacred those destinations became to the company. Like many of her sister Clyde steamers but uniquely amongst the MacBraynes paddlers, war service was her lot in the 1914-18 war. Between the end of the war and her demise in 1928, some mishaps befell her, the last involving a fire alongside at Oban which killed the master and two others. Her figurehead entered the Glasgow Transport Museum collection.

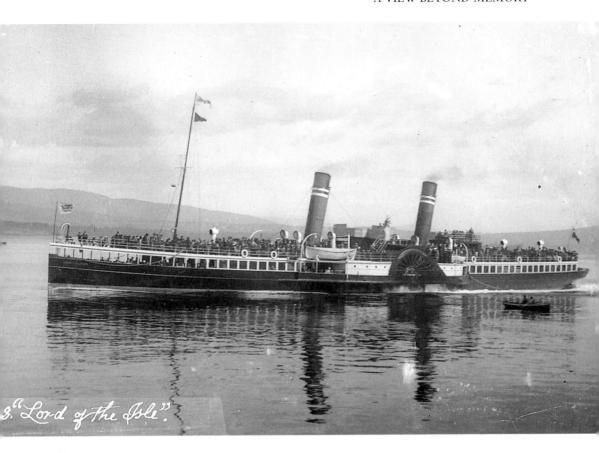

S. "Lord of the Isle".

Exemplifying the phenomenon of repeated use of names, this PS *Lord of the Isles* was the second use of one of the Prince of Wales' Scottish titles. Another of those titles, namely the Duke of Rothesay, seems never to have been used on a Clyde steamer; indeed, it is a name associated with steamers working out of Heysham. In the 1990s, the third vessel named *Lord of the Isles* was a member of the Caledonian MacBrayne fleet. The two earlier users were not owned by either constituent. Their owners had been The Glasgow and Inveraray Steamboat Company. The earliest vessel had been built for that route in 1877. The popularity of the route and its accompanying tours led to the larger PS *Lord of the Isles* being launched in 1891. One of the tours operated was 'the famed Loch Eck tour', some publicity of which is illustrated later. The above picture was probably taken in the early years of the 1900s after the ship's promenade deck had been extended right to the bow, a distinctive feature which is clearly visible.

As the twentieth century progressed, the paddlers were to find their match with the faster turbine powered vessels. One of their operators was actually called Turbine Steamers Ltd and their competition on the Inveraray route led to the *Lord of the Isles* being sold to them in 1912. After further use on a variety of services, she went to the breakers in 1928.

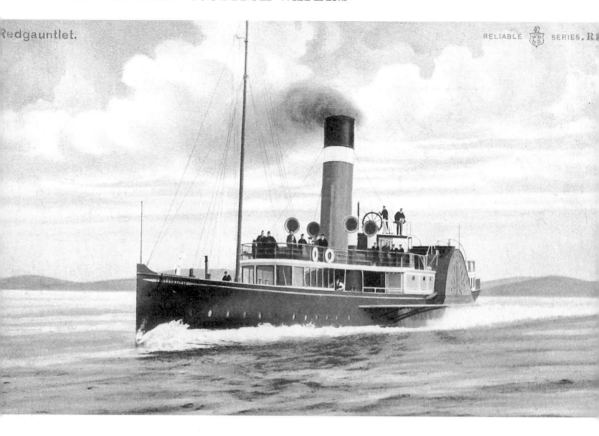

Redgauntlet. RELIABLE [logo] SERIES. R1

The PS *Redgauntlet* (1895) was a much smaller ship than the *Lord of the Isles*. For the first time in this selection, she introduces the concept of a railway boat. Legal requirements made her owners, the North British Railway, operate through the North British Steam Packet Company until 1902. The company had arrived on the Clyde in 1866 and, after running from Helensburgh, settled down in 1882 to run from nearby Craigendoran Pier about which in 1931 the poet W. H. Auden (then a schoolteacher in Helensburgh) conjured up this hilarous image in 'Journal of an Airman': 'Packed excursion trains at five minute intervals, jumping the points, enter the sea at Craigendoran Pier.' By then, the London & North Eastern Railway had inherited this operation and Craigendoran remained the start of many a journey until its closure in 1972.

Craigendoran was in shallow water and for that reason suited paddlers. Initially *Redgauntlet* ran to Rothesay, but after only a few years, cruises became her mainstay. Over the years, many Clyde steamers were disposed of away from the river. Blockade running in the American Civil War tempted an earlier generation away. Two World Wars claimed others. *Redgauntlet* herself did not manage the generations of local service that some sisters managed. There were three competing railways: the North British, the Caledonian, and the Glasgow & South Western. Around 1908, the railway companies decided that co-operation was better than competition. *Redgauntlet* was redundant on the Clyde and, in 1909, was sent to the Firth of Forth, still working for the North British. War service followed before trace of the vessel was lost in interwar France.

18

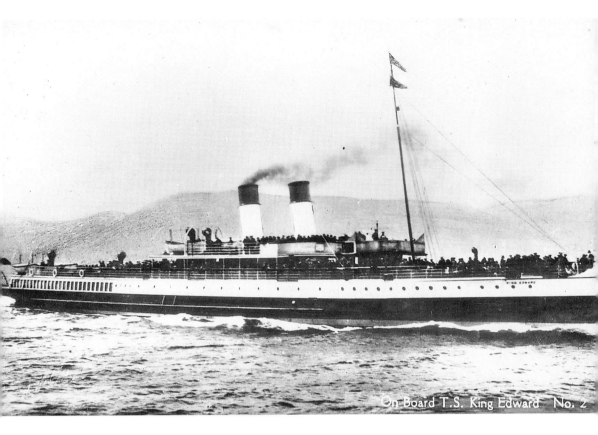

On Board T.S. King Edward No. 2

If the PS *Comet* back in 1812 represented a revolution, the TSS *King Edward* of 1901 is only a degree or so off in importance. One of the Williamson clan – John – was prepared to back an unknown horse. In conjunction with the shipbuilder Denny of Dumbarton, who would make their mark with what followed, and the all important Tyneside marine engineer the Hon. Charles Parsons, a turbine-powered steamer was introduced to the Firth. Parson's own innovating *Turbinia* had been built in 1894.

King Edward was the first turbine-powered merchant ship anywhere. The turbines gave her greater speed and economy than the paddlers. She could exceed 20 knots. To own the pioneering vessel, the principles formed the Turbine Steamers Syndicate. In due course, she put the paddlers on the Inveraray run under great pressure, including the famed *Lord of the Isles*. Runs to Campbeltown were another regular aspect of her life. First World War service took her far away in an arc stretching from the Channel Islands to Archangel.

Many prototypes fail. *King Edward* stayed in service until 1951. The now-nationalised Caledonian Steam Packet, by then part of British Railways, scrapped her in 1952 and parts of her machinery were preserved by the Glasgow Transport Museum.

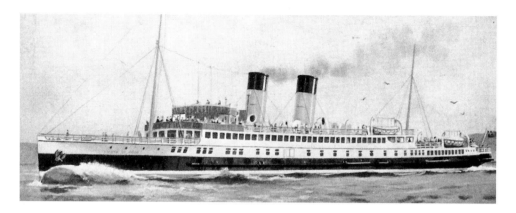

Another Denny turbine steamer, but nearly thirty years on from the *King Edward*, was the TSS *Duchess of Montrose* (1930). Despite those years, the two ships show considerable visual similiarities. An enclosed upper deck is the major development. Ship design may have become conservative but the ongoing sagas of ownership had led to new circumstances on the Clyde. In 1922, railway companies had been 'grouped' and the London & North Eastern Railway and the London Midland & Scottish Railway each found themselves with Clyde steamer fleets. The LMS fleet embraced that of the Caledonian and Glasgow & South Western Railways and continued the Caledonian Steam Packet Company whose lineal descendant is with us today.

This ship was the second holder of the name in the Clyde fleets and her prime task was pleasure-cruising. Her advent in 1930 represented something of an act of faith by her owners in the economic circumstances. She innovated in being a one-class ship and her trips reached into the lower firth encircling Arran and Ailsa Craig and even reaching far off Stranraer before 1936. The breakers called in 1965. There was a virtually identical sister, but built by Harland & Wolff in Govan and called *Duchess of Hamilton*.

Four years on from the *Montrose* and the LMS took a paddler from the Fairfield yard in Govan. The style critics of the time complained about her disguised paddle boxes. All too soon, there were more serious matters to worry about. The Second World War ensured that the *Mercury* was destined never to be one of the long-lived favourites of the firth. Called up for minesweeping work, she was herself mined and sunk on Christmas Day 1940. Fortunately, all the crew survived. Her 1934 sister the PS *Caledonia* exemplified the other trend, lasting with the C.S.P. until 1969.

2

PUBLICISING THE SERVICES

Time to begin to consider our special angle. With very few exceptions, the vessels from the heyday of these services have all been broken up. Ship preservation is a challenging task and only a very few individuals can own such craft, though a few Puffer hulls are privately owned. Pictures are a different matter and many individuals made collections or hoarded postcards, and remembering the era through the visual image is not too difficult.

Within that task, however, there is a genre of material whose collection, while rewarding, appears none too simple. A vast array of advertising material had to be generated to promote these services. Much was, of necessity, colourful and attractive. Large posters were selectively distributed and can rarely be found today outside an auction. They were the exception; literally millions of brochures and leaflets have been produced. Often given away, they remain difficult to track down, even when from only twenty years ago.

Scotland is fortunate that in Edinburgh both the Scottish Record Office and the Scottish Life Archive of the National Museums of Scotland have taken an interest in such ephemeral material and the interested student can access a representative selection, while Caledonian MacBrayne have also retained material.

The Caledonian Railway produced a booklet each year with artwork, timetables and information (see colour section p.1). Inside such a production, the pages were crammed with enthralling travel opportunities. This extract's significance is in showing the 1903 programme for the two new turbine steamers, which were not actually Caledonian vessels then. The *King Edward* was then two years old and was busy against the *Lord of the Isles* on the Ardrishaig route. The *Queen Alexandra* had come in the wake of the *King Edward*'s success. Denny's produced her in 1902. Both larger and faster than the first turbine vessel, she was dedicated, as this timetable shows, to the Campbeltown run. Unfortunately, a serious fire in 1911 was followed by sale to the Canadian Pacific Railway and use from Vancouver. The name remained familiar because Denny's produced a replacement in 1912.

DAILY EXCURSIONS

In connection with Caledonian Rly. and Caledonian Steam-Packet Co., Ld.

NEW TURBINES—

"KING EDWARD"

To ARDRISHAIG and INVERARAY.

"QUEEN ALEXANDRA"

To LOCH RANZA and CAMPBELTOWN.

From Gourock at 9.0 a.m., Dunoon, 9.15 a.m., Wemyss Bay, 9.45 a.m.

CONNECTING TRAINS LEAVE

Glasgow (Central), - - 8.55 a.m. to Wemyss Bay.
„ - - 7.5 a.m. to Gourock.

Passengers have about 4¼ hours at Ardrishaig, 1½ hours at Inveraray, 2 hours at Campbeltown, or 4½ hours at Loch Ranza.

Cheap One-Day Fares from Glasgow and Coast Towns.

For Particulars see Newspapers and Posters.

TURBINE STEAMER COACH TOURS.

To CRINAN and back same day, per "King Edward" to Ardrishaig, thence Coach. Coach Fare, **2 6.**
Passengers have 1½ hours at Crinan.

To MACHRIHANISH and back same day, per "Queen Alexandra" to Campbeltown, thence Coach. Coach Fare, **1/6.**

EVENING CRUISES

BY NEW TURBINE STEAMER

"QUEEN ALEXANDRA" or "KING EDWARD"

On TUESDAYS, THURSDAYS, and FRIDAYS, till further notice.

(For Sailings during Glasgow Fair Holidays see Special Advertisements.)

Train from Glasgow (Central) - - - at 6.30 p.m.
Steamer from Gourock - - - - at 7.25 p.m.

On a PLEASURE CRUISE,

Arriving back for 9.10 or 9.20 p.m. Trains, Gourock to Paisley and Glasgow.

MUSIC ON BOARD.

RETURN FARES FROM GLASGOW AND PAISLEY—

Third Class and Steamer, - - - - - **2s.**
First Class and Steamer, - - - - - **3s.**

RETURN FARE (Steamer only), 1s.

7

Nos. 4 & 5.

21st June till 8th September
(30th June excepted.)

ROUND THE

Island of Arran

Every TUESDAY,

ROUND

AILSA CRAIG

Every THURSDAY,

By the "IVANHOE."

Leave Gourock at 8.45 a.m. *via* Dunoon, Wemyss Bay, Rothesay, Craigmore, Largs, Keppel, and Millport.

Passengers from the Holy Loch, Blairmore, Cove, and Kilcreggan by the first morning Steamer transfer at Gourock, returning by the 7.50 p.m. Steamer from Gourock to destination.

Leave		a.m.	p.m.	Leave		a.m.	p.m.
		Arrive Return Journey about				Arrive Return Journey about	
Gourock	-	8.45	7.45	Craigmore	-	10.5	5.55
Dunoon	-	9.0	7.10	Largs	-	10.30	4.10
Wemyss Bay		9.20	5.0	Keppel	-	10.45	3.55
Rothesay	-	10.0	6.0	Millport	-	10.50	3.45

Train from Glasgow (Central) at 7.55 a.m. *via* Wemyss Bay, returning by the 5.32 p.m. Train.

RETURN FARES.

From Glasgow—5/ 1st and Saloon ; 4/ 3rd and Saloon ; 3/ 3rd and Steerage
 ,, all Ports—2/6 Saloon ; 2/ Fore-Saloon.

A view of the work assigned to the *Ivanhoe* in later life is afforded by this extract from the 1904 Caledonian Railway Excursion Programme. Trips to Ailsa Craig were a hardy favourite for a very long time. Sadly they are a rather rare opportunity nowadays. Ailsa Craig's majesty had inspired the poetry of Keats's 'Heark,en, thou craggy ocean pyramid!...'. (See colour section p.3.)

THE ROYAL ROUTE.

The Royal Mail Swift Passenger Steamer

"COLUMBA" OR "IONA"

SAILS DAILY (Sunday excepted) FROM MAY TILL OCTOBER, from Gourock Pier at **9.15** a.m., in connection with Train leaving Glasgow (Central Station) at **8.30** a.m. for Gourock; also in connection with Express Trains from London and the South, Edinburgh, &c., for

KYLES OF BUTE, TARBERT, AND ARDRISHAIG,

CONVEYING PASSENGERS VIA CRINAN AND CALEDONIAN CANALS FOR

OBAN, STAFFA AND IONA, GLENCOE, FORT-WILLIAM, INVERNESS, LOCH AWE, LOCH LOMOND, LOCH KATRINE, THE TROSSACHS, LOCH TAY, LOCH EARN, LOCH SCAVAIG, LOCH CORUISK, MULL, SKYE, GAIRLOCH, LOCH MAREE, LOCHINVER, STORNOWAY, ISLAY, &c.

TARBERT AND ARDRISHAIG.

A WHOLE DAY'S SAIL BY THE "COLUMBA," or
Pleasure Sail and Coach Drive to West Loch Tarbert and back.
From GLASGOW (Central) at **8.30** a.m., *via* Gourock,
calling at DUNOON **9.30**, INNELLAN **9.50**, and ROTHESAY **10.15** a.m.;
also, during July and August
From GLASGOW (Central) at **9.45** a.m., *via* Wemyss Bay, direct to Ardrishaig.

EDINBURGH TO TARBERT AND ARDRISHAIG AND BACK IN ONE DAY.

From EDINBURGH (Princes Street Station) at **6.30** a.m.

From 18th June till 31st August the "IONA" will leave Wemyss Bay at 6.5 p.m. (Train from Central Station, Glasgow, at 5.12 p.m.) for Kyles of Bute, Tarbert, and Ardrishaig, returning following morning to Wemyss Bay, in time for Train due in Glasgow (Central Station) at 9.56 a.m.

To INVERARAY and OBAN

AND THE

FAMED LOCH-ECK ⚓

⚓ COACH TOUR,

AND THE

NEW ONE-DAY TOUR,

Via STRACHUR, HELL'S GLEN, AND LOCH GOIL,

By "LORD OF THE ISLES."

Train from Glasgow (Central Station) at 8.45 a.m., *via* Gourock, calling at Dunoon at 9.40 a.m., Rothesay 10.25 a.m., Tighnabruaich 11.5 a.m.
From Oban at 9.40 a.m., Inveraray at 2.20 p.m. daily, calling as above, for Special Express Train from Gourock at 6.40 p.m., for Glasgow, Edinburgh, and the South.
Piano and Organ on board Steamer for the use of Passengers.
Full particulars from Caledonian Railway Company's Time Tables, &c.

Here on one page of the 1904 Caledonian Railway Excursion Programme, two competing operators, neither being part of the Caley itself, are featured. Each route was already a classic. MacBraynes, of course, were operating the Royal Route, not that they were mentioned by name, and so the *Columba* and *Iona* have to carry the glory. The Loch Eck tour featured the *Lord of the Isles*. It is unlikely that today's publicity would make much of 'Piano and Organ on board Steamer for the use of Passengers'. The passengers of the period would presumably have been ready to respond to the sort of popular tune that from later years 'The Song of the Clyde' represented: 'There's paw and maw at Glasgow Broomielaw. They're goin "doon the water" for "The Fair"...'. *Iona* was especially favoured as a name in the MacBraynes fleet. By the time of the 1970 vessel, the name had been used seven times.

⁓ BILL OF FARE. ⁓

On board the "Duchess of Hamilton," "Duchess of Rothesay,"
and "Ivanhoe."

FIRST CLASS SALOON.

BREAKFAST, - - - **2s.**
From 7 till 10 a.m.
Fish. Ham and Egg. Cold Meats. Tea. Coffee. Toast and Preserves

BREAKFAST, - - **1s. 6d.**
With Single Dish (as above).

LUNCHEON, - - - **1s. 6d.**
From 10 a.m. till 12 noon.
Soup. Cold Meats. Potatoes. Biscuits and Cheese.

LUNCHEON, - - - **2s. 6d.**
From 12.15 till 3.30 p.m.
Soup. Fish. Cold Joints. Roast Beef. Lamb. Braised Ham. Ox Tongue. Pressed Beef. Vegetables and Potatoes. Sweets. Salad and Cheese.

TEA, - - - - - **2s.**
From 4 p.m.
Fish. Cold Joints. Boiled Eggs. Toast. Preserves.

TEA, - - - - **1s. 6d.**
With Single Dish (as above).

PLAIN TEA, - - - - **1s.**
Toast, Cakes, Biscuits, and Preserves.

SUNDRIES.

Plate of Meat and Potatoes, -	- 1s.
Plate of Soup, with Bread, -	- 6d.
Sandwiches, - - each 3d. and 6d.	
Biscuits and Cheese, with Butter,	6d.
Cup of Tea or Coffee, with Bread and Butter, - - - -	6d.
Biscuits and Pastries, - - each 1d.	
Cup of Tea with Cake, Biscuit, or Plain Bread and Butter, -	6d.

SECOND CLASS SALOON.

And on all Intermediate Steamers.

BREAKFAST, - - **1s. 6d.**
Ham and Egg or Fish. Tea. Coffee. Toast and Preserves.

LUNCHEON, - - - **1s. 6d.**
Soup. Cold Meat and Potatoes. Biscuits and Cheese.

TEA, - - - - - **1s. 6d.**
Cold Meat or Fish. Toast, Biscuits, and Preserves.

PLAIN TEA, - - - - **9d.**
Toast, Biscuits, and Preserves.

SUNDRIES.

Plate of Meat and Potatoes,-	1s.
Plate of Soup, with Bread, -	- 6d.
Cup of Tea or Coffee, with Bread and Butter, - - -	6d.
Sandwiches, - - each 3d. and 6d.	
Biscuits and Cheese, with Butter,	6d.
Single Biscuit and Cheese, - -	2d.
Biscuits and Pastries, - - each 1d.	

Tea may be had in the General Saloon at any time
on application to the Stewardess.

Two pages on and it is time for tea. Solid British fare was the favoured style. The crested silverware that was on board provided extreme value for money. Items that might have been used to serve these very dishes were still in use aboard Caledonian MacBrayne vessels in the 1980s.

A bit on Loch Creagan

THROUGH THE
OSSIAN COUNTRY.

ROUTE.—Train from Oban at 9.40 a.m. for Connel Ferry, cross the ferry at Falls of Lora, join coach at North Connel Inn, do the above drive to Ardchattan Priory, and get back to Oban at 4.52 p m. by rail. Passengers have the option of performing the journey between Oban and Connel by steamer "Princess Louise" without additional charge.

Fares (exclusive of Ferry charge) :—First Class, 8/6.

Falls of Lora, Ossian's Selma, Barcaldine Castle, Loch Creran Glen Sallach and Ardchattan Priory.

THE points of interest in this excursion, as far as Creagan Ferry, are described in the first part of the chapter "Through Ballachulish, Glencoe, and Glen Etive." The region is known as Benderloch, "the country between the lochs." Glen Sallach, by which the coach route crosses from Creagan to Ardchattan Priory, affords most charming views both of Loch Creran and Loch Etive. The rest of the tour has been dealt with in the end of the chapter already referred to.

Creagan Station

22

THE FALLS OF LORA
AND DUNSTAFFNAGE.

ROUTE.—Rail from Oban at 9.40 a.m. and 12.40 p.m. for Connel, thence by steamer *via* Dunstaffnage, reaching Oban at 12.15 and 4.0 p.m. The route may be taken the reverse way, for particulars of which see bills.

Fares for the Round :—Train and Steamer, First Class, 2/- ; Third Class, 1/6.

AGAIN and again in the Ossianic poems the Falls of Lora are mentioned with affection. "The murmur of thy streams, O Lora ! brings back the memory of the past ; the sound of thy woods, Garmallar, is lovely in mine ear." And when one sees the waters of Loch Linnhe, at a spring tide, pouring over the rock ledge in the narrows at Connel, it is not difficult to understand how the sight must have impressed the settlers in the region in any mystic time.

Hardly less ancient than the days of Ossian himself is the early story of the fortress on its low promontory at the loch mouth a mile to the westward. Dunstaffnage, or Dunstaffinch, as the earlier name ran, was the capital strength of the early Scots or Gaels who came from Ireland. Settled first in the south of Cantyre, they had moved north to the region about Inveraray, giving it the name of Earrha Gael, or Argyll, the "land of the Gael." Columba had crossed to help their wavering fortunes, and in the sixth century their kings were firmly established on

Loch Etive, Falls of Lora, Dunstaffnage, Dunolly.

23 Connel Ferry Viaduct

From the interior of a George Eyre-Todd guide to Oban and the 'land of the Gael' (see colour section p.5), this spread shows tourist features of the area. Connel Ferry Viaduct is still there but has carried road traffic exclusively since the railway closed in 1966. It was built in 1903 when the Caledonian opened a branch from Connel Ferry to Ballachulish. This had to cross the tidal inlet of Loch Etive. At the narrowest point suitable for a bridge, a rare example of what are in practice salt-water falls existed where the outgoing tide can ebb out at 10-12 knots and drop four feet. The bridge had to be built clear of these dangers, resulting in its distinctive shape. At first, the bridge was purely for trains. In 1909, a charabanc on rails and a truck offered an early form of Motorail service accommodating road vehicles. After 1914, both forms of traffic were accommodated with a roadway beside the track which was closed when a train was due.

The tour detailed was in effect a simple half-day excursion from Oban, whose extremity at Connel Ferry was only six miles away. Its key feature, in addition to the Falls of Lora under the bridge, was the use of a steamer in one direction between Oban and Connel Ferry calling at Dunstaffnage Castle. In this case, the steamer was run by Alexander Paterson (or son) between 1892 and 1934 when MacBraynes purchased the operation. For most of that time the vessel was the SS *Princess Louise*, which was fondly regarded in the Oban area.

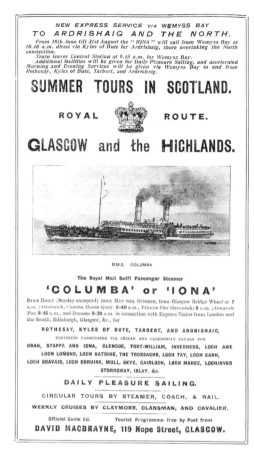

NEW EXPRESS SERVICE via WEMYSS BAY.
TO ARDRISHAIG AND THE NORTH.
From 18th June till 31st August the "IONA" will sail from Wemyss Bay at 10.40 a.m. direct via Kyles of Bute for Ardrishaig, there overtaking the North connection.
Train leaves Central Station at 9.45 a.m. for Wemyss Bay.
Additional facilities will be given for Daily Pleasure Sailing, and accelerated Morning and Evening Services will be given via Wemyss Bay to and from Rothesay, Kyles of Bute, Tarbert, and Ardrishaig.

SUMMER TOURS IN SCOTLAND.

ROYAL ✠ ROUTE.

GLASGOW and the HIGHLANDS.

R.M.S. COLUMBA

The Royal Mail Swift Passenger Steamer

'COLUMBA' or 'IONA'

SAILS DAILY (Sunday excepted) FROM MAY TILL OCTOBER, from Glasgow Bridge Wharf at 7 a.m.; Greenock, Custom House Quay, 8-40 a.m.; Princes Pier (Greenock) 9 a.m.; Gourock Pier 9-15 a.m., and Dunoon 9-30 a.m. in connection with Express Trains from London and the South, Edinburgh, Glasgow, &c., for

ROTHESAY, KYLES OF BUTE, TARBERT, AND ARDRISHAIG,

CONVEYING PASSENGERS VIA CRINAN AND CALEDONIAN CANALS FOR

OBAN, STAFFA AND IONA, GLENCOE, FORT-WILLIAM, INVERNESS, LOCH AWE LOCH LOMOND, LOCH KATRINE, THE TROSSACHS, LOCH TAY, LOCH EARN, LOCH SCAVAIG, LOCH CORUISK, MULL, SKYE, GAIRLOCH, LOCH MAREE, LOCHINVER STORNOWAY, ISLAY, &c.

DAILY PLEASURE SAILING.

CIRCULAR TOURS BY STEAMER, COACH, & RAIL.

WEEKLY CRUISES BY CLAYMORE, CLANSMAN, AND CAVALIER.

Official Guide 6d. Tourist Programme free by Post from

DAVID MACBRAYNE, 119 Hope Street, GLASGOW.

TOUR No. 14.
OBAN.
In connection with Royal Mail Steamer "Columba."

	Going via Gourock or Wemyss Bay and Ardrishaig. Returning via Dalmally and Callander.			Going via Callander and Dalmally. Returning via Ardrishaig and Gourock.			
	a.m.	a.m.	a.m.		a.m.	a.m.	a.m.
Edinburgh (Princes St.),leave	7¼10	7 45	...	Glasgow (Buchanan St.),... leave	7¼20	9 15	...
Glasgow (Central), ,,	8 30	9 45	...	Edinburgh (Princes St.) ... ,,	7 50	9 25	...
Gourock,leave	9 17	Oban,arrive	12 0	2 50	...
Wemyss Bay ,,	...	10 40	...	Oban,leave	8 40
Kyles of Bute, ,,	10 55	Crinan, ,,	10 20
Ardrishaig, ,,	12 40	12¼50p	...	Ardrishaig, ,,	1 0p
Crinan, ,,	3 0	3 0	...	Kyles of Bute, ,,	2 40
Oban,arrive	4 50	4 50	...	Gourock, ,,	4 25
Oban,leave	7 0	7 0	7¼55	Glasgow (Central),arrive	5 25
Edinburgh (Princes St.) arrive	½20p	Edinburgh (Princes St.),... ,,	7 50
Glasgow (Buchanan St.),	11¼25	11¼25	12 20				

b During June Passengers leave Edinburgh (Princes Street) at 6.30 a.m.
d During June Passengers leave Oban at 7.30 a.m., or they may travel by any other suitable Train from Oban during the day. f Arrives 10 minutes earlier during June.
g During June Passengers leave Glasgow (Buchanan Street) at 7.10 a.m.

FARES FOR THE ROUND.

From	1st Cl. & Cabin.		3rd Cl. & St'ge.		From	1st Cl. & Cabin.		3rd Cl. & St'ge.	
	s.	d.	s.	d.		s.	d.	s.	d.
Aberdeen,	32	0	27	0	Gourock,	21	0	11	6
Airdrie,	21	6	11	9	Grangemouth,	23	6	12	2
Alexandria,	21	0	11	6	Greenock (Cathcart Street), }	21	0	11	6
Alloa,	22	0	12	0	Greenock (West),				
Annan,	44	0	23	0	Hamilton,	23	0	12	9
Arbroath,	28	0	20	0	Holytown,	21	6	12	0
Ardrossan,	26	0	14	0	Irvine,	20	0	14	0
Beattock,	35	3	18	10	Kilmarnock,	26	0	14	0
Belfast (G. & J. Burns),	37	0	19	6	Kilwinning,	25	9	14	0
Biggar,	32	9	17	8	Kirriemuir,	34	0	18	0
Bothwell,	22	8	12	3	Lanark,	26	0	14	0
Brechin,	42	0	22	0	Larbert,	21	0	11	6
Bridge of Allan,	21	0	11	6	Law Junction,	25	0	13	3
Callander,	21	0	11	6	Leith,	26	0	15	6
Carlisle,	47	6	24	9	Lockerbie,	39	9	21	0
Carluke,	25	9	14	0	Merchiston,	26	6	15	6
Carstairs,	28	0	15	0	Midcalder,	26	0	15	6
Clydebank,	21	0	11	6	Moffat,	35	9	19	0
Coatbridge,	21	0	11	6	Montrose,	42	0	22	0
Grieff,	29	0	15	6	Mossend,	22	6	12	6
Dalmally,	21	0	11	6	Motherwell,	23	6	12	9
Douglas,					Muirkirk,	29	6	16	0
Douglas (West),	29	4	16	0	Oban,	21	0	11	6
Doune,	21	0	11	6	Oban (via Edinburgh)	26	6	15	6
Dumbarton,	21	0	11	6	Paisley,	21	0	11	6
Dumbarton (East),	21	0	11	6	Peebles,	37	0	19	6
Dumfries,	42	3	22	1	Perth,	29	0	15	6
Dunblane,	21	0	11	6	Port-Glasgow,	21	0	11	6
Dundee,	34	0	19	0	Rothesay,	21	0	11	6
Dunoon,	21	0	11	6	Rutherglen,	21	3	11	6
Edinburgh—					Saltcoats,	26	0	14	0
Princes Street,					Shotts,	26	0	14	3
Waverley,	26	6	15	6	Stirling,	21	0	11	6
Falkirk (Grahamston),	21	9	11	10	Stonehaven,	48	0	26	0
Forfar,	34	0	18	0	Uddingston,	22	3	12	6
Glasgow and District	21	0	11	6	Westcalder,	26	0	15	6
Stations,					Wishaw,	24	0	13	3

Tickets are available during the Season, with liberty to break the journey at all or any of the Stations or places on the Route.

Tickets for the Trip from Oban to Staffa and Iona and back, including Guides and Boatmen, can be had at the above Stations. Fare 18s.
d Holders can travel in Cabin of Steamer on payment of 4s. 6d. extra to Purser on Board.

TOUR No. 14 B.—Tickets are issued from Glasgow to Edinburgh (Princes Street), via Gourock, Crinan Canal, Oban, Callander Dunblane, Larbert, and Linlithgow; also from Edinburgh (Princes Street), going via Larbert and Callander, and terminating at Glasgow.
Fares, 1st Class 26s. 9d.; Third Class 13s. 10d.

TOUR No. 14 C.—Tickets for the same route as Tour No. 14 are issued from Glasgow, Pollokshields and Oban on Fridays and Saturdays available to return up to and including the Monday following, at 18s.
First Class, and 10s. Third Class.

Tickets for these Tours are also issued on board the Steamers "Columba" and "Iona."
Tickets for Tours Nos. 14 and 14 C are also obtainable on board the Steamer plying between Crinan and Oban.

Tours available by the Caledonian Railway throughout Scotland were heavily promoted in the railway's 'Official Tourist Guide', issued annually. In 1904, this was a 266-page volume in which eighty-one numbered tours were itemized. These ranged across Scotland but many covered the destinations reviewed in our own volume. The material reproduced shows part of the Caledonian Railway's own take on the MacBrayne's Royal Route which used the Callander & Oban Railway in one direction so shortening the time required for an entire round trip by steamer. The attached timetable suggested that *Columba* was entirely responsible for the sea voyage, though in fact the element through the Crinan Canal needed the canal-sized TSS *Linnet*, and thereafter other steamers like the *Chevalier* and *Mountaineer* carried on to Oban. The Caledonian's tour omitted the northern leg to Fort William and beyond.

3

THEN AND NOW

The collector of illustrated ephemera, like postcards and leaflets, will often enjoy the opportunity to compare and contrast scenes and some examples follow. This view of Bowmore was on sale in the 1940s. Look carefully and two cars can be found.

It is the addition of motor vehicles and television aerials which creates the main change in the scene by 1987. This view taken in reverse looks down the main street to Loch Indaal. Despite the pier visible in both views, the shallow water of the loch has meant that Bowmore has not figured largely on steamer itineraries.

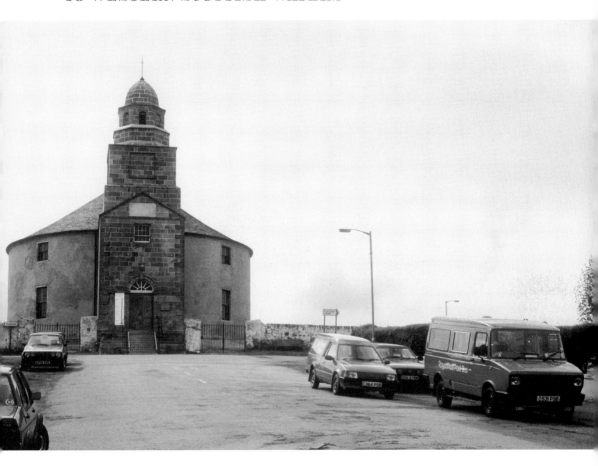

Turn around and Bowmore's round church of 1768 is as prominent as it ever has been. It was created along with the rest of the settlement as a showpiece planned village by Daniel Campbell. For the traveller, a feature of this May 1987 view is the Postbus. These are now an established feature of Scottish island travel where sometimes they are the only form of internal public transport. Yet the first Scottish Postbus only commenced in 1968 and that was away to the east around rural Dunbar. The first island route was on Skye in 1972. Islay saw its first in 1973 when Postbuses replaced Highland Omnibuses and linked the villages to both the airfield and the Calmac ferries. Those services thus featured in the first Scottish Postbus timetable booklet of 1973 wherein one service had mushroomed into twenty-five within eighteen months, so making that sixty-four-page volume a worthy collectable in itself. Collecting Postbus literature can occupy some people full time!

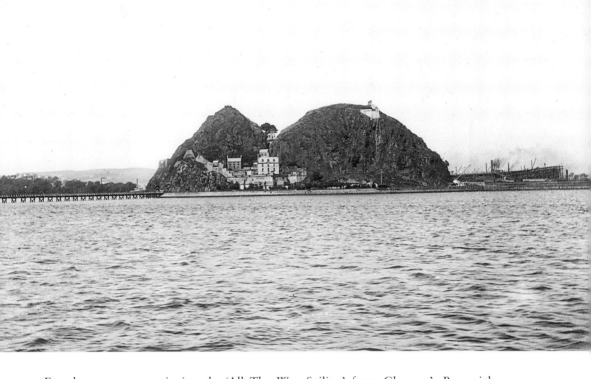

For the passengers enjoying the 'All The Way Sailing' from Glasgow's Broomielaw, a trip through the Kyles and on into Loch Fyne would be a feast of natural beauty. Going downstream, a harbinger of the treats to come was Dumbarton Rock.

The rock is the solidified basalt that was once the molten material of a volcano. The softer 'country rock' was eroded away to leave this plug upstanding. Dumbarton had once been pivotal in Scottish history. *Dun Breatann* meant Fortress of the Britons, and between roughly the fifth and eleventh centuries AD, it was the capital of the Kingdom of Strathclyde. Its political significance has long gone, but as a fortress, it remained defensible into Napoleonic times.

In the nineteenth century, Dumbarton became a capital of another sort. For over eighty years prior to 1963, if you wanted a fast passenger steamer, the Denny shipyard of Dumbarton was one of the favoured companies. Ship model testing and turbine propulsion would be two of the innovative ideas that the Denny family worked with. Their products were recognised worldwide from New Zealand's Cook Strait, along the Irrawaddy in Burma, through the English Channel with its railway packets and car ferries, and onto the Forth with the Queensferry car ferries which Denny's actually ran. The yard was on the tributary River Leven north of the rock, and in this image, a ship can be seen on the stocks to the right.

'The flotsam at which Dumbarton gapes and hungers', W. H. Auden, 1932. The sense of defeat is almost palpable in this view taken in 1989 from Dumbarton Rock, of the old Denny yard site on the River Leven. It is perhaps still more painful when one remembers that the yard had gone into voluntary liquidation twenty-six years beforehand. Almost buried in the detritus and looking rather unkempt is the *Glen Etive*. This was not a Puffer but it is their lineal descendent as a 350-ton motor coaster of 1970. Her owner, Glenlight Shipping, carried on Puffer trades until their demise on 6 January 1994. The company derived from Puffer owners Ross & Marshall and Hay-Hamilton. Its parent family tree went straight back to the Clyde Shipping Company founded in 1815. At the time of this picture, *Glen Etive* was regularly engaged in classic Puffer work, taking building materials from Dumbarton, up the Gareloch to the Trident Submarine Base, then under construction.

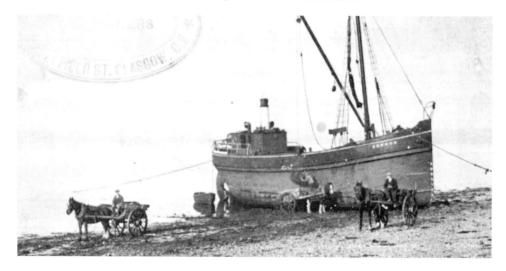

A classic Puffer scene from the turn of the twentieth century.

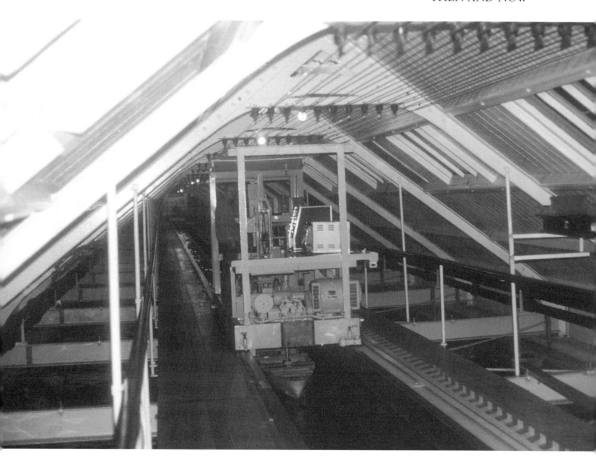

Hiding rather discretely behind a modest façade in Castle Street at Dumbarton is one of Denny's greatest innovations. So important indeed, that when the yard closed, other owners kept this facility working until, in 1984, it passed to the Scottish Maritime Museum. The subject of what might seem a rather bizarre picture was the world's first commercial ship model test tank, opened in 1883. All sorts of maritime milestones were created in miniature here, including the QE2. Wax ship models were precisely planed to exact shape, then towed by an overhead electric railway up and down a 100-yard-long tank. The Scottish Maritime Museum keeps the complex in working order and opens it to the public as the last operational relic of Dumbarton's most glorious industry (oh, I forgot the whisky!).

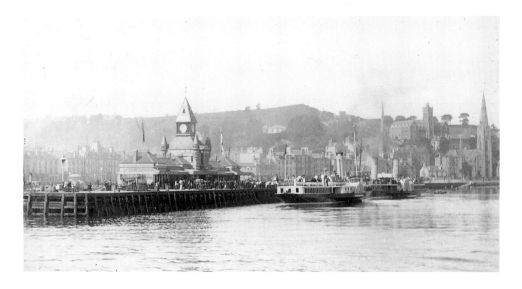

'The Day We Went To Rothesay O': the capital of Bute and immortalised by music hall song. Rothesay was one in the handful of compelling magnets that drew the steamers and their crowds to its pier. Dunoon, Largs, Millport and Ayr formed the other key Clyde resorts that the steamers brought patrons to. Certainly there were many other destinations but places like Carrick Castle and Arran avoided the intense commercialisation that attended the leaders. Even so, it would be unkind to call any a 'Scottish Blackpool'. The soaring hills were never far away as this view of Rothesay makes entirely clear.

Instead, as this image of about 1900 shows, the trademarks of Scottish architecture and the importance of Church life did not abandon the sea front. At Rothesay, the ranks of Victorian hotels, the Winter Garden's masterpiece in cast iron, the electric trams of Scotland's sole island network, and after they went in 1936, the stylish Pavilion which opened in 1938, could all be described as icons of the resort.

The 1885 pierhead building could join that list too, prior to its reconstruction, when a featureless sixties monstrosity replaced the exotic terminal building in this picture. Sadly, the original burnt down in 1964. Its successor was opened on 11 May 1968 by the Queen Mother. One wonders what she truly felt. The new replacement is a definite improvement on the late-1960s terminal.

The prominent hilltop building (right) was Rothesay Academy, which burnt down in 1954.

Opposite: This detail of the pierhead is significant for one item. The steamers tended to have their own gangways at their regular ports of call. There are at least five in this image and on the one in the centre the lettering can be read. It belongs to the (third) *Iona*. The smaller predecessor to the *Columba*, her Rothesay calls around the turn of the century, according to the 1904 Caledonian guides, were part of a Wemyss Bay to Ardrishaig operation during June, July and August. Already getting on in years, this 1864 paddler lasted until she was broken up beside the legendary *Columba* in 1936.

Views of Rothesay inspired poster art as in this British Railways-commissoned image of the mid-1950s. The steamers were kept centre stage. The three vessels are not easily identified but the twin-funnelled one could be one of the *Montrose/Hamilton* pair, while the cargo vessel in the inner harbour should be noted. Along the seafront, the Winter Garden and the Pavilion can be made out, while in the distance, the Kyles of Bute leads away to the delights of Tighnabruaich and beyond. The artist Frank H. Mason was no local man. He had done work for the North Eastern, Great Western, London & North Eastern Railways as well as Cunard White Star before the war, and hailed from Scarborough. He must have been well into his seventies when he undertook this piece, having been born in 1876.

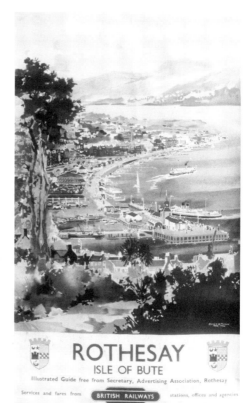

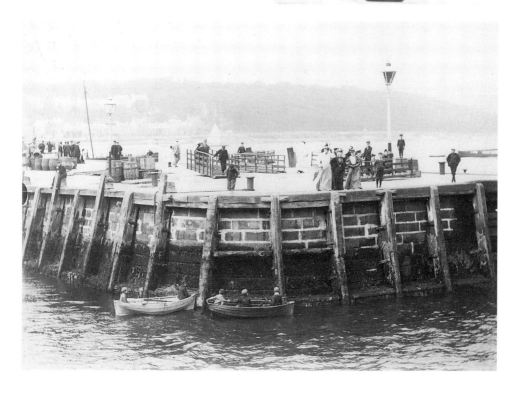

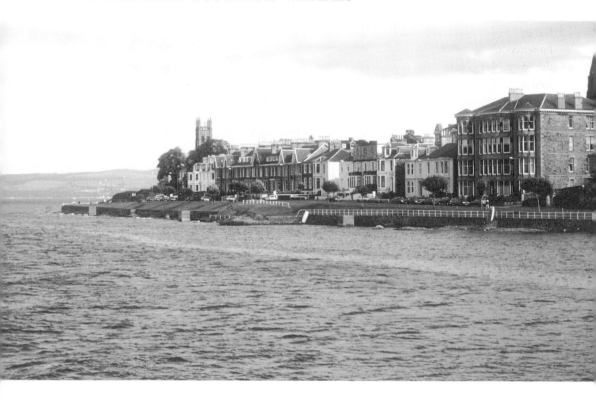

The seafront of several generations past can still be enjoyed at Rothesay as in this view shot from the MV *Balmoral* in 1989. This timelessness extended into the island's guide published by Bute Newspapers. This was a delightfully useful production, particularly for the walker, and its reprints extended into the era of decimal currency. So, upwards of forty years after the trams had gone, the map still marked the tramway and a backcover note had to advise 'Electric Tramlines discontinued 1936'.

Opposite: Unlike Rothesay, the pier facilities at Largs were rather modest. In the 1930s, the LMS image was to the fore. The steamer arriving is the *Queen Mary II*. Destined to be the last saltwater steamer in the Caledonian MacBrayne fleet at her 1977 demise, she was a classic Denny product. Launched in 1933, her suffix appeared as a result of the larger Cunard vessel, ship number 534, in 1935. In this view, she is clearly in her pre-1954 state with two funnels (only one after her 1957 reboiling) and with only one mast. She is likely to be on her regular 10 a.m. sailing from Glasgow coming into Largs at 2 p.m. before a cruise in the direction of Arran and then the return run.

Largs benefited from spending in the 1930s. Along the seafront, the Barrfields Pavilion, Nardini's café and The Moorings were all acknowledged as fine buildings. Clearly the LMS contributed in a small way with its pierside waiting room and ticket booth. The LMS ticket collector will probably have fun identifying tickets from this outlet and from the railway station only a couple of hundred yards up the street which had a 1930s concourse itself.

Largs was among the resorts favoured by the poster artists. In this case, the result is signed by Johnston. Its Railway Executive allegiance dates it to between 1948-53. The steamer is the PS *Caledonia*, a Denny product of 1934 for the Caledonian Steam Packet. She lasted through to the 1969 season and ultimately and sadly ended up burning out as a restaurant boat in London in April 1980. Nardini's café is the structure to the left of the church.

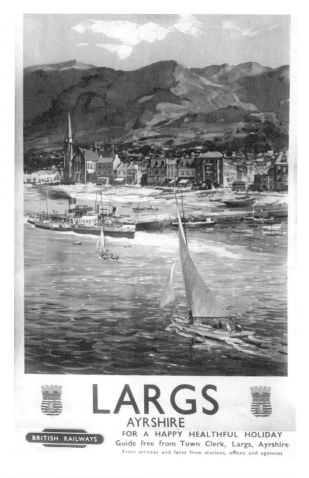

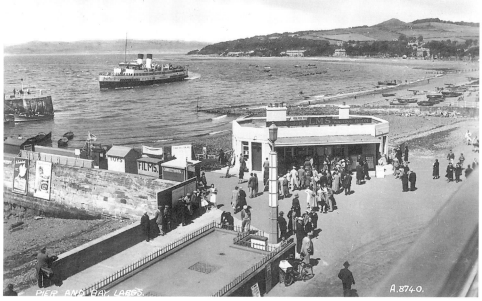

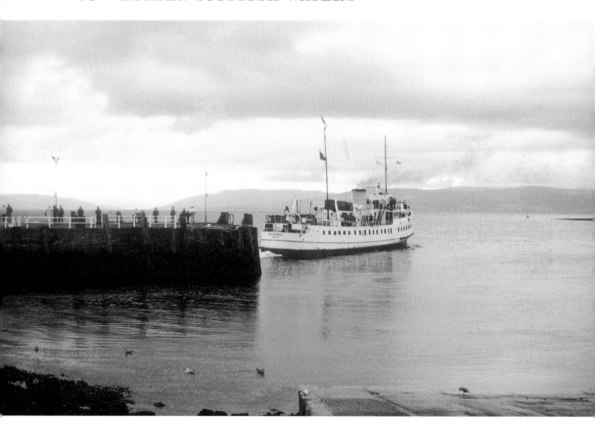

Excursion steamers call rather infrequently at Largs nowadays, but three operators were calling in 2000: Caledonian MacBrayne (their last year of cruises), *Waverley* Steam Navigation and Clyde Marine Motoring. The example in this view belongs to the second named. *Balmoral* was bought as a running mate for the PS *Waverley* in 1985. Most of her operations take place outside the Firth of Clyde but a regular appointment for her is the Glasgow September Holiday during which she offers Clyde sails such as this occasion on 17 September 1989. She is a motor vessel built in 1949 by Thornycrofts of Southampton. Her earlier career was spent first with Red Funnel in the Solent and then with P&A Campbell in the Bristol Channel, both of whom were respected companies.

In the photograph, it is evident that a slipway is in the foreground. Its installation had led to the demise of the charming 1930s office and its prosaic nature is an apt introduction to the long-running saga of the Cumbrae services. Largs is the obvious harbour from which to serve Cumbrae and before the motor car gained sway, it was simply a matter of running small passenger ships like the *Wee Cumbrae*, *Ashton* and the *Leven* on a thirty-five-minute run beside the island to Millport Pier. Latterly, the dedicated vessel was the *Keppel*; but none of these could handle cars. The end result of a complex story was that, in 1972, this new slipway at Largs opened for a route running straight across to the old Tattie Pier on Great Cumbrae. Small car ferries were brought in, though, for another fourteen years, the *Keppel* maintained a passenger-only link direct to Millport. Pier decay was one factor in the demise of that operation, although after a long campaign, Millport's pier was renovated.

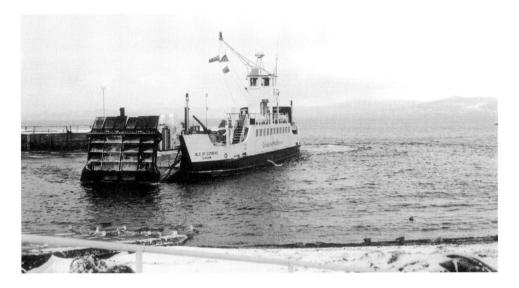

Initially the new car ferry to Cumbrae made use of other route's cast-offs, but the service became so popular that a larger vessel designed exclusively for the route arrived in 1977. This was the MV *Isle of Cumbrae*. On 12 January 1987, snowfall even at sea level had whitened the foreshore and the ferry's bow door as she arrived at Largs.

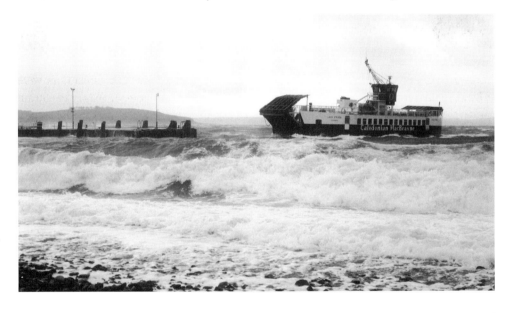

Blizzard conditions at Largs may not be so common but strong winds are an occupational hazard. Cumbrae usually provides some shelter, but on 24 March 1989, a storm force nine was blowing. Coupled with a very high tide and seas washing right over the pier, the MV *Loch Striven* was having a hard time on the job. Growth in traffic had meant that in 1986 a twin pair of car ferries had been introduced onto the Cumbrae service. The *Loch Striven* and the *Loch Linnhe* could offer a fifteen-minute interval service between them.

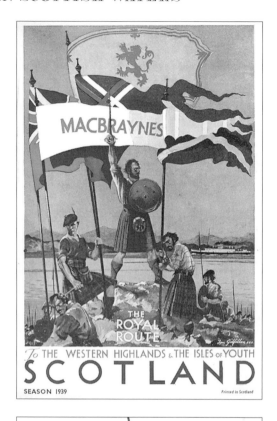

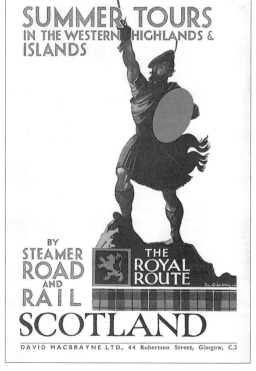

4
MacBraynes after 1939

Few years would turn out to be as momentous as 1939. In the images that follow, the changes that after the war would swiftly affect the steamer operators will be largely charted by the publicity material that was issued. The eighty-page guide (opposite), issued in 1939, was reflecting an age about to be deeply shaken. Political changes like nationalisation and technological changes like the demands of the car would increasingly set the agenda in the decades that followed. Nationalisation was an issue for MacBraynes because, in 1928, the company had become partly owned by the LMS railway, whose shares became state owned in 1948.

All of which was unlikely to be in the mind of those who handled this guide in 1939. Instead, they perhaps remembered that the guide was a hardy annual produced since 1879. What a romantic image the covers create. The Royal Route was not a new slogan but the idea of the Isles of Youth reflected more closely the introduction to the guide provided by Donald MacLaren. His prose bears quotation:

> At this phase of the evolution of society, men and women, jostling in the layers of a mindless commercial system, are seeking another dimension for their dreams and desires.
>
> Each day advertises a quicker and smoother way of living and the next discards a multitude of prescriptions how to breath, to sleep and to eat.
>
> It is a frenzied search for some place out of themselves, a shore or a hillside where they may rest and recapture the music and breath of youth.
>
> And out there, on the chord of the setting sun, lies a region that is ever new – the Isles of Youth …
>
> The Isles of Youth belong to another state of human affairs – another plane of experience – where the burdens of obligation and compulsion are unknown and the eye is satisfied.

Perhaps this was why Para Handy never seemed too burdened by the obligation of timekeeping. Undeniably this was a romantic way to commence a travel brochure. Today it would seem unbearably highbrow; it almost assumed that the writings of Huxley, Auden and Orwell would be familiar. Even so, the rest of the brochure, thoroughly illustrated in monochrome by R. M. Adam and others, did well at portraying the image. When one comes to the impressions of Iona and Staffa as seen in 1939, and then remembers that even a car ferry in the 1980s could conjure the same romance when arriving in those places, then one may grant a certain reality to the idea of the Isles of Youth.

The romance was continued in a route map for MacBraynes' operations superimposed on a clan map (opposite). Significantly, elements of retrenchment can just be discerned. Gairloch now only had a freight service. The route through the Caledonian Canal is present along with an already extensive motor coach network. The steamer link from Oban to Crinan was omitted. The Glasgow to Inverness prime service, fulsomely detailed in a travelogue in the guide, used a motor coach between Ardrishaig and Oban. When in 1929 the Crinan Canal steamer *Linnet* was withdrawn, the complications of a replacement made the attraction of a straightforward motor connection too compelling.

It was really only a blip for a journey for which 'as the first breath of summer blows over the waters and the fields, Glasgow knows that the three red funnels of the *Saint Columba* are at South Broomielaw Quay and that the ship sails at seven-eleven'. The *Saint Columba* was a variation on the popular *Columba* name theme of MacBraynes. She was actually a 1936 rename of the 1912 turbine *Queen Alexandra*, younger sister of the *King Edward*, so transformed to succeed to the role of the old *Columba*.

The motor coach element was justified by quoting La Rochefoucauld's maxim that 'We must ourselves be at ease if we would discover any merit in the world'! Hopefully having started with breakfast on the ship which 'is one of the fixed stars in the epicurean firmament' in which the grilled herring were 'their own grace', the traveller's stomach would not be too disconcerted by the coast road to Oban.

Although elements of the tradition had been re-packaged, two major elements were unchanged for the final time in 1939. After the war, Glasgow would no longer be the start point. At the Highland end, having arrived by steamer at Fort William's railway station, the Inverness-bound traveller took a short connecting train ride to Banavie where the PS *Gondolier* waited for the run through the Caledonian Canal. (See also colour section p.12.)

SEE THIS SCOTLAND FIRST!

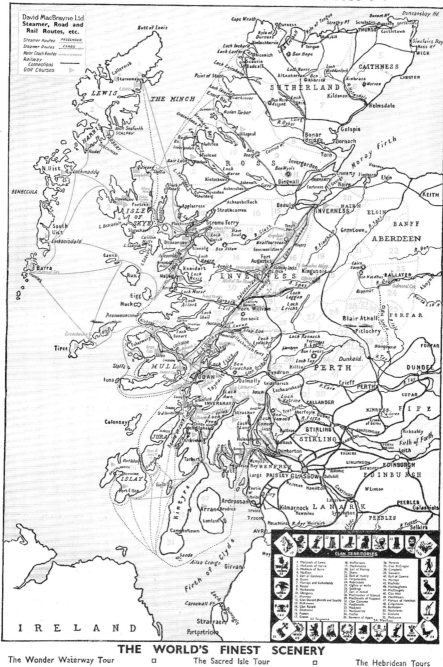

THE WORLD'S FINEST SCENERY

The Wonder Waterway Tour ▫ The Sacred Isle Tour ▫ The Hebridean Tours

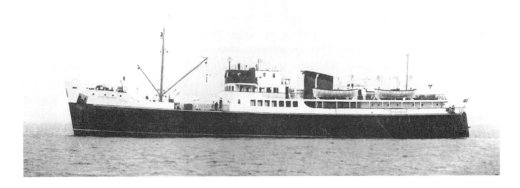

The early postwar flagship of the MacBraynes fleet was the TSMV *Loch Seaforth* and she was given pride of place in the 1951 brochure (see colour section p.10). The commitment to build a new mail vessel for the Stornoway service had been made in 1938, but the war intervened. Denny was the favoured builder and, on 6 December 1947, she took up station. She was constructed as a motor vessel which by then was to be expected from MacBraynes. The company was considerably ahead of Caledonian Steam Packet in this regard and had ordered numerous motor ships between the wars.

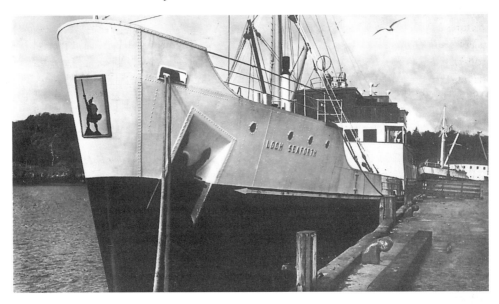

The ship was quite large with a gross tonnage in excess of 1,000. Considerable effort, despite the austerity of the period, went into *Loch Seaforth*'s outfitting. There was even a clansman on the bow. Her worst feature was the noisy diesel machinery. Her career ended rather sadly in a grounding incident in the Gunna Sound between Tiree and Coll on 22 March 1973. By pure chance, both the chairman and general manager of the new Caledonian MacBrayne were on board! No one was lost but the vessel subsequently ended up blocking Tiree's unfortunate pier for nearly two months. Scrapping at Troon followed.

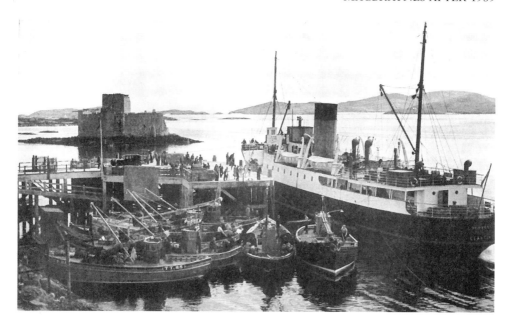

The 1951 brochure was well illustrated inside, including views in and out of Fingal's Cave, that *ultima thule* which the company regularly served. One of the classic locations for steamer pictures has to be the pier at Castlebay on Barra. The stronghold of the MacNeills on its own islet is usually worked into the composition as in this instance. In 1951, cars are on the pier but roll-on roll-off is still decades away. Even in the 1990s, Barra did not have a linkspan, vehicles having to be loaded by the ship's own hoist, causing MV *Lord of the Isles* to be so built in 1989. The cluster of wooden fishing vessels is another thread of longevity.

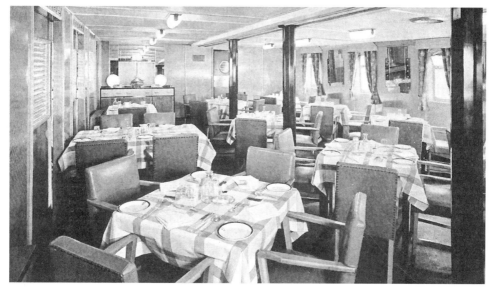

MacBraynes were evidently proud of *Loch Seaforth*'s dining facilities.

STEAMER FLEET

Type	Vessel			Gross Tons
S.S.	CLYDESDALE	-	-	- 412
S.S.	HEBRIDES	-	-	- 585
T.S.S.	KING GEORGE V	-	-	815
M.V.	LOCHBROOM	-	-	- 325
Tr.S.M.V.	LOCHBUIE	-	-	- 33
M.V.	LOCH CARRON	-	-	- 700
M.V.	LOCHDUNVEGAN	-	-	- 562
T.S.M.V.	LOCHEARN	-	-	- 542
S.S.	LOCH FRISA	-	-	- 519
D.E.V.	LOCHFYNE	-	-	- 754
S.S.	LOCHGORM	-	-	- 635
T.S.M.V.	LOCHIEL	-	-	- 603
T.S.M.V.	LOCHINVAR	-	-	- 216
T.S.M.V.	LOCHMOR	-	-	- 542
T.S.M.V.	LOCHNELL	-	-	- 31
T.S.S.	LOCHNESS	-	-	- 777
D.E.V.	LOCHNEVIS	-	-	- 568
T.S.M.V.	LOCH SEAFORTH	-	-	1090
M.V.	LOCHSHIEL	-	-	- 208
Tr.S.S.	SAINT COLUMBA	-	-	851

Of the above fleet, the following vessels were on War
Service :

T.S.S. KING GEORGE V 1940-45. On troop service
in the Channel and at Dunkirk. After Dunkirk,
troop tender at Gourock.

D.E.V. LOCHNEVIS 1940-44. Mine laying.

Tr.S.S. SAINT COLUMBA 1939-46. Admiralty Clyde
Boom Defence Depot Ship.

38

A nice feature of these annual brochures down to the present day is the listing of the vessels in the fleet, supplemented at times since 1977 by the company's own publication of a full fleet list in booklet form called *Ships of the Fleet* or *Hebridean and Clyde Ferries*. These create a collectable in their own right. In 1951, the fleet of twenty vessels was clearly showing the preponderence to the diesel engine with only seven true steamers. The bulk of the *Loch Seaforth* is evident. The 1998 fleet would boast seven ships in excess of 1,000 tons and one, the 1995 *Isle of Lewis*, would be of 6,753 tons, witness to an enormous growth on the Lewis service which the *Loch Seaforth* had been built for.

To note the war service of the relevant vessels was a mark of respect. Beside the list, the sleek lines of another motorship were illustrated. This was the Denny-built *Lochiel* of 1939. This close relative to the *Loch Seaforth* also managed a sinking, at West Loch Tarbert in 1960. After six months out of action, the ship returned to service. For many years from 1974, she was a restaurant ship in Bristol Docks before the breakers called in 1996.

Opposite: Publicity material from after 1945 is going to be much easier to unearth than pre-war material and since the tradition of attractive publicity is maintained to this day, there is much to seek. The following selections (and those on pages 10-12 of the colour section) provide an impression of the variety put into the annual timetable covers, at a time when the equivalent publication by the Scottish Region of British Railways went through decades of identical blue covers with not a hint of illustration.

Take the cover of the 1957 catalogue, for instance. In an age when we are fed with a diet of full-colour pictures, it is worth seeing how effectively a well executed piece of artwork relying only on black and white (plus a blue wash in the original) could produce such an entrancing image. Not much weight is given to the vessels (and no road vehicle intrudes)

but a composition of pier, castle, lighthouse and the serried ranks of peaks stretching away will surely leave you wishing to be so transported. It is the capacity of this literature to kindle memory and evoke desire wherein lies its effectiveness. For each viewer, there will be a personal composition behind the literalness of the image (which hints of Castlebay and Isle Ornsay). I see this and remember courting days on the pier at Craighouse on Jura. It is a shame that the item is anonymous and that the identity of the artist involved is unknown.

Inside, the company lost not a paragraph in redeveloping *The Royal Route* concept, for in 1956, the new Royal Yacht *Britannia* has taken the Royals on what became an annual series of cruises in the Western Isles. An illustration showed Tarbert's (Harris) fishing fleet dressed overall to welcome the Royal cruise.

The temptations of full colour were not far behind at MacBraynes. The annual brochure for 1960 (see colour section p.11) shows their experiments with colour plates. However, the company recognised the limitations then present with colour reproduction. Between then and the amalgamation with Caledonian Steam Packet, leading to the final MacBraynes brochures being issued for 1972, all of the covers used colour artwork and not photography. The result was tremendously evocative, as this cover shows. In various forms, the flags lasted throughout the rest of the decade. The theme was clear: MacBraynes as a Scottish institution could stand proud with the national flags and with the bravery of the Highlander. Specific location and even vessel identity were sacrificed to this noble cause. The alert will realise that this was actually a revival of pre-war themes. Despite the similar artwork, the various versions of this image are redrawn and the background ships change. The pre-war versions were signed by Tom Gilfillan. As a slightly different poster, it had existed in 1938. Charting the exact changes of the MacBraynes 'Flag' theme can become very time-consuming.

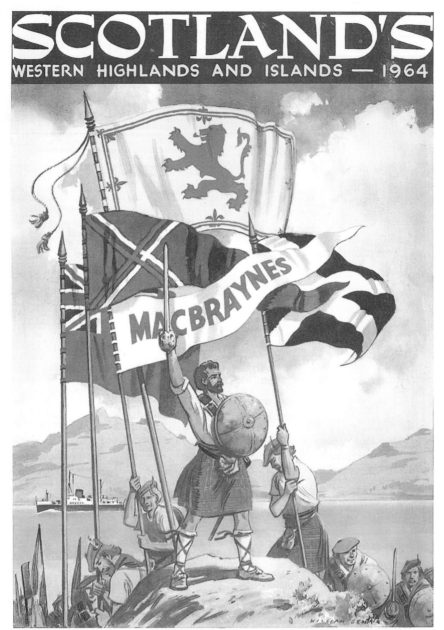

The flag theme was used in 1963 and 1964 for the cover of an oversize timetable brochure (9in x 13in). Its size makes its preservation difficult and you are unlikely to find one which has conveniently spent the decades in an envelope. Inside, both colour artwork and photography were used. The cover itself seems similar to 1962 but it has actually been entirely redone (look closely at the detail), and it is also signed – by William Semath.

COACH TIME TABLES AND FARES

GLASGOW COACH STATION *is situated at* 46 PARLIAMENTARY ROAD, C.4
All times and fares are subject to alteration and should be confirmed before travelling.
For full details of all Coach Services and Fares—see Coach Services Time Table.

TABLE 29 GLASGOW-CAMPBELTOWN Daily

ARDVASAR-KYLEAKIN (SKYE)
Daily except Sundays

ARMADALE-PORTREE (SKYE)
Daily except Sundays

PORTREE-KYLEAKIN (SKYE)
Daily except Sundays

For times and fares on the above services see Coach Services Timetable

	a.m.	p.m.	Fares Glasgow to				a.m.	p.m.
			S.	R.				Z.
Glasgow - - dep.	9 0	3 15			Campbeltown - dep.	7 0	2 30	
Arrochar - - arr.	10 33	4 48	6/1	11/4	Tarbert - - "	8 25	3 0	
Inveraray - - "	11 40	5 55	10/9	19/9	Ardrishaig - - "	8 55	3 10	
Lochgilphead - "	12 45p	7 0	14/6	26/3	Lochgilphead - "	9 5	4 20	
Ardrishaig - "	12 50	7 5	14/8	26/8	Inveraray - - "	10 15	5 17	
Tarbert - - "	1 20	7 35	17/4	30/3	Arrochar - - "	11 12	7 0	
Campbeltown - "	B	9 0	23/9	38/1	Glasgow - - arr.	12 55p		

B—Connection arrives at 4.10 p.m. Z—Connection departs 11.0 a.m., 12.30 p.m. on Sundays.

CONNECTION WITH OBAN Except Sundays
The 9.0 a.m. bus from Glasgow connects at Lochgilphead with the 2.0 p.m. bus for Oban, arriving there at 4.5 p.m. On the return journey the bus leaves Oban 9.45 a.m. and connects with the 3.10

Hire a MACBRAYNE COACH for your outing

THEATRE PARTIES WEDDING PARTIES SOCIAL CLUBS

Individual page headers were specially created and, as in this example, had definite charm. The vehicle is a pastiche in a rather stretched form of a 1962 twenty-nine-seat Bedford VAS coach. The key components of the Duple Bella Vista body are reproduced. More from this production is reproduced elsewhere.

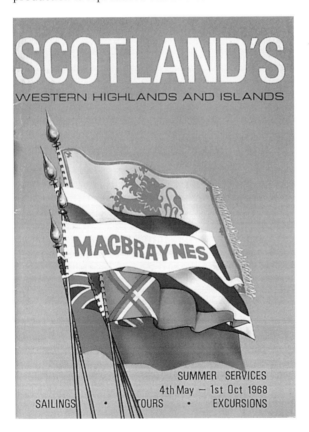

SCOTLAND'S
WESTERN HIGHLANDS AND ISLANDS

MACBRAYNES

SUMMER SERVICES
4th May — 1st Oct 1968

SAILINGS • TOURS • EXCURSIONS

The final glance at this series of annual productions looks at the situation in the late 1960s with the 1968 cover, a design which was used from 1966 to 1970. It was applied to large brochures and to a smaller-format timetable, in this case sixty-four pages packed with information and otherwise virtually bereft of illustration.

Supporting the annual brochure was a host of literature promoting individual routes or special occasions. The following items examine some of these. One guesses that every time a ship was launched and then commissioned, celebratory leaflets and invitations appeared. These would have had a restricted circulation and will certainly require some tracking down today. The example shown here was produced to mark the two 1955 additions to the MacBraynes' fleet.

David MacBrayne Ltd.

have commissioned

TWO
NEW VESSELS

for service in

THE WESTERN HIGHLANDS AND ISLANDS
OF SCOTLAND

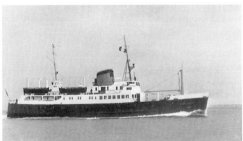 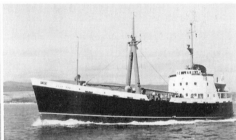

The pair were a part of the commitments the company undertook having gained the 1952 mail contract. *Claymore* (left) was the second bearer of the name (in 1978, a third arrived). Denny again were the builders and traces of the superstructure and funnel shape that would become familiar with the 1964 car ferries can be discerned. *Claymore*, however, was not car-friendly; eleven could be carried but only in the hands of the ship's derrick. Her interior decoration was to a particularly high standard with the Clansman emblem engraved in the glass of the dining saloon doors. She was built for the Inner Islands mail route from Oban. Without effective car-carrying capacity, the changes of the 1970s made her redundant and she was sold in 1976.

The second 1955 vessel had an even shorter life with MacBraynes. *Loch Ard* was effectively a trim motor coaster intended for the cargo run from Glasgow to the islands. Powerful derricks even enabled her to load lorries and buses. Containers and the roll-on roll-off ferry all made life extremely difficult for the conventional coasting operation in the 1960s. Finishing her MacBraynes life on the Glasgow-Islay service, *Loch Ard* was sold in 1971.

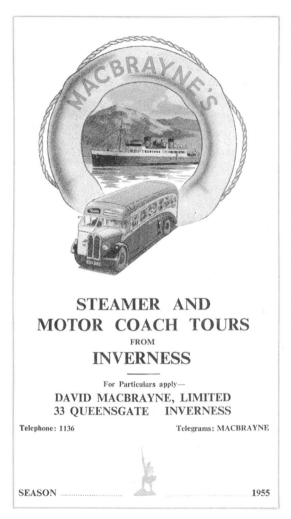

STEAMER AND
MOTOR COACH TOURS
FROM
INVERNESS

For Particulars apply—
DAVID MACBRAYNE, LIMITED
33 QUEENSGATE INVERNESS

Telephone: 1136 Telegrams: MACBRAYNE

SEASON 1955

Simple handbills like this were printed in their thousands. Each location of substantial interest to MacBraynes required its programme and for many years this was the style employed. Subtle variations in the choice of vessel and coach were employed. Doing the honours here are *Lochfyne* and an AEC Regal. The registration EGA 642 can be made out confirming that this was a coach which gave the company twelve years service before sale to Garnock Valley of Kilbirnie. With no steamers at Inverness postwar, all the opportunities detailed relied on the motor coach, even if two tours ended up afloat. One of them is covered by the next subject.

Opposite: Both MacBraynes and Caledonian Steam Packet vessels could be found on Scottish freshwater. In MacBraynes' case, the Caledonian and Crinan Canal operations were well known. This is an example of another. Loch Shiel stretches away from Glenfinnan for about eighteen miles to Acharacle whence in an erratic fashion the sea can be reached. Few tarmac roads reach its shores, and with the advent of the West Highland Railway, the opportunity for a mail boat service from Glenfinnan existed. Even before that, MacBraynes had endeavoured to serve the loch from 1893, in a venture which included moving a corrugated-iron church from Govan for use a hotel annexe. That first venture died. Other operators provided a service for over fifty years.

Then, in 1953, MacBraynes reappeared with two brand-new motor launches, the *Lochshiel* and the *Lochailort*. The service was maintained until 1967 when, with the advent of the road between Lochailort to Kinlochmoidart, the company again withdrew. Finding any sort of illustration for this operation is a challenge, which makes this undated handbill rather attractive.

CIRCULAR TOUR TO
LOCH SHIEL

The Loch Shiel Tour is circular; it combines sailing and coaching; it takes you to one of the most remote, beautiful and unspoilt corners of Scotland. The combination creates one of the most satisfying tours it is possible to imagine, and one which lingers long in the memory.

The tour is really in four sections; first, a coach trip from Fort William to Glenfinnan; then a sail down the lovely waters of Loch Shiel; another coach trip from Acharacle by the shores of Loch Sunart to Corran Ferry; and, finally, a drive by Loch Linnhe back to Fort William. Each of these sections has its own individual beauty and its own associations, but they combine to form a day's touring which, in the opinion of many experienced travellers, is the finest thing of its kind in the country.

The first section takes you out of Fort William by the foot of Ben Nevis and across to Banavie where the eight locks of Neptune's Staircase raise the Caledonian Canal some eighty feet. Beyond this is Corpach, where the canal actually begins, and in whose Church-yard is an obelisk raised to the memory of Colonel John Cameron who fell at Quatre Bras. The obelisk acts as a reminder that this is the heart of the Cameron country.

There is a spell then by the calm waters of Loch Eil, which seems to be designed to give the greatest possible dramatic effect when the soaring mountains and naked rocks around Glenfinnan are reached.

In the heart of this wonderful theatrical setting stands the statue of Prince Charlie, and one has the impression that he is waiting for the clansmen to come marching from the hills and glens to raise the Standard as they did two hundred years ago.

From the monument, Loch Shiel stretches down between the hills for some eighteen miles, and the sail to Acharacle at its far end is a unique experience. Partly, this is because of the beauty of the scenery; partly because of the fact that there is no road on either side of the Loch, and this gives a fine sense of remoteness. The few houses here depend on the boat for their mails and supplies.

At the little village of Acharacle there is time for tea, and then the coach takes you by a road which rises quickly and then plunges down towards the entirely different scenery of Loch Sunart.

This is one of the most fiord-like of the Highland lochs, and its lovely shores are well-wooded—chiefly with oak. On the far side can be seen the hills of Morven. Strontian, in a lovely position by the side of Loch Sunart, was famous at one time for its floating church. This unusual arrangement was made because the landlord would not provide the Free Church with land on which to build.

The next section is through the wild desolation of Glen Tarbert and then, with exquisite views of the mountains of Glencoe, along the birch-lined winding road by the edge of Ardgour.

Close by the little lighthouse which marks the Corran Narrows, the ferry boat takes you from Argyllshire to Inverness-shire, and there is a final drive by the shores of Loch Linnhe into Fort William.

The above Tour can also be carried out in the reverse direction.

DAVID MACBRAYNE LIMITED
Clyde House :: 44 ROBERTSON STREET, GLASGOW, C.2

PLEASURE SAILINGS

and Motor Excursions from Oban

by
R.M.S.
King George V

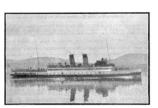

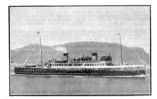

R.M.S.
Lochfyne

or other Vessel

(Weather and Circumstances permitting)

DAVID MACBRAYNE LTD.
STEAM PACKET OFFICE
NORTH PIER. OBAN

Oban was the hub of MacBraynes' operations and was a substantial tourist destination in its own right. Not only did it receive its own seasonal programme but a weekly newsheet was produced. These were intended to be hung up and pulled off by tourists and usually the result is a missing corner. Doubtless other key locations did the same, Largs certainly, but the survival rate for what was once such a common piece of ephemera is limited. This example is the cover of the programme for the first week of September 1956. The cover would be used again and again with blocks for each tour dropped in as required. At this time, up to six tours a day were on offer. The destinations on the Wednesday were Glencoe circular by road and steamer; Staffa, Iona and Round Mull by steamer; Fort William by steamer; Inverness by steamer and road; the Loch Sheil tour; and finally an evening cruise to Fort William and back. The trip to Iona departed every day and merited its own special advert, for this was none other than 'the Finest One day-Excursion in Great Britain by RMS *King George V* (or other steamer) to St Columba's Sacred Isle of Iona, burial place of Scottish Kings and the Isle of Staffa on which is situated the world famous Fingal's Cave (Passengers intending to land at Staffa are advised to wear low-heeled footwear)'.

MacBraynes would continue to offer the Sacred Isle Cruise until 1988 and rather more will be seen of it later. For the collector of this literature, the cruise itself merited its own seasonally issued leaflet complete with a route description and map. In later years, the juxtaposition on this of decimal currency and the *King George V* seemed somewhat anachronistic.

In contrast to the choices offered from Inverness and Oban, the programme from Portree on Skye was much more modest. A single-sheet handbill sufficed. The provision of a high-season evening cruise to Gairloch is interesting; otherwise, the opportunities all relied on the mail boat service which was an institution operating from the railheads at Mallaig and Kyle of Lochalsh to Raasay and Portree. With its long coastal passage including the Sounds of Sleat and Raasay, the scenic element of the voyage was considerable. The vessel used in 1957 was the motor ship *Lochnevis* of 1934, which had been a stalwart of the route. In 1959, the *Loch Arkaig* arrived. What is left of this service is now the domain of the 1979 *Lochmor*, but Portree has not been served since 1975. The cover shows subtle changes from the Inverness example. The coach once again shows its registration, being OGB 468, one of a trio of Bedford SB vehicles delivered in 1955. It gave the company thirteen years service.

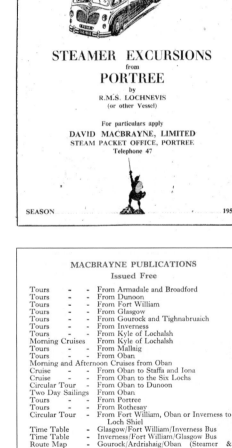

MACBRAYNE PUBLICATIONS
Issued Free

Tours	- -	From Armadale and Broadford
Tours	- -	From Dunoon
Tours	- -	From Fort William
Tours	- -	From Glasgow
Tours	- -	From Gourock and Tighnabruaich
Tours	- -	From Inverness
Tours	- -	From Kyle of Lochalsh
Morning Cruises		From Kyle of Lochalsh
Tours	- -	From Mallaig
Tours	- -	From Oban
Morning and Afternoon Cruises from Oban		
Cruise	- -	From Oban to Staffa and Iona
Cruise	- -	From Oban to the Six Lochs
Circular Tour	-	From Oban to Dunoon
Two Day Sailings		From Oban
Tours	- -	From Portree
Tours	- -	From Rothesay
Circular Tour	-	From Fort William, Oban or Inverness to Loch Shiel
Time Table	-	Glasgow/Fort William/Inverness Bus
Time Table	-	Inverness/Fort William/Glasgow Bus
Route Map	-	Gourock/Ardrishaig/Oban (Steamer & Coach)
Route Map	-	Glasgow/Fort William/Inverness (Coach)
Coloured Folder of Western Highlands and Islands		

Motor Coach Time Tables 2d. each
Islands Area —Islay, South Uist and Benbecula, North Uist and Skye.
Northern Area—Glasgow, Tyndrum, Glencoe, Kinlochleven, Ballachulish, Fort William, Glenfinnan, Achnacarry, Roy Bridge, Kingussie, Fort Augustus, Inverness, Glenurquhart, Corriemony, Foyers, Whitebridge, Mallaig, Arisaig.
Southern Area—Glasgow, Inveraray, Lochgilphead, Ardrishaig, Tarbert, Campbeltown, Oban, Arrochar, Lochgoilhead, Carrick Castle.

This extract from the 1957 brochure is a keynote for the collector – the list of MacBraynes publications that will appeal. Twelve locations were issuing the *Tours* leaflet and various other titles will be recognised from elsewhere in this account.

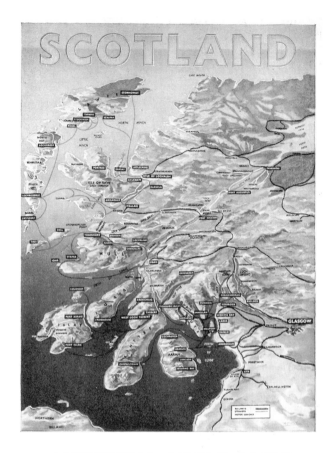

WESTERN HIGHLANDS
AND ISLANDS

BY MACBRAYNE'S & BRITISH RAILWAYS

The aerial view of the dissected coastline of Western Scotland became an inspiration for publicity material in the 1950s and 1960s. Many examples were used by the Caledonian Steam Packet and the genus of the idea might be as early as the North British Railway. That railway link led to the theme of this 1954 leaflet. Since MacBraynes was partially railway-owned and many services operated in direct connection with trains, this integration made sense. This artwork was reused elsewhere. The 1954 and 1955 brochures used it with some changes as the centre spread route map. A poster version was also produced.

It is a rare piece of signed artwork and came from William Nicholson, who undertook the related British Railways/Caledonian Steam Packet material as well as two different Clyde Coast posters in the genre. He was the chief artist in McCorquodale's Glasgow studios during the 1930s, 1940s and 1950s. McCorquodale's had handled railway printing work including timetables, posters and postcards since the nineteenth century.

SPECIAL DAY EXCURSION

in association with
MESSRS. DAVID MacBRAYNE LTD.

(FIRST CLASS ONLY)

To STAFFA AND IONA

by Train and Steamer

On Saturday, 10th September, 1960

OUTWARD			RETURN		
Friday night, 9th September			Saturday, 10th September		
TRAIN			**STEAMER**		
		p.m.			p.m.
ABERDEEN	leave	8 30	OBAN	arrive	6 0
DUNDEE				**TRAIN**	
(Tay Bridge) ...	,,	10 10	OBAN	leave	7 0
EDINBURGH			PERTH	arrive	11 22
(Princes Street) ...	,,	10 14	EDINBURGH		
PERTH	,,	10 40	(Princes Street) ...	,,	11 24
			DUNDEE		
			(Tay Bridge)	,,	11 55
Detrain at Oban in time to board the			ABERDEEN	,,	1 45a.m.
Steamer for breakfast commencing at 8 0					(Sunday 11th)
a.m.					

RETURN FARES FROM

(inclusive of First Class sleeping berth accommodation on outward rail journey ; breakfast, luncheon and afternoon tea and steamer ; dinner on the return rail journey from Oban).

ABERDEEN	**DUNDEE**	**EDINBURGH**	**PERTH**
210/-	**168/-**	**168/-**	**155/-**

ACCOMMODATION LIMITED

Intending passengers are requested to book in advance

TICKETS OBTAINABLE IN ADVANCE

at ABERDEEN, DUNDEE (Tay Bridge), EDINBURGH (Princes Street) and PERTH stations only and are valid on the date for which issued and by the services specified.

All information regarding Excursions and Cheap Fares will be supplied on application at stations or to A. Haworth, District Commercial Manager, Dundee—Telephone No. Dundee 26835 or J. K. Cumming, District Commercial Manager, 23 Waterloo Place, Edinburgh—Telephone No. WAVerley 2477 or J. H. Young, District Traffic Superintendent, 80 Guild Street, Aberdeen—Telephone No. Aberdeen 23432 or J. Killin, District Traffic Superintendent, Perth—Telephone Perth 2282.

NOTICE AS TO CONDITIONS—Tickets are issued subject to the Conditions and Regulations contained in the Bills and Notices of or applicable to British Railways or to any other body, company or person upon whose services the tickets may be available.

B.R. 35000—B 29547—VZ—August, 1960 George Outram & Co. Ltd., Perth.

The visit to Staffa was without doubt the ultimate experience that MacBraynes regularly offered. It was some feat to take a large steamer on a daily basis through the summer to a remote, uninhabited island off the west coast of Mull. Steamer passengers had reached the island since 1825 and poets like Scott and Keats had been there earlier. Turner and Wordsworth came later courtesy of steam. Part of the knack behind the business was using the railway connection at Oban. A trainload of excursionists was good money for a steamer, while in return the railways appreciated that people might travel a long way just to visit Staffa. Dedicated railway excursions to this end were the norm well into the 1960s. This example is a simple one-sided handbill promoting an excursion from Scotland's east coast cities. Would we look forward to such an occasion today? The trip involved overnight departures in First Class sleeping cars to Oban where the *King George V* (in all probability) was ready to serve breakfast. This extravaganza finally ended in the small hours of Sunday morning.

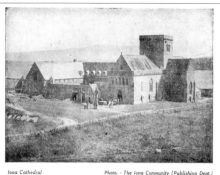

Iona Cathedral Photo. - The Iona Community (Publishing Dept.)

UNIQUE RAIL AND STEAMER CRUISE
TO THE
HIGHLANDS AND ISLANDS OF SCOTLAND
Friday Night 5th JUNE 1959
FROM LONDON Euston – RUGBY Midland
COVENTRY – BIRMINGHAM New Street
WOLVERHAMPTON High Level and CREWE
To STAFFA & IONA

———— COMBINED RAIL AND STEAMER FARES ————

LONDON		100/-	BIRMINGHAM		87/-
RUGBY		92/-	WOLVERHAMPTON		85/-
COVENTRY		90/-	CREWE		79/-

CHILDREN UNDER 14 YEARS OF AGE HALF-FARE

TICKETS CAN BE OBTAINED ON DIRECT APPLICATION TO THESE STATIONS
OR BY PREVIOUS NOTICE TO OTHER STATIONS AND OFFICIAL RAILWAY AGENTS

LONDON MIDLAND

Long-distance travel was traditionally the railway's *forte*, and if Aberdeen seems far flung from Iona, then the London market might seem still more unlikely. However, the knowledgeable audience who could recognise the draw of the Sacred Isle did exist in the English capital and the evidence of the response is the survival of a number of handbills like this one. Travel was by overnight train (with sleeping berths only an option) in time to board KGV's normal 9 a.m. departure. Oban was left at 8.15 p.m. for another overnight trek south. Further examples of handbills exist for similar tours run from towns in the English Midlands or North.

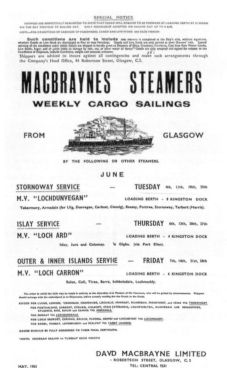

If Staffa and Iona were the emotional highlight of the MacBraynes' operation, the contrast of the day in, day out, in-all-weathers cargo service should not be forgotten. Despite its May 1963 date, this poster has quite a nineteenth-century feel to it. It is presented in rather archaic poster form as the sort of item that might be pinned up in a shipping office.

The three ships involved were the MV *Lochdunvegan*, *Loch Ard* and *Loch Carron*. All entered the fleet between 1950 and 1955 revealing a 1950s confidence in a traditional approach that the 1960s would challenge. The vessel illustrated is the *Loch Carron*. The last coaster in the fleet was this ship, and when her service ended in 1976, she was the last coaster working on scheduled sailings from Glasgow. Additionally, the MacBraynes interest now had no sailings scheduled around the Mull of Kintyre. It was the end of an era.

The first half of the 1970s saw the end of numerous MacBraynes milestones. From 1 January 1973, the fleet became Caledonian MacBrayne. The coasting trade was in terminal decline and only one MacBraynes steamer was left to be handed over. The *King George V* had come from Denny's in 1926, being built for Turbine Steamers Ltd, and entered the MacBraynes fleet in 1935. In 1936, she left the Clyde and took up the Oban-Staffa-Iona route with which she was to be associated for a further thirty-eight years. Her main break was for her war service which included six runs to Dunkirk in May 1940. In the hands of Caledonian MacBrayne, only two seasons were left, which makes the colour leaflets produced rather poignant. Indeed, since it was only the 1970s that saw the widespread use of colour photography in leaflet design, only four steamers ever really benefited from this type of promotion: *Waverley, Queen Mary II, Maid of the Loch* (all from the Caledonian Steam Packet side) and *King George V.*

The example featured is the 1973 edition. The season ran from 21 May to 15 September. On five days of the week, the

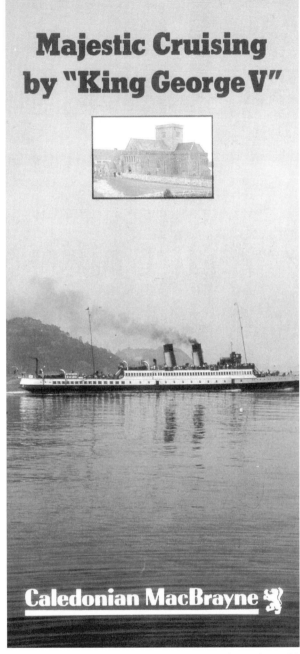

Sacred Isle Cruise ran, while, on high season Sundays, the last vestige of another old favourite was run. This was the Six Lochs Cruise which went as far as Crinan and featured the passage of the Gulf of Corryvreckan in the journey between Scarba and Jura. The alert might be trying to spot Barnhill on Jura, the remote farmhouse where George Orwell wrote *1984.* Worked into the schedules were the remains of the Oban-Fort William service which ran on Wednesdays and Fridays.

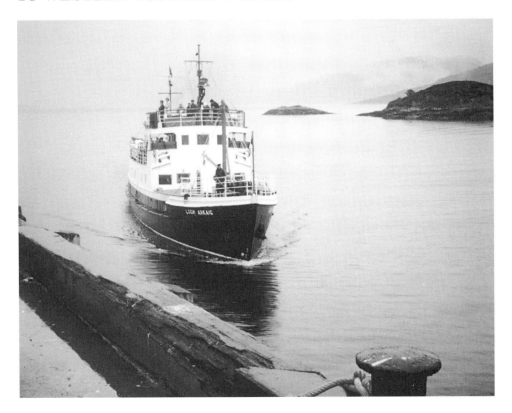

You may not have gathered that under the guise of a Scottish name (with the 'e' indicating the subtlety of an Ulster grandfather), in your author there lurks someone brought up on the Norfolk Broads. For many years, my view of these steamers was precisely that of the millions of tourists crossing the border. For all of us in that category, for whom the steamers were not daily fare, our memories of those early key visits will be precious. For someone who prior to his eighteenth birthday had only been to Scotland three times, I was fortunate that two of those occasions featured the vessels. On the second occasion, I was a thirteen-year-old clutching an Instamatic and making a circular tour with father which took in a Deltic diesel locomotive up the East Coast Main Line, Aberdeen, Inverness, Kyle, Skye, Mallaig, the West Highland Line and the Thames Clyde Express before a prosaic diesel multiple unit trundled us back into East Anglia from Leicester's grimy Victorian station.

One result of that 1973 visit was a trip on *Loch Arkaig* in the first year of the Caledonian MacBrayne regime. Here the vessel is seen arriving at Kyle of Lochalsh. Unlike the advertising literature, the day was grey. The journey calling at Raasay and onto Portree could still weave its spell, however.

Loch Arkaig's trim superstructure did not make it immediately clear that she had commenced life as a Second World War inshore motor minesweeper. I believe her first identity was MMS 233, completed by Bolson's of Poole in 1942. MacBraynes bought her in 1959 and entirely rebuilt her. She operated the Small Isles and Portree mail runs, but after 1975, Kyle became her northern terminal. Ultimately her wooden hull told against her and she sank in Mallaig Harbour on 28 March 1979.

5
FOCUS ON THE 1964 *COLUMBA*

My childhood link with *Loch Arkaig* extends into the second *Columba* too, when a journey to Mull used her in her maiden season. The two ships possess a further connection with one another (despite their immense technical divergences). When *Loch Arkaig* was commissioned on 14 April 1960, C. B. Leith, MacBraynes' general manager, announced the most strategic change of policy in the company's history. On the Clyde, car ferries had been demonstrably successful; now their era was to arrive in the Western Isles. An order for three new ships resulted.

The new Hall, Russell & Co.-built ships arrived from Aberdeen in 1964 and, by a quirk of funding, were actually owned by the Secretary of State for Scotland. They were named the *Hebrides*, *Clansman* and *Columba* in order of building. The third named came to be regarded as the flagship of the fleet and, during 1986-88, when she was the last of the trio in service, a series of distinctive special cruises ensured her fame. This affection was compounded by her being the final vessel to operate the Sacred Isle Cruise. What is more, she still carries passengers in the Western Isles.

These links indicate that the modern-day *Columba* is worthy of as much respect as her two maritime ancestors in the MacBraynes fleet. It is an interest which opens up another angle on the publicity take since it provides the opportunity to illustrate what can be achieved if a collector decides simply to concentrate on one vessel of significance. While finding such material for the two predecessors would be extremely challenging, some effort ought to fill a lever arch file with 1964 *Columba* material.

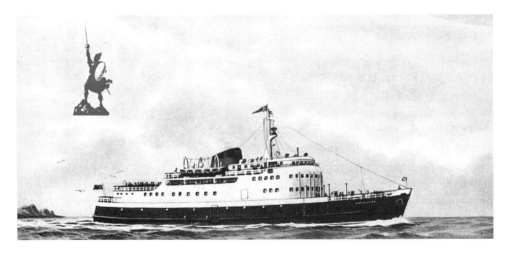

The story can be regarded as starting with this 1964 item taken from the cover of a simple four-side leaflet introducing the new concept of the car ferry. The routes were to be Oban-Craignure-Lochaline for *Columba*, Mallaig-Armadale for *Clansman* and the triangular route out of Uig to Harris and Uist for *Hebrides*.

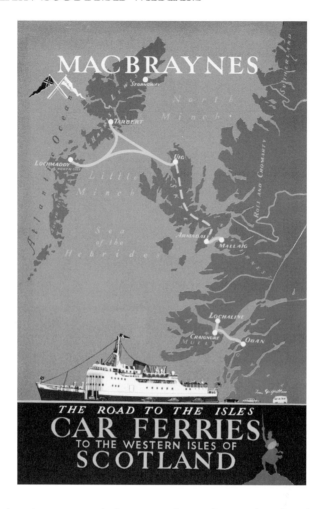

The advent of the trio put an entirely new angle on 'the Road to the Isles' slogan which had been the subject of a Kenneth MacLeod song many decades before. MacBraynes really were taking the road to sea. A detailed look at the artwork will reveal a significant little glitch. Pure roll-on roll-off was still some way off. All sorts of agencies actually owned the piers that the ships used and the rapid installation of linkspans to create the genuine article (as already operated at Stranraer or the English channel ports) was still some way away. Instead, following the Caledonian Steam Packet example, vehicle hoists (not unlike aircraft carrier lifts) were fitted. These enabled a fixed pier to be used at different states of the tide for side loading. These ships did not have end doors. The artwork is signed by Tom Gilfillan, who was still undertaking work for MacBraynes having done so since before 1939. Inside this piece was a full timetable for the three new services. There was also an apologetic note after the ships' delivery schedule slipped. The timetable should have started with the summer services on 1 May 1964. In fact, MacBraynes had to print the timetable knowing that not all the ships would be in place until July. *Columba* finally commenced service on 30 July, relieving other ships which had been struggling to undertake the new routes using their old loading technology of a derrick.

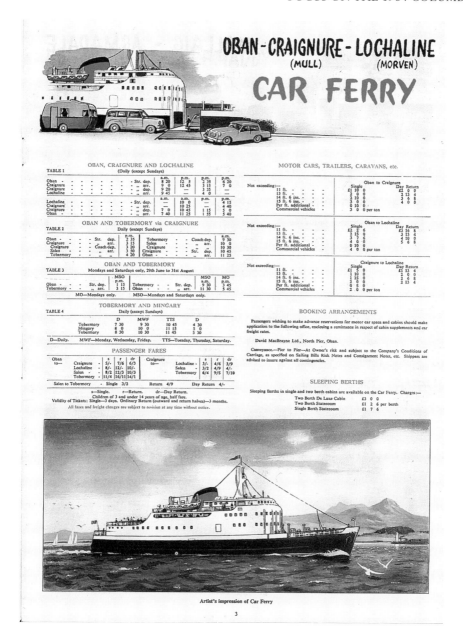

Artist's impression of Car Ferry

Despite the hiccup of the late delivery, MacBraynes were determined to make the most of the new revolution. The dramatic large-size summer timetables of 1963-64 have already been mentioned. Inside the 1964 edition, considerable reworking was undertaken to promote the new ships. The new schedules were printed and artwork included that focused on the hoist loading (with three different views in successive pages) and the rather colourful impression at the bottom of page three (above). The workings featured were the *Columba*'s, and by commencing the timetable with them, they helped anchor the idea that this was the flagship operation.

Excursion Sailings from Oban
by RMS COLUMBA
9 May until 22 October 1977

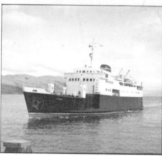

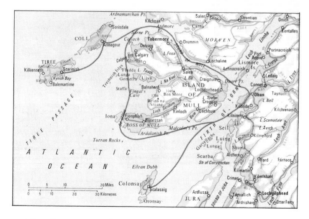

Caledonian MacBrayne

With the *King George V* gone, the company had no wish to abandon the Oban cruises entirely and a vessel of suitable stature was to hand. In 1975, *Columba* left the Craignure run to others and between then and the end of the 1988 season, she handled a complex summer schedule out of Oban. This saw her provide the car-ferry services to Tiree, Coll and Colonsay while leaving her Tuesdays and Thursdays free to run the Sacred Isle Cruise. Since the ship had cabin accommodation, a considerable effort was made to sell the mini-cruise concept possible by her entire itinerary. By now, publicity was thoroughly in the era of colour photography and a growing sense of specialist design. Each year's variation on the Oban cruise theme leaflet is worth finding. The example shown is from 1977. A new shape was now a regular sight lying at anchor in the Sound of Iona, as this cover shows.

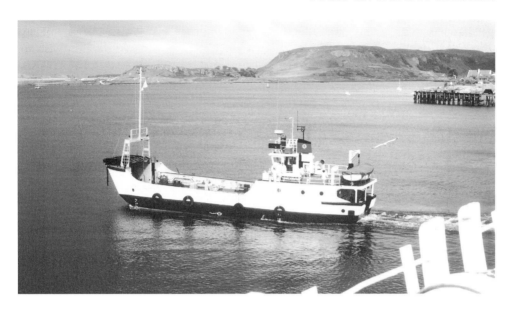

The following sequence of images will give an idea of what participating in the Sacred Isle Cruise was like. All were taken on 10 July 1984. Oban was playing host to three MacBraynes ferries. The *Caledonia* was handling the Mull car-ferry runs and would have left at 8 a.m. Next out (in this picture) was the small Island class ferry *Eigg* heading for Lismore at 9 a.m. By then, *Columba* was well loaded with passengers who, like myself, having watched *Eigg* leave, would then be engaged by *Columba's* own 9.15 a.m. departure arrangements.

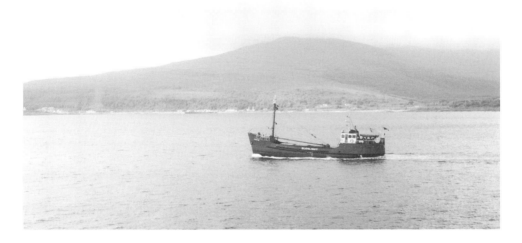

The cruise went to the north of Mull through the Sound of Mull. Before long, the *Caledonia* was passed inbound back from Craignure. At least two other ships were in the sound that day: the luxury private vessel MY *Braemar* of the Royal Thames Yacht Club and the welcome sight of the ubiquitious Glenlight going about her business. That day it was the *Glenfyne* of 1965.

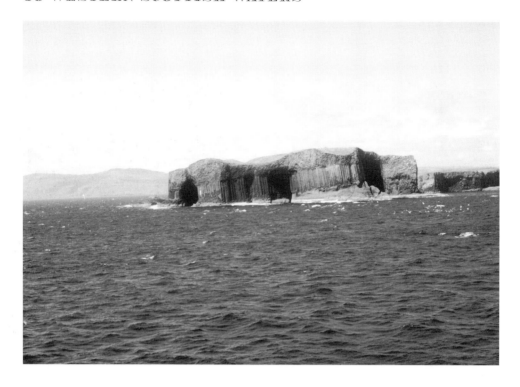

Past Ardmore Point and the vessel faced the wider waters which in a south westerly were fully exposed to the Atlantic. Reaching Treshnish Point (on Mull), *Columba* passed between the mainland of Mull and the Treshnish Islands. These waters were potentially slightly more sheltered and the first objective was now in sight. Staffa lies about halfway between the Treshnish Isles and Iona.

The landings on Staffa seen earlier had ceased some time before *King George V* finished. One guesses that landing passengers twice in one cruise using smaller ferry boats was quite a challenge. Instead, the ship came in as close as the weather made safe. On this occasion, it was close enough to well appreciate the basaltic columns and the caves which made the island's reputation. Fingal's Cave is to the right and, as the ship lay in the seas, there followed a poignant touch. Crackling over the *Columba*'s PA system came a recording of Mendelssohn's *Hebridean Overture*. The quality was not memorable but the effect was electric. Mendelssohn had been one of the earlier visitors to Fingal's Cave, coming in 1829; not too long before, the price of the excursion was two bottles of whisky and 15s. In the years MacBraynes came here, they had removed the exclusive cachet to the excursion and by playing Mendelssohn aboard a car ferry named after a man of piety and leadership, might well be held to have discharged a worthwhile social obligation.

The enthusiast must refrain from advising companies in today's hard-pressed commercial world to do this or that. Here, however, I must offer my judgement that it will be a happy day when the Sacred Isles Cruise returns to the Caledonian MacBrayne schedules. In fact, since 1988, tours to Staffa have been the subject of a Caledonian MacBrayne ticket, but only in the context of a multi-leg ship and coach tour across Mull. These conclude in the hands of Gordon Grant's or other operators' small craft.

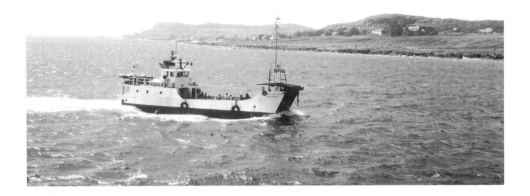

Arrived in the Sound of Iona, *Columba* dropped anchor. The island does not boast much more than a slip and everyone wishing to land from *Columba*, *King George V* and their predecessors had to be tendered ashore. Prior to 1979, when the small car ferry *Morvern* seen in this picture arrived, the traditional means of going ashore used MacBraynes' red boats. These formed a small fleet of wooden launches. The red boats had also to be out on station at Staffa in the days when *King George V* allowed her passengers to land there. Even with a small car ferry to effect the landing, matters could become interesting.

Going ashore about 1.15 p.m. to Iona on 10 July 1984 posed no problems. The reward was a peaceful view of *Columba* anchored in a sunlit sound. Cloud was, however, moving in from the north as the harbinger of the arrival of a weather front.

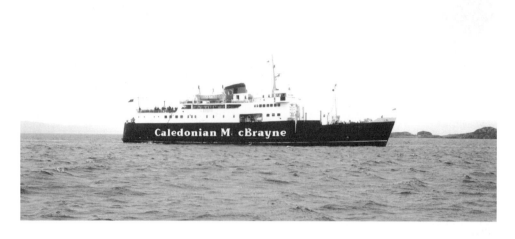

Passengers were allowed over two hours ashore on Iona which is quite long enough for the weather to change. There were enough passengers to ensure that perhaps three trips were needed by the *Morvern* to fill *Columba*. As this picture reveals, we returned to a *Columba* lying in a distinctly choppy sound. The A of MacBrayne has disappeared. That is the location of the door in the side of the hull which was open and through which the passengers had to pass.

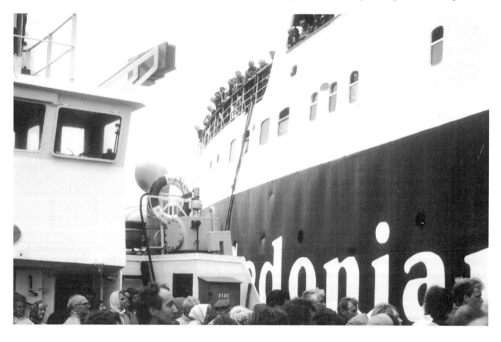

Lying the *Morvern* alongside *Columba* in these conditions was no mean task, nor was the next step of transferring shiploads of tourists for whom pitching ships were not a daily environment. As can be seen, for those who had made the transition, relief permitted the activity to become a spectator sport.

As the two ships rose and fell alongside each other, with large inflated fenders to keep them apart, the passengers were individually manhandled across the space in the critical few seconds when the rising and falling doorway mated with the *Morvern*'s fender.

After that excitement, for many passengers it was time for tea during the long haul back along Mull's south side and the return to Oban which was scheduled for 6.30 p.m. A visit to the shop could be rewarded with some suitable reading matter. In addition to the company's fleetlists, during the mid-1980s, other material was produced which would be collectable today. In 1987 a photo booklet MV *Columba* was published by the company. An eighteen-page guide to the cruise entitled *The Sea Road to Iona* was also available. This is worth dwelling upon. The 1984 edition I have was written for the *Columba* and is crammed full of information about the cruise which was a 120-mile-long trip. No publisher was indicated but authors were: Ann K. Jones and Ralph Roney. I do not know that anything so substantial for the cruise existed previously. I suspect that Caledonian MacBrayne were the publisher, and it is clear that two other volumes in the series existed. These matched other Caledonian MacBrayne routes: *The Sea Road to Mull* and *The Sea Road to Bute*.

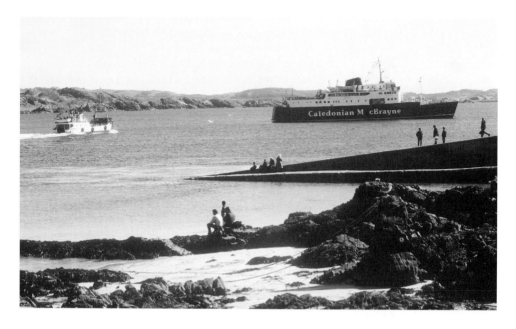

Another day, another year and *Morvern* is again tendering to *Columba*. It is 2 April 1988, Easter weekend, and the beginning of *Columba*'s final season with the company. In her last years, several opportunities were afforded to take *Columba* and her paying public to some unusual locations. Of course, there was nothing special about *Columba* being here, but the day before, in order to take up station, she had offered a public cruise from Largs to Tarbert, around the Mull of Kintyre, through the Sound of Islay to Oban (see colour section p.13). There, passengers could stay aboard overnight, prior to an Easter Sunday visit to Iona and a special service in the Abbey church, during which the company's Marketing Officer, Walter Bowie, played the organ. Much the same had happened the year before.

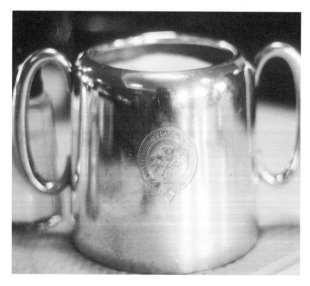

For a company whose car ferry could regale its passengers with Mendelssohn and whose erstwhile principal was a young man when the composer made his inspirational visit, no surprise should be occasioned if the same ferry's tea service was of apt pedigree. In her last season, *Columba* was using silverware from an assortment of the company's ancestors. This piece was crested North British Steam Packet Company, which dates it to earlier than 1922.

Caledonian MacBrayne Limited

ST. KILDA CRUISE

BY

M.V. 'Columba'

from Oban to St. Kilda
3 to 5 MAY, 1980

ITINERARY—

SATURDAY 3 MAY —
OBAN NORTH PIER	depart 1700
CASTLEBAY, BARRA	arrive 2330
CASTLEBAY, BARRA	depart 2359

SUNDAY 4 MAY —
ST. KILDA ISLAND	arrive 0900
then non-landing cruise, circumnavigating the St. Kilda Islands	
ST. KILDA ISLAND	depart 1300
CASTLEBAY BARRA	arrive 2000
CASTLEBAY. BARRA	depart 2300

MONDAY 5 MAY —
OBAN NORTH PIER	arrive 0600
and disembark MV Columba by	0800

In the event of adverse weather, the Company reserve the right to alter the itinerary if necessary.

Columba's ultimate adventures in the hands of Caledonian MacBrayne were the few special cruises that she offered to St Kilda. These started with a trip in 1979 and continued on and off until her final visit in 1987. They were two night affairs out of Oban and for the more hardy young folk, accommodation was on your own inflatable bed on the car deck. Blankets were offered by the chief steward.

The 1980 handbill for this is illustrated. Contemplate a half-hour stopover at Castlebay with a departure at one minute to midnight in May. The cafeteria pledged to be open 'throughout most of the cruise' and a running commentary was promised during the four hours while at St Kilda. To my eternal regret, I never made that passage. All hope is not lost, for should monetary fortune shine, more than the spirit of the *Columba* still takes passengers to St Kilda, and I might yet make that passage myself.

Now crystal clear are the falling waters,
And bonny blue are the sunny skies.
Fresh o'er the mountains breaks forth
the morning,
The ev'ning gilds the ocean swell;

Robert Burns – Bonnie Bell

HEBRIDEAN
PRINCESS
The elegant way to cruise
the Scottish Highlands & Islands.

It is no strange phenomenon for a MacBraynes vessel to find a new owner. On the whole the ships were well maintained and the market for car-ferries is quite clear. *Maid of Argyll, Claymore, Hebrides, Clansman* and others have made journeys to new owners far away. The Mediterranean is quite a hunting ground for such ship lovers. *Columba* was left as the remaining member of the 1964 trio, and when her sale was announced, her destination was a surprise. In 1988, she set off to Great Yarmouth for a £2 million conversion to become the *Hebridean Princess* of Hebridean Island Cruises Ltd. Her blue hull carried echoes of the Royal Yacht *Britannia* and with such associations of country-house quality, she returned to Oban.

Her subsequent seasons have been a complete success. No longer a car ferry, the one-time pride of the MacBraynes fleet is now an exclusive mini-liner whose crew of thirty-seven cater for fifty passengers. Retirement has become rejuvenation and both Staffa and St Kilda in 1999 had to take their place as two amongst a galaxy of destinations. These included Norwegian fjords, Ailsa Craig, Rathlin Island, Douglas on the Isle of Man, Fair Isle, the Summer Isles and Mingulay.

One cannot be surprised that Robert Burns was enlisted on the cover of the maiden season 1989 brochure. No one can argue with the 1999 brochure's introduction that 'this unique booklet has always set out to stimulate the senses by unlocking the traveller inside all of us and helping him or her to embark on an armchair voyage of discovery to the world of *Hebridean Princess*'. In whatever guise, the *Columba* tradition has not deceived. The old company's literature did not hide the odd little hiccup when she took up service back in 1964. The Sacred Isle Cruise could not be undersold and nor can this lady's 1990s programmes. An interest in *Columba* promises much.

6

SOME OTHER OPERATORS

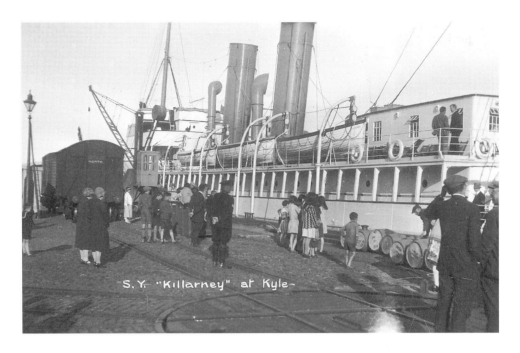

S. Y. "Killarney" at Kyle.

Hebridean Princess is not the first vessel to offer a regular programme of West Highland cruises. Those with longer memories will think of the SS *Killarney* or *Lady Killarney*. These were ships of Coast Lines Ltd operating from Liverpool. The idea of a cruise programme run out of Liverpool for the English market made good sense and the Coast Lines venture started about 1931. The vessel first used was the SS *Killarney*. This had started life in 1893 as the *Magic*. A motor ship made her redundant on Irish sailings in 1930 and the Scottish operation commenced. *Killarney* must have made herself familiar to judge from the postcards that show her in the Highlands. On occasion, the passengers even ended up playing the locals at cricket. In this view, the vessel is berthed at Kyle of Lochalsh.

Killarney offered no more Scottish cruises after 1939 and was withdrawn in 1948. Two funnels were replaced by one and the TSS *Lady Killarney* took up the operation between 1948 and 1956 (see the leaflet for the final season on p.14 of the colour section). This ship began life as the *Patriotic* of 1912, a Harland & Wolff production from the same year as the *Titanic*. A different sort of fame was enjoyed when, in 1921, she carried King George V on the occasion of the opening of the Northern Ireland Parliament. Her Second World War service as a hospital ship left her quite suitable for cruising and after further alterations including adding a card and a smoke room, she was dedicated to the Scottish cruises.

Lady Killarney became the last pure passenger ship exclusively cruising in British seas, until *Hebridean Princess* revived the concept. There was considerable sadness at her withdrawal.

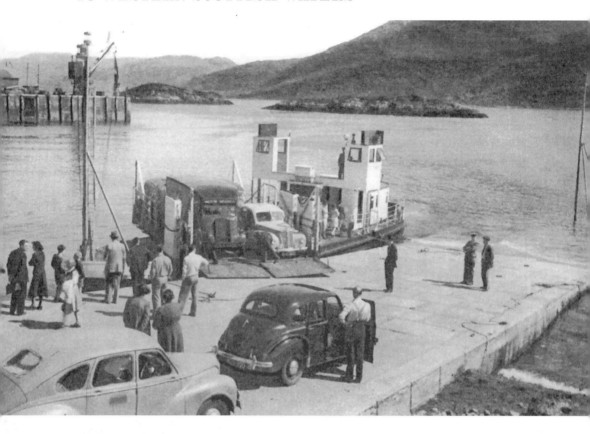

While at Kyle of Lochalsh, the Coast Lines vessels would have had to mix with much humbler fry. Their literature of the postwar years bore the imprint of the Caledonian Steam Packet company, for the Kyle-Kyleakin ferry was a one-time far-flung outpost of that Clyde empire.

With the railway at Kyle from 1897, the ferry crossing to Kyleakin on Skye became important. Lessees handled the ferry until 1 January 1945 when MacBraynes themselves, who had run the service from 1935, withdrew. Thereafter, the LMS railway directly ran the service in which manner it became a member of the Caledonian Steam Packet fold until the changes of the 1970s. The ferry remained critically important even gaining two brand-new vessels in 1991 which became the largest used on the crossing. Then the bridge opened in 1995 and that's another story.

First, at Ballachulish and then at Kyle from 1930, the idea of the turntable ferry took off. The traditional ferry landing was a slipway accessible at most states of the tide. Such a structure is ideal for modern bow-loading ferries with their hydraulic ramps. Prior to that technology, the answer was a small vessel with a steel car deck mounted on a turntable which could be swung onto the slip. Both our illustrations show this technology at work as current in the 1950s and 1960s. The first image from a postcard shows the loading operation at Kyle. The railway pier is visible in the left background.

Several generations of such vessels worked at Kyle and those shown in the illustrations would be one of the 1950s *Portree, Broadford* or *Lochalsh*. These names were reused and the precise story of the ferries at Kyle could fill a small booklet. Owing to the inevitability of their use, they did not require a 'hard sell'. The service was detailed in the BR Scottish Region timetables, otherwise a flimsy, annually issued handbill like the example shown for 1966 sufficed. 1966's was the first to be illustrated, before which plain handbills in the exact genre of the standard railway productions were used. Ironically, the turntable technology shown was in the process of being replaced at Kyle in the years from 1966.

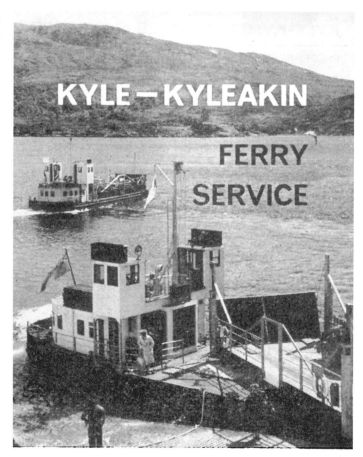

KYLE — KYLEAKIN
FERRY SERVICE

Daily — including modified service on Sundays
1 JUNE to 30 SEPTEMBER 1966

A frequent ferry service operates between Kyleakin (Skye) and Kyle of Lochalsh (crossing time 5 minutes) for the conveyance of passengers, luggage, motor vehicles, livestock and merchandise.

WEEK-DAYS

from 04 30 to 07 00 in accordance with traffic requirements.*
from 07 00 to 21 45 frequent crossings.

Late evening sailings as follows :—

from Kyleakin	22 00,	22 30 and	23 00
from Kyle of Lochalsh	22 15,	22 45 and	23 15

SUNDAYS

from Kyleakin	13 00	to	20 45
from Kyle of Lochalsh	13 15	to	21 00

* A special sailing from Kyleakin at 05 30 connects with the early morning train from Kyle of Lochalsh station.

Sailings are not guaranteed and the right is reserved to alter the above services as circumstances may require.

THE CALEDONIAN STEAM PACKET COMPANY LTD

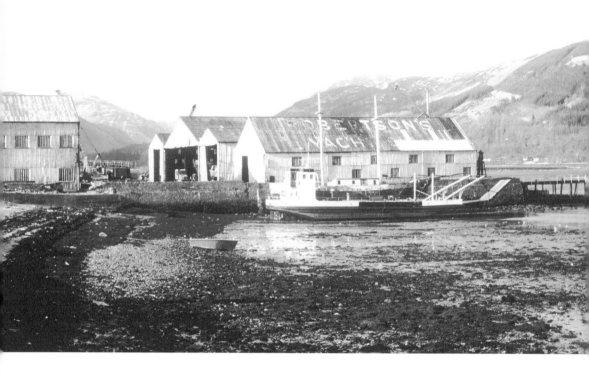

Former Kyle ferries usually found new owners. In this instance, the 1966 successor to the 1950s *Broadford* is on the hard at Robertson's yard at Sandbank in the Holy Loch in March 1987. She had wound up there having been sold in 1986 to a Mr Hooper, after a period from 1971 in use on the Colintraive-Rhubodach route onto Bute. For that service, a bow ramp was installed instead of side loading, the change is clearly seen in the picture.

Opposite: The next image is back at Kyle and, while it may not be apparent, shows *Broadford's* sister, the 1965 *Portree*. The fascination of this humble leaflet for the winter 1967 service is that it provides a rare glimpse into the complications of the Kyle fleet. When *Portree* arrived, there was a determination to replace the traditional turnable. Instead, side doors were fitted, which are clearly visible, and the wheelhouse was placed at the bow. Cars drove aboard and then via a flush-mounted turntable in the deck were shunted around. In this manner, nine vehicles could be carried. The 1991 ferries carried thirty-six cars. *Portree* was not successful and, in 1970, was rebuilt to look like the *Broadford*.

KYLE-KYLEAKIN FERRY SERVICE

Weekdays 1 October 1967 to 25 May 1968

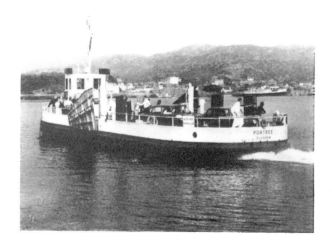

WEEKDAYS

There is a frequent service between Kyleakin (Skye) and Kyle of Lochalsh (crossing time 5 minutes) for passengers, luggage, motors, livestock and merchandise.

WEEKDAYS

from 04 30 to 08 00 as required *
from 08 00 to 21 15 frequent crossings.

Late evening sailings as follows :—

from Kyleakin	21 30,	22 00,	22 30 and	23 00
from Kyle of Lochalsh	21 45,	22 15,	22 45 and	23 15

NO SAILINGS ON SUNDAYS

* A special sailing from Kyleakin connects with the 04 55 train from Kyle of Lochalsh station.

Sailings are not guaranteed and the right is reserved to alter the above services when necessary.

THE CALEDONIAN STEAM PACKET CO LTD

TRAIN, MOTOR AND YACHT TIMES
30th May to 10th September, 1960

GOING via BALLACHULISH

		a.m.
OBAN	Train leave	9.42
CONNEL FERRY	,, ,,	10. 6
BENDERLOCH	,, ,,	10.13
CREAGAN	,, ,,	10.30
APPIN	,, ,,	10.38
DUROR	,, ,,	10.50
KENTALLEN	,, ,,	11. 0
BALLACHULISH FERRY	,, ,,	11. 7
BALLACHULISH (Glencoe)	,, arrive	11.14
BALLACHULISH (Glencoe)	Motor leave	11.20
		p.m.
LOCHETIVEHEAD	,, arrive	1.15
LOCHETIVEHEAD	Yacht leave	1.45
ACHNACLOICH	,, arrive	3.45
ACHNACLOICH	Train leave	4. 9
CONNEL FERRY	,, arrive	4.17
OBAN	,, ,,	4.37
BENDERLOCH	,, ,,	5.27*
CREAGAN	,, ,,	5.45*
APPIN	,, ,,	5.55*
DUROR	,, ,,	6. 8*
KENTALLEN	,, ,,	6.17*
BALLACHULISH FERRY	,, ,,	6.24*
BALLACHULISH (Glencoe)	,, ,,	6.31*

GOING via ACHNACLOICH

		a.m.
OBAN	Train leave	9.30
CONNEL FERRY	,, ,,	9.48
ACHNACLOICH	,, arrive	9.55
ACHNACLOICH	Yacht leave	10.15
		p.m.
LOCHETIVEHEAD	,, arrive	12.30
LOCHETIVEHEAD	Motor leave	1.20
BALLACHULISH (Glencoe)	,, arrive	3.30
BALLACHULISH (Glencoe)	Train leave	3.57
BALLACHULISH FERRY	,, ,,	4. 2
KENTALLEN	,, ,,	4. 9
DUROR	,, ,,	4.18
APPIN	,, ,,	4.31
CREAGAN	,, ,,	4.38
BENDERLOCH	,, ,,	4.55
CONNEL FERRY	,, arrive	5. 4
OBAN	,, ,,	5.35

* Change at Connel Ferry

The Premier Circular Tour of the
HIGHLANDS

PASS OF GLENCOE

GLEN ETIVE

AND

LOCH ETIVE

DAY CIRCULAR TOUR

DAILY (EXCEPT SUNDAYS)

30th MAY to 10th SEPTEMBER, 1960

**By Train, Motor and Yacht
" Darthula II "**

Viewing the Wildest and Grandest Mountain
and Loch Scenery in the Highlands

NOTE:—Places of special and historical interest will be described
during the journey

DINING FACILITIES ON BOARD YACHT " DARTHULA II "
(Fully Licensed)

Morning Coffee, Lunch, Plain Tea and Refreshments
at moderate charges

Motor calls at Glencoe Hotel in each direction, allowing time for
Coffee, Tea and Light Refreshments

In every year right up to the present, there has always been a variety of lesser operators working small areas of coastline. In the years from 1968 until 1991, an invaluable comprehensive account of these lesser operators was regularly published. This was usually known as 'Getting Around the Highland and Islands', being a comprehensive all-mode timetable published by The Highlands and Islands Development Board. It was a charmer in its own right. Its level of detail was remarkable. Here is the content of table 402 in 1983: 'Boat Hires from Deerness – Between June and mid-August, circumstances permitting, the lighthouse boatman at Deerness may ferry up to eight passengers'. That was on Orkney, but throughout the north and west, all sorts of little enterprises were duly recorded. The private successor's service on Loch Shiel was the subject of table 352. Today, one is back to trawling the tourist information offices.

Earlier, the Caledonian Railway's tour to the shores of Loch Etive in about 1904 was discussed. Eighty years on and the twenty miles of sheltered water above Connel Ferry running towards Glencoe maintained its own timetable in the H.I.D.B production as table 346. One reason why Loch Etive has retained a boat service is to provide mail services to remote settlements. The difficulties of the Falls of Lora may have helped discourage the larger operators from working the loch. Instead private owners have been a feature of the loch since the first in 1877. That first service with the SS *Ben Starav* started by trying to negotiate the falls and soon gave that element up. With the odd break, the services have continued.

Our illustration of this operation shows the publicity current in 1960. At the time the motor vessel named the *Darthula II* had served the loch since 1939, which she continued to do until replaced in 1964. For the tourists, a traditional circular tour from Oban embracing all of train, coach and vessel was on offer. The station at Achnacloich on Loch Etive largely functioned for these boat connections. In its heyday a Loch Etive Boat Train with headboard ran from Oban. Achnacloich was closed for good in 1965.

DRIVE ON OFF
To Islay & Jura

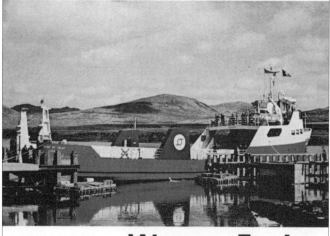

Western Ferries

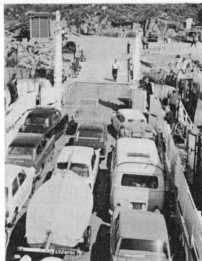

Previous page and below: Among the independent concerns at work since the Second World War, one stands right out. Western Ferries has proved an effective example of private enterprise challenging state provision in not just one but two significant operations. The Clyde operations will be encountered later. Here it is time to look at Western Ferries' challenge on the routes to Jura, Gigha and Islay.

In the late 1960s, MacBraynes services to the islands were old fashioned. Businessmen knowing the example of cheaper operations in Norway set up Western Ferries in 1967 to provide no frills roll-on roll-off services. For the next fourteen years, there were fun and games in West Loch Tarbert and further afield. For the publicity collector, this competitive atmosphere and the highly involved service pattern, which cannot be narrated here, ensured the creation of some noteworthy gems.

Essentially three vessels were involved, one of which remained current in the area working for Western Ferries until 1998. The first vessel is illustrated in these examples of publicity current in 1969. They show the *Sound of Islay* which was delivered new to the company in 1968. The cover shows her berthed at Port Askaig on Islay. Her larger companion of 1970, the *Sound of Jura*, appeared on a run of later leaflets.

Due to the turbulent circumstances afflicting Western Ferries improvisation could be discerned. Timetables showed a service to Colonsay around 1972. Some can be found overprinted with a notice cancelling this stillborn development. In 1974, there was a front cover note: 'All times and charges shown in this timetable are provisional. The fuel situation, which changes daily at the time of going to press, may necessitate changes at short notice'.

DRIVE ON OFF

to ISLAY and JURA

Western Ferries presently provide a drive-on/drive-off service to Islay twice a day. This will be increased to three sailings per day as from 4th May 1969.

A vehicle ferry link between Port Askaig, Islay and Feolin, Jura, is also being established.

For full information enquiries to:—

WESTERN FERRIES LTD.,
Kennacraig,
WEST LOCH TARBERT,
Argyll.

Phone:—WHITEHOUSE (ARGYLL) 218

The third member of this operation was MV *Sound of Gigha*. Part of Western Ferries' concept was to dramatically improve access to Jura by running the larger car ferry to Port Askaig on Islay and thence this landing craft design across the narrow sound to Feolin on Jura. She came secondhand to the company in 1969. She had been built in 1966 for something of an ancestor to Western Ferries called Eilean Sea Services. They had actually started the first roll-on roll-off service to Islay running from Port Ellen. In this incarnation as the *Isle of Gigha* the activity came to an abrupt end when a capsize killed two people and lost some lorries.

The vessel was reborn as *Sound of Gigha* and in her role seen here as the Jura ferry operated with no further fuss until replaced in 1998. Simple unillustrated leaflets, similar to the Kyleakin ferry examples, were issued for about thirty years. The service was at its busiest (as here) during the annual Three Bens fell race each May. The photograph was taken at the Feolin terminal on 23 May 1987.

With the H.I.D.B. timetable gone, a partial route to continuing to keep track of the non-Caledonian MacBrayne operations has been the publication of public transport guides by local councils. Strathclyde Regional Council was quite effective at this and their successor Argyll and Bute Council has continued a series of area books leading to *Sound of Gigha*'s service appearing in their mid to late 1990s Jura and Islay guide. Determined effort is required to keep up with these publications but they are the raw source material for future historians.

Opposite: Prior to Western Ferries settling down to the quiet life in the 1980s, they abounded in exciting ideas. Here is publicity for arguably the most dramatic result. Today one only has to stand at Corsewall Lighthouse or beside Loch Ryan to see how ferry technology is in the process of dramatic change. The idea of high speed ferries pre-dates the 1990s, however. One of the very few previous examples to have been deployed in the Clyde or Western Isles has been at the initiative of Western Ferries.

Norwegian influence was present again since the ship was designed, built and owned in Norway. With a 27-knot maximum speed, Western Ferries anticipated much in chartering her, announcing her as 'the first highspeed catamaran to operate in British waters and the only express passenger vessel in service in Scotland'. A first season in 1976 was operated on the Clyde and has its own publicity to hunt for, while 1977 was spent in the Highlands. The ship was popular but never quite popular enough and her sailings ceased sometime after 1980. While she lasted, the intensity of her schedule was breath-taking. It included Western Ferries own Sacred Isle Cruise to Iona and Staffa. Passengers were landed by dinghy at the latter. At times, she was scheduled into Crinan on the first regular service into that port since 1928. Calls to Fort William, bereft since *King George V*'s demise, recommenced. In 1978-79, scheduled sailings to Moville (a Republic port on Lough Foyle) and Portrush in Ulster operated.

The latter concept was so breath-taking that when I first read of this, not previously having known of the idea and not having the relevant Western Ferries leaflet (the one shown is undated but is probably for 1977), I had to consult the H.I.D.B. bible. This duly obliged in the 1978 edition for service 324c. This offered the amazing prospect of a £19.50 through fare from Inverness to Belfast via a sea leg from Oban to Portrush. The overall journey took from 5.15 a.m. at Inverness to 4.40 p.m. at Belfast with the sea crossing taking four hours. Had the Troubles not been so intense (requiring half-hour security examinations in port), perhaps this whole venture would have bloomed further. Anyone fortunate enough to secure photographs, tickets or leaflets for this service from the Highlands to Ireland would be extremely lucky.

Luxury high-speed cruises from Oban & Fort William

BY 25-KNOT SEABIRD

Seabird Services

DAY CRUISES

BY PASSENGER BOATS "BLAVEN" "ROYAL SCOT" and "QUEEN OF SCOTS"
June to September

LOCH NEVIS
MONDAYS, WEDNESDAYS, FRIDAYS and SATURDAYS
Dep. MALLAIG 9.30 a.m. and 1.10 p.m.
Dep. INVERIE 10.30 a.m. and 2 p.m.

TARBERT and KINLOCHNEVIS
MONDAYS and FRIDAYS Dep. MALLAIG 1.10 p.m.
TARBERT 3 p.m. Arr. MALLAIG 5.15 p.m.

LOCH HOURN (KINLOCHHOURN)
TUESDAYS Dep. MALLAIG 11.30 a.m.
Arr. MALLAIG 5.30 p.m. 1 hour ashore

LOCH SCAVAIG and LOCH CORUISK
MONDAYS and WEDNESDAYS
Dep. MALLAIG 11.30 a.m.
Arr. MALLAIG 6 p.m. 2 hours ashore

LOCH MOIDART and CASTLE TIORAM
FRIDAYS Dep. MALLAIG 11.30 a.m.
Arr. MALLAIG 6 p.m. 2 hours ashore

ISLE OF EIGG
SATURDAYS Dep. MALLAIG 11.30 a.m.
Arr. MALLAIG 5.30 p.m. 2 hours ashore

ISLE OF RHUM
THURSDAYS Dep. MALLAIG 11.30 a.m.
Arr. MALLAIG 5.30 p.m. 2 hours ashore

LOCH DUICH and FIVE SISTERS OF KINTAIL
THURSDAYS Dep. MALLAIG 10.30 a.m.
Arr. MALLAIG 5.30 p.m.

MALLAIG-SKYE (ARMADALE)
PASSENGER FERRY M.V. "BLAVEN"
See separate Handbill

ISLE OF SOAY MAIL SERVICE
For particulars apply at Boating Office or Marine Hotel

— DAY LAUNCHES FOR HIRE —
— FISHING PARTIES ARRANGED —

N.B.—All Sailings subject to weather and circumstances permitting
BOOKING IN ADVANCE (EVE OR MORNING OF TRIP) ADVISABLE
Above Sailings connect with train leaving Fort William 9.50 a.m. daily,
and return train leaving Mallaig 6.20 p.m.

For particulars apply to :—
ALEXANDER MACLENNAN (MALLAIG) LTD.
at BOATING OFFICE or at MARINE HOTEL Phone 17

Courier, Inverness

This resumé of lesser operators needs to continue on a less elevated note. From well before the Second World War, a variety of local cruises had operated out of Mallaig in the hands of Alexander MacLennan. This undated handbill shows the menu and is likely to date from the 1950s. More than pleasure kept this operation going. The Mallaig-Armadale service was part of MacLennan's province, for which the *Blaven* was built in 1939. Nowadays, Caledonian MacBrayne dominates that. The services heading the handbill were mail runs to areas of the mainland that still have no road access.

MacLennan gave up in 1968 and his successor on the Loch Nevis mail run was Bruce Watt followed by his son. The backbone for a number of these enterprises have been traditional wooden hulls, some being former fishing vessels. One such has been a familiar sight at Mallaig.

Watt's fleet has used several vessels but probably the best known is the TSMV *Western Isles* shown here tied up at Mallaig on 13 July 1984 prior to offering his core duty. That is a trip as the Loch Nevis Mail Service where several settlements, most notably that of Inverie on Knoydart, depend on this vessel for the mail. Some time after this picture was taken, a small deckhouse was added to the boat which rather spoilt its appearance. Other trips that Watt operates take visitors to Loch Scavaig (Skye), Loch Hourn and Eigg.

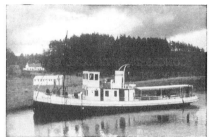

CALEDONIAN CANAL (British Waterways)

M.V. SCOT II.

CRUISES on the

CALEDONIAN CANAL
and LOCH NESS

The home of the famous "monster"

DAILY (during May and June) from Muirtown
COMMENCING 15th MAY, 1961, at 10.15 a.m., 2.15 and 6.30 p.m.
Tickets 10/- per cruise. Duration about 3½ hrs.

MUIRTOWN, where the canal crosses A.9 road to the north.
A suitable Car Park for Patrons is available at Muirtown Lock and a Bus Service to Muirtown is available from Farraline Park Bus Station, Inverness.
Light Refreshments are available on board at Moderate Prices.

The Vessel Scot II has Accommodation for 70 Passengers and may be booked on the Evening Cruise on Tuesdays, Thursdays and Fridays for Private Parties.
Further particulars from
CANAL OFFICE, CLACHNAHARRY. Telephone: Inverness 33140

After the outbreak of war in 1939, the long-standing traditional service of MacBraynes through the Caledonian Canal was dead. Between then and 1961, there were only three seasons when private owners attempted to provide some form of substitute. Thereafter, some form of provision has again been continuous but almost all public cruises in this period have gone no further west than Fort Augustus.

It had to be human nature that 1961 saw two operators each launch a service from Muirtown Wharf at Inverness. The private operator, a Mr Newlands, lasted until 1968. The other operator was the state in the shape of the British Waterways Board and they lasted rather longer.

Illustrated is part of the cover of the simple handbill that launched the B.W.B. service in 1961. There were actually two different handbills produced for that season. Subsequently, annual handbills like this eventually gave way to colour leaflets.

The vessel had been the canal's ice-breaking steam tug of 1931 which was converted to diesel and for handling passengers in 1960 so becoming MV *Scot II*. B.W.B. gave up the service in the early 1990s, by which time the private Jacobite Cruises service was well placed to take over.

Earlier glimpses of Glenlight Shipping have suggested that among the other operators, the coastal cargo trades should not be ignored. It is possible to find Glenlight publicity literature but many of the lesser freight carriers operated on a more word-of-mouth basis. Indeed often the challenge is identifying the owners of a vessel which may have been photographed, let alonge finding any publicity for it.

On 18 May 1987, during a tramp up Jura to the Gulf of Corryvreckan, I was rewarded with this shot of a coaster passing through the disturbed water to the east of the gulf. In the background is the islet of Coiresa and Craignish. Years later and after some work, I hope to be able to say that it was the MV *Deersound* of Kirkwall.

Many views both spectacular and unconventional are afforded in the Western Highlands. Lingering for a moment on Jura enables me to present a favourite, for it speaks so directly to the idea that whilst the Highlands and Islands can sometimes be physically a short line on a map from populated areas, the difficulties of communication remain very forceful. The outline of the Island of Arran seen from the Ayrshire Coast will be familiar to many. Few, however, will have seen the silhouette of Arran in reverse, seen not from Kintyre, but looking right over Knapdale and Kintyre, when seen from Jura. The lighthouse in view is Skervuile. Save from taking to the air, whichever route is taken, the journey from the likes of Irvine to Jura, which places are in line of sight, remains a day's work.

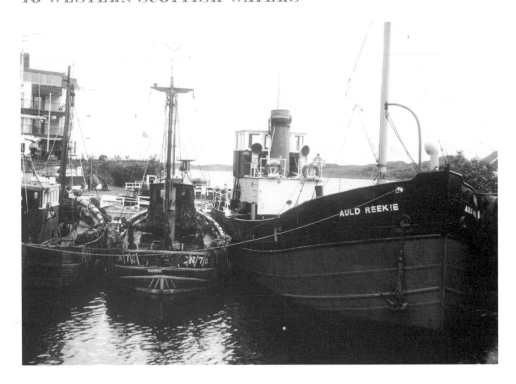

While lingering with the Sound of Jura, the opportunity can sometimes be taken to pay homage to a proper Puffer. If in the area, it is always worth seeing what is tied up in the terminal basins of the Crinan Canal. Conventional steam puffers went out of trade in the 1970s but a few diesel conversions lingered on, whilst a trio of steam hulls entered preservation.

In Crinan basin, on 14 July 1984, the preserved steam puffer *Auld Reekie* was tied up. Like virtually all of the survivors, her origins lie in an Admiralty order for a batch of Puffer hulls during the Second World War which were finished as V.I.C.s or Victualling Inshore Craft. Many were later sold into trade.

Auld Reekie had a moment of fame when displayed at the Glasgow Garden Festival in 1988 and yet more when used in the Gregor Fisher television rendition of *Para Handy* in the 1990s. Other survivors in recent times have been *V.I.C. 32* (steam and used for stay aboard charters), the *Marsa* and *Spartan*, which are diesel conversions, and the *Eilean Eisdeal*, another diesel conversion but which still carried cargo into the mid-1990s. Far away at Ellesmere Port is the oldest Puffer left, the steam-powered *Basuto* of 1902.

Para Handy, Neil Munro – they were the twin combination that have guaranteed the puffer's fame since Neil Munro's stories first appeared around 1900. One distinctly collectable spin off from the *Para Handy* saga is a music tape called *Highland Voyage*. This was released by Scottish Records in 1988 and featured recordings made many years previously of Roddy MacMillan and his crew singing puffer songs. For some reason they had not been used in the second generation of *Para Handy* programmes. The views expressed thereon upon the value of the Crinan Canal to a puffer crew make hunting this rare tape thoroughly worthwhile.

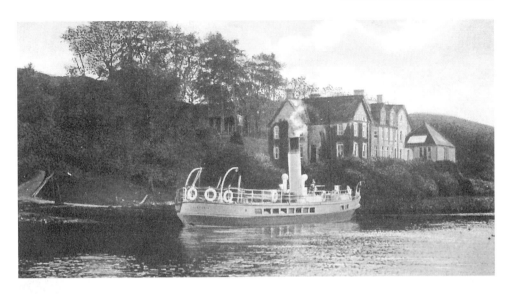

Not far to the north-east of Crinan lies the twenty-three miles of inland water that constitutes Loch Awe. Passenger sailings on Loch Awe prior to 1951 were split between local hoteliers and the Hutcheson/MacBrayne/Caledonian Steam Packet companies in some complex relationships. Ulitmately, between 1936 and 1951, the Caledonian Steam Packet's TSMV *Countess of Breadalbane* (II) was on the loch. That vessel was to end up on Loch Lomond where this narrative will meet her again. The activities of the local hoteliers can be illustrated by these images of the TSS *Caledonia* at the pier by Portsonachan Hotel.

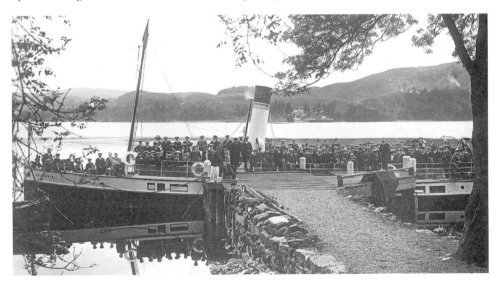

Mr Cameron, who owned the hotel, ran the steamer which arrived in 1895. In an operation which took place on numerous British lakes and lochs, the new steamer was prefabicated and then delivered in parts by rail. Since she was sold in 1918, the survival of postcards featuring her is good fortune.

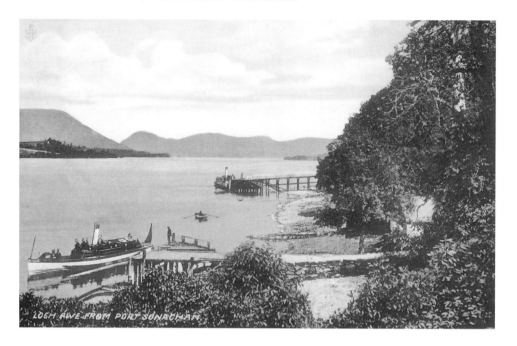

Further postcard views of Loch Awe. The loch was fortunate to have one railway station on its banks. The Callander & Oban Railway actually managed three loch stations. Achnacloich for Loch Etive has been mentioned. Loch Awe station was so named and lay on the northern shore of the loch. The third loch served was Loch Tay which had its own branchline at Killin and more boat connections. All this closed in 1965 but with the advent of steamboats on Loch Awe once again, that station reopened on 1 May 1985.

7

THE RAILWAY TO THE WESTERN SCOTTISH WATERS

The glance at Loch Awe reminds us just how important the railways had been in Western Scottish Waters. True, the steamships had become established prior to the railway age, but it was the railway that brought mass tourism to the steamers, whether by bringing them to the Clyde Coast, or by taking them from the 1880s onwards through the mountains to the western seaboard. The railways that reached Oban, Fort William and Mallaig to accomplish that objective are well worth some individual attention.

These lines have received considerable study, notably at the hands of John Thomas. Apart from the salient facts, our glance will endeavour once again to tell the story with an eye to the publicity that their presence engendered. The first route in was the Callander & Oban opened in 1880 and already seen as the subject of Caledonian Railway publicity. Since 1965, only the half west of Crianlarich has functioned. Between 1894 and 1901, the North British Railway and its West Highland Railway subsidiary had taken the tracks first from Craigendoran to Fort William, and then onto Mallaig. The two companies crossed at Crianlarich and since Beeching's axe, all trains to Oban have reached Crianlarich over the former NBR metals.

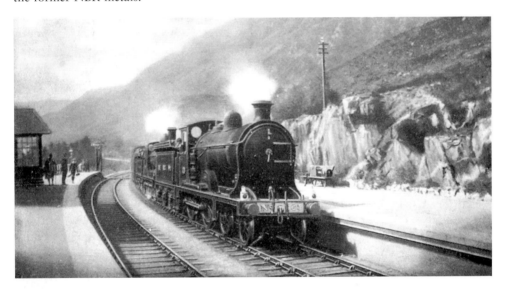

Given the gradients, double-headed passenger trains were to be expected, as this Locomotive Publishing Company postcard, dating probably from between 1906 and 1914, shows. A train is in Glenfinnan station headed by one of Reid's Intermediate K class 4-4-0s. It appears to be 865 and behind it is possibly one of the original 1893 Holmes' West Highland Bogies, another 4-4-0.

The Golden Jubilee of the West Highland took place during the Second World War. Despite those circumstances and largely due to the enthusiasm of a youthful George Dow, then in the LNER Press Relations Office, a glossy forty-four page history, thoroughly illustrated, was produced in 1944. Some of its illustrations are reproduced here.

George Dow was a fascinating man who himself made a great contribution to railway history, and whose son went on to become the Head of the National Railway Museum. Through working in the Press Office, some sensitivity to publicity might be expected. As a result, his own volume reproduced in monochrome two posters for the line. One was this North British example of 1906. Was this the originator of the 'bird's eye' view of the West Highlands?

The importance given to Craigendoran is noteworthy for, not only was it the headquarters of the NBR fleet but as the junction for the West Highland system, it effectively represented both modes of the company's penetration into the area. Another feature of the map is the branch beside the Caledonian Canal to Fort Augustus. This turned out to be a spectacular commercial failure. It offered an erratic passenger service between 1903 and 1933 under the auspices of both the NBR and the Highland Railway.

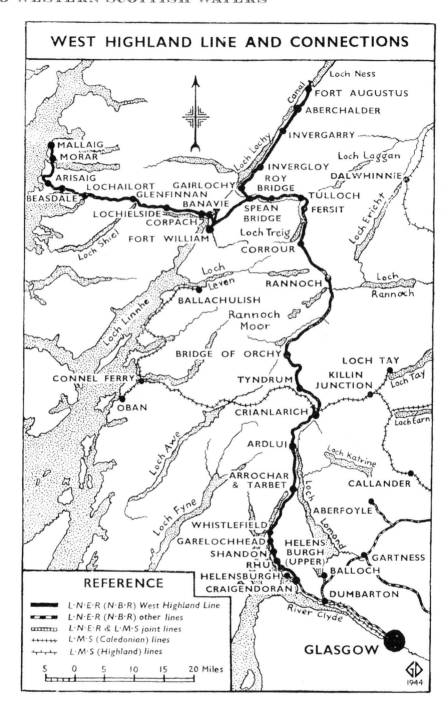

This clear map of the lines serving the West Highlands showed the system in Dow's volume. Very apparent is the long diversion across Rannoch Moor which the Ben Nevis massif forced upon the engineers. The only other alternative would have used Glencoe and the lochside beyond Ballachulish. The total mileage of the LNER network beyond Craigendoran was 165.

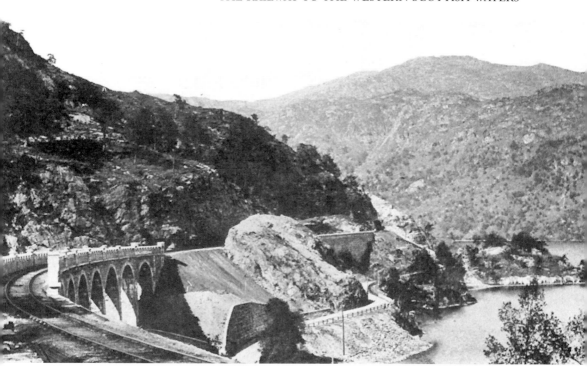

It is difficult to conceive just how earth-shattering the new railway must have appeared to the people of the area. Prior to its arrival, Fort William had relied, apart from the steamers, on a six-hour mail coach journey to Kingussie on the Highland Railway.

Unsurprisingly, the civil engineering of the line was dramatic but, despite that, the length of line from the south to Fort William only required one tunnel, a tiddler of forty-seven yards. That is visible in this illustration taken when the line was fresh. Viaducts and massive retaining walls were the norm, however. The location is Creag-an-Arden on Loch Lomond-side where scenic sensitivities led to the only arched masonry viaduct on the line. This was built of whinstone and given the ornamental decoration visible. A second tunnel appeared on the line in the 1930s when the diversion around a deepened Loch Treig was made. Beyond Fort William, tunnels were abundant.

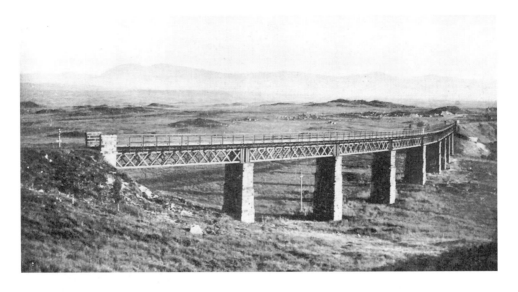

On the route to Fort William, the other viaducts used lattice metal girder on masonry pier construction. Beyond there, the line saw one of the first major uses of mass concrete in British engineering. The McAlpine company were closely associated with the line's engineering and this fashion for concrete led to the nickname of 'Concrete Bob' for Robert McAlpine.

The example shown here is of the lattice girder type. Its location on Rannoch Moor is a reminder that this waste which the railway crossed for twenty miles is little changed today. In one of the more amazing aspects of the line's construction, seven people involved in its planning, including Robert McAlpine, tramped across the moor in late January 1889 and came within a whisker of tragedy owing to the terrain.

An example of the extreme weather conditions sometimes encountered on the West Highland!

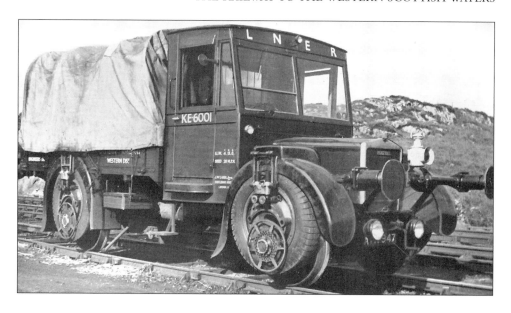

A taste for the unfashionable may have led to my enthusiasm for railway and shipping publicity literature. By the same token, some recognition is worth according to the oddest item of traction used on the West Highland Railway. Since the 1980s, road/rail vehicles have become more common in Britain, generally used to assist permanent way maintenance. The pioneers went back to the 1930s and the activities of Karrier's of Huddersfield. In this little-known venture, perhaps the least-known element of it was the sale of a goods lorry version to the LNER in 1934 for permanent way duties. A passenger version for the LMS was a bit better known. The LNER sent theirs to the West Highland where this picture was taken. George Dow evidently felt it worth credit, along with the school in a coach body at Gorton, the snow shed on Rannoch Moor (below) and the automatic level crossing gates at Fort William, which were other novelties on the line.

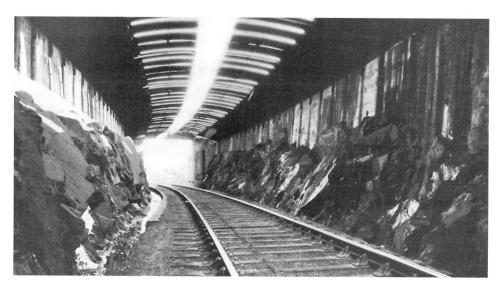

Opposite and below: Much earlier, an indication of the the type of publicity available from the first years of the century was given. That sort of material is extremely difficult to collect today. However, if the individual were to turn their attention to the era of Nationalisation (1948) onwards, a vast array of attractive items can be found coming right up to the present day.

One category of item has received an issue almost every year. That is the line guide, of which, prior to 1965, three versions can be traced. There was one for the West Highland route proper and two for the former Callander & Oban. These were for each of Glasgow and Edinburgh to Oban. The general pattern since then has been a combined issue for the surviving routes but the detail of covers and design has been extremely varied.

Prior to 1965, the interior pattern was quite established, and judging from other parallel styles, the route guide's artwork derived from pre-nationalisation publications. As a result, the former LMS line to Oban was more geographic in presentation than the 'straight line' style of the LNER-oriented West Highland offering.

The samples reproduced below and opposite are from the 1955 edition for the Glasgow to Oban run. The impression given by the cover is one of leisurely enjoyment in armchair comfort from the privacy of one's compartment as a succession of gallery-like vistas (here the Pass of Brander) are provided for contemplation. What the train was actually like on Glasgow Fair Monday may have been a different matter, but this does appear to be First Class.

The map sections reproduced are for the final leg from Crianlarich. The connections through the lochside stations at Achnacloich and Loch Awe can be appreciated. It is Loch Awe that is the backdrop to the cover.

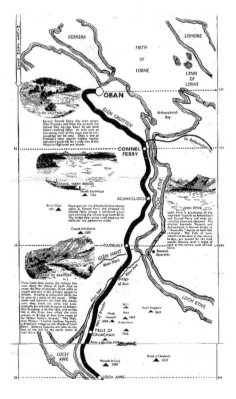
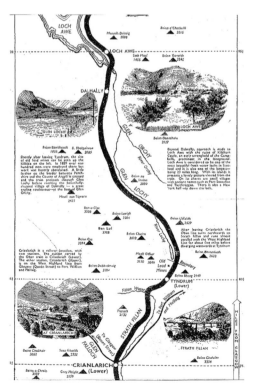

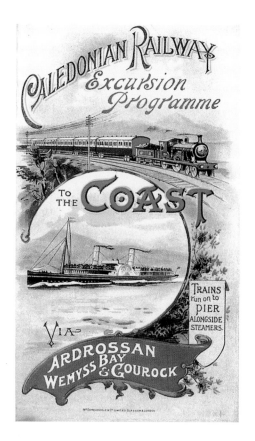

1 & 2. The covers shown here are from an annually produced booklet whose vignettes appeared to change each issue. The vessel featured with its huge paddle boxes is quite possibly the *Ivanhoe* which, by the time this brochure was published, in 1903, had joined the Caledonian Steam Packet fleet.

ARDROSSAN

WEMYSS BAY

GOUROCK.

McCorquodale & Co Limited Glasgow & London.

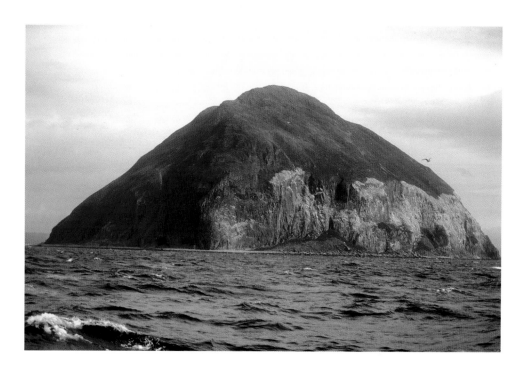

4. For decades, Ailsa Craig was most often passed by passengers on the Irish steamers, though often this was at night. This relationship gave the island its nickname of Paddy's Milestone since it was almost exactly halfway between Glasgow and Belfast. The island is remotely situated in the lower Firth of Clyde about ten miles from Girvan which provides the best land vantage point and where nowadays boats can still be hired for the journey. Less than a mile in diameter, and yet more than 1,000 feet high, the whole location can seem a bit implausible. Certainly as an East Anglian lad, I actually had to buy the Ordnance Survey map to convince myself that I had not dreamt it all up. The island once had a manned lighthouse and even a small railway serving a quarry. The igneous stone was made of microgranite and that explains the island's origins since it is the remains of an intrusion of molten rock from deep within the earth's mantle from which the surrounding softer 'country' rock has long since been eroded. Curling stones from the island were highly favoured but quarrying ceased in 1971.The view reproduced was taken in relatively recent times during a special excursion on 9 May 1987 by Caledonian Macbrayne's *Glen Sannox* which ran from Gourock to Stranraer and back.

3. *Opposite:* The rear cover of the 1904 version of the Caledonian programme. A point to dwell upon is the vignette of station and pier. The Clyde terminals engender almost as much sentimentality as the ships. Fairlie, Dunoon, Craigendoran, Gourock, Largs, Millport Piers...the list could run and run. Few now remain in their traditional state and some have been wiped clean away. Mostly, timber was used in their construction, ensuring continuous maintenance costs. In 1903, the totally new Wemyss Bay station shown here was opened, replacing the original 1865 station. Fortunately, this complex continues to be well maintained.

5. The more general railway publicity productions always had much to say about the steamers. This was the cover of a substantial and well-illustrated 162-page book issued in 1904. Very much a quality guide, it did not lower itself to include adverts. Instead, the steamers got their due in chapters like 'To the shores of Clyde'. There the pride of the Edwardian heyday of the steamers oveflowed: 'Certainly nowhere does there exist such a magnificent fleet of palace steamers as that which plies to and fro upon these waters.'

6. & 7. George Eyre-Todd was commissioned to write both this and the last guide. He was a respected Scottish author of the period. Oban's development as a tourist centre owed much to both the steamer and the railway, but it was the steamship services that were there first. The Caledonian Railway did not arrive until 1880. Fifty-five years before that and six steamers were already at work serving the Western Isles. The tourist incentive originated even earlier owing much to Dr Johnson's travels in the eighteenth century and Sir Walter Scott who landed on Staffa in 1810. From then on, the land of the Gael was on the cultural tourist's itinerary and Oban began to acquire the sobriquet (quoted by Eyre-Todd) of 'the Charing Cross of the Highlands'. This fifty-six-page booklet was a serious affair not defaced by adverts. In it the classic itineraries to Iona and the now rather forgotten one to Portsonachan on Loch Awe are among those detailed. The rear cover (below) took the opportunity to show the Caledonian's most spectacular local feature. Another image of this was used again inside (see p.25).

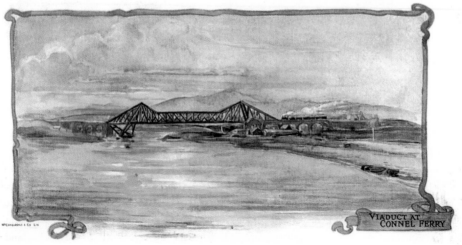

8. For the educated tourist on a diet of Ossian, Eyre-Todd and Walter Scott, what better means of orienting oneself in the local geography than the purchase of the Ordnance Survey map? After the First World War, the O.S. began to produce tourist maps. Amongst the first, and still highly regarded for its cover artwork, was Oban, published in 1920. The cover by Arthur Palmer was amongst his earliest and his best. The chronicler of the subject John Paddy Browne describes it as 'the One-inch Tourist map cover most admired by collectors of map cover art'. Inside was really no less colourful albeit in a strictly cartographic manner. The cover clearly shows Oban with its seaside railway terminal and steamers. The passenger station was to the right.

Official
A.B.C.
TOURIST GUIDE
TO THE
HIGHLANDS OF SCOTLAND
VIA THE HIGHLAND RAILWAY
INVERNESS

9. The western seaboard north of Kintyre benefited from three different railway companies reaching it. The Caledonian got to Oban, the North British to Fort William and Mallaig. This left the Highland Railway centred on Inverness to throw a branch westwards from Dingwall which in 1870 reached tidal water on the western coast at Strome Ferry. There were considerable problems in developing steamer services from here and the railway eventually reached the terminus at Kyle of Lochalsh in 1897. Significantly, it looks as if all these terminals will remain rail-served in the future, despite Kyle coming very close to losing its line in 1974. Back in 1913, in the heyday of the Highland, rail and steamer services were still envisaged as the only realistic way to enjoy the country. So the Highland, like the Caledonian, was busy producing its own guides for the tourists. The cover of an example is reproduced here. Its theme was, logically enough, more highland than maritime but the next illustration will demonstrate that the Highland had its own maritime opportunities. These tourist guides are rare survivors nowadays, let alone examples in mint condition. Evidence within the volume suggests that 12,000 had originally been printed.

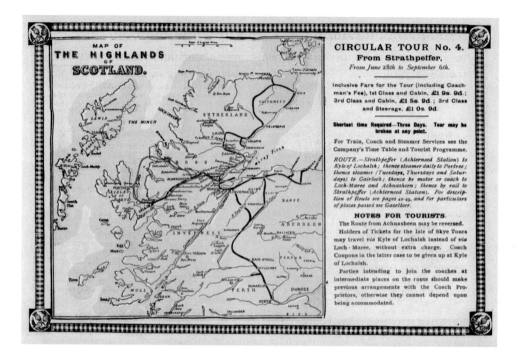

10. With a route to the west coast open, the Highland Railway was in a position to serve Skye and the Outer Hebrides. Initially using its own fleet, the railway company worked in conjunction with other operators like MacBraynes after 1880. Typically one operator's tours were cleverly interworked with others. The leg from Skye to Gairloch used a regular MacBraynes excursion from Oban to Gairloch. The tour shown was offered in the 1913 guide. Many of the tourists who patronized the Highland's opportunities used Strathpeffer as a staging point. This inland resort situated on its own special branchline owed much in its development to the advent of the railway. Despite this, passengers for the west had, as in this tour, to make their way out of town to use Achterneed Station. The important role of remote Achnasheen as a changing point is illustrated. Into the 1990s, it remained a hive of activity but is nowadays, without its hotel or staffed station, something of a desolate spot. Its decline finally came when the trains ceased to bring the mail for onward transmission in 1994 and the Postbus which had once run to Laide was abandoned in 1997, leaving just the Postbus to Torridon.

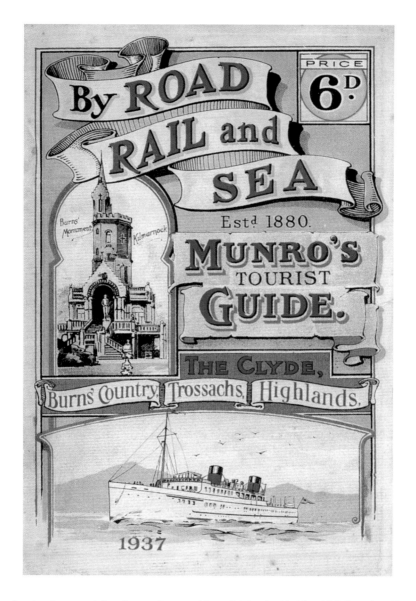

11. Another hardy annual for the tourist was *Munro's Tourist Guide* which lasted well over fifty years. This was associated by 1937 with the London Midland & Scottish Railway, so amongst its gems is a detailed description of the journey on the very sleepy Cairn Valley Light Railway down in Dumfriesshire. As the cover makes clear and due to the nature of the LMS interests, plenty of attention is given to the western seaboard, particularly with former Glasgow & South Western Railway areas in the south-west. The extensive descriptions along with the adverts and a number of folding maps make procuring a copy a treat. Owing to the way it was updated, some anachronisms persisted. Five pages were devoted to the delights of the 'Carrick Coast Line' which abounded in spectacular sea views as it wound its way from Ayr to Girvan past Heads of Ayr and Turnberry where the railway hotel of 1906 was given its due. The hotel had prompted the branch's construction but most of the branch had closed to passengers by 1933, leaving the unfortunate guide to commence its entry by saying 'This line, now used only by goods traffic ...'.

12. & 13. MacBraynes celebrated their centenary in 1951, though actually it was 100 years from the birth of their David Hutcheson ancestor. On 10 February, eighteen vessels were dressed overall in celebration. The thirty-eight-page annual brochure was rather more modest than 1939's. Even so, the icons of the subject were there on the attractive cover: the clansman, Iona and Staffa. The reverse (below) had as its centrepiece a MacBraynes coach. This was likely to be one of the 1939 AEC Regals. The clansman on the side is clear. One was even fitted to their radiators! In the following decades prior to the disintegration of the early 1970s, the concerns of the motor traveller would carry more and more weight in the company.

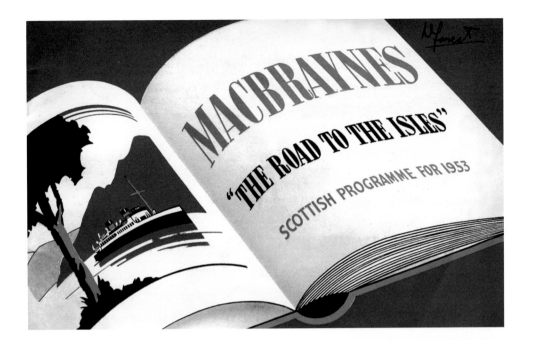

14. The cover for MacBraynes' 1953 programme was quite restrained. The vessel providing inspiration is the TSMV *Lochfyne* of 1931, which was the pioneer in the series of Denny motor ships for the company. Due to her diesel-electric propulsion, she attracted a lot of technical interest when new. Her life with the company lasted until 1970. 'The Road to the Isles' slogan was prominent in the 1950s publications and it may fairly be guessed that the role of the company's road transport operations was getting a share of the emphasis. After 1964, the slogan received a clever reworking.

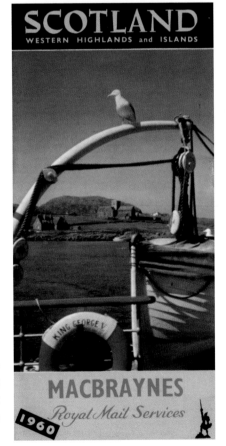

15. The cover for the 1960 brochure was the first to use a full-colour plate. It is nice enough but the printing technology of the time could not quite do the subject full justice and subsequently the company reverted to using artwork.

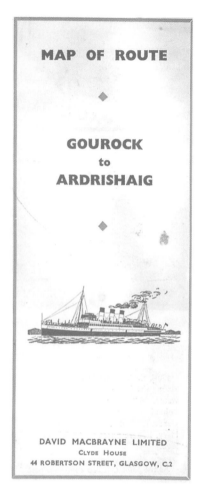

MAP OF ROUTE

◆

GOUROCK
to
ARDRISHAIG

◆

DAVID MACBRAYNE LIMITED
CLYDE HOUSE
44 ROBERTSON STREET, GLASGOW, C.2

16. This undated route guide is a charming piece which is likely to date from the mid-1950s. When *Saint Columba* resumed her service in 1947, the leg from Glasgow was dropped. *Saint Columba* carried on for twelve more seasons and then, in 1959, the motor ship *Lochfyne* substituted. The guide was cleverly arranged to provide one side for the maritime leg and on the other the road tour. (See also p.40.)

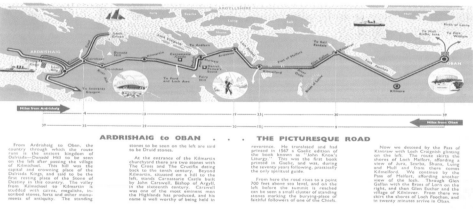

ARDRISHAIG to OBAN . . . THE PICTURESQUE ROAD

From Ardrishaig to Oban, the country through which the route runs is the ancient kingdom of Dalriada—Dunadd Hill to be seen on the left after passing the village of Kilmichael. This hill was the capital and crowning place of the Dalriada Kings, and said to be the first resting place of the Stone of Destiny in this country. The valley from Kilmichael to Kilmartin is studded with cairns, megaliths, inscribed stones, forts and other monuments of antiquity. The standing stones to be seen on the left are said to be Druid stones.

At the entrance of the Kilmartin churchyard there are two stones with The Cross and The Crucifix dating back to the tenth century. Beyond Kilmartin, situated on a hill to the left, stands Carnassarie Castle built by John Carswell, Bishop of Argyll, in the sixteenth century. Carswell was one of the most eminent men the Highlands has produced, and his name is well worthy of being held in reverence. He translated and had printed in 1567 a Gaelic edition of the book known as "John Knox's Liturgy." This was the first book printed in Gaelic, and was, during the seventy years following, practically the only spiritual guide.

From here the road rises to a point 700 feet above sea level, and on the left before the summit is reached can be seen a small cluster of standing stones marking the burying-place of faithful followers of one of the Chiefs.

Now we descend by the Pass of Kintraw with Loch Craignish glinting on the left. The route skirts the shores of Loch Melfort, affording a view of Jura, Scarba, Shuna, Luing and Mull and from there comes Kilmelford. We continue by the Pass of Melfort, affording another view of the loch. Through Glen Gallan with the Braes of Lorn on the right, and then Glen Euchar and the village of Kilninver. From there we skirt the shores of Loch Feochan, and in twenty minutes arrive in Oban.

17. The interior is simple but effective, enabling the salient points to be recognized even on a blustery deck. The Caledonian Steam Packet produced their own versions of this document for the 'All the Way Cruise' from Glasgow to Tighnabruaich.

18. & 19. Two glimpses of the scenes enjoyed by passengers aboard *Columba* during her Easter 1988 cruise (see p.68). With fine weather, the Mull of Kintyre was passed close by enabling a full appreciation of its rocky shores and the tidal races. On a clear day like this, the Antrim coast, just eleven miles away, forms a major feature. However, this shore is fully exposed to westerly gales from the Atlantic. Few then are the people who have enjoyed this view.

Further north, the passage of the Sound of Islay was pleasant if not quite so unusual. On a fine day, the remarkable features of this passage are the seaside distillery villages on the Islay shore being contrasted with this view (below) of the utter emptiness of the large island of Jura. This island is dominated by the triple peaks of the Paps of Jura (which can even be seen from Ayrshire) and by its lines of raised beaches and ancient sea cliffs.

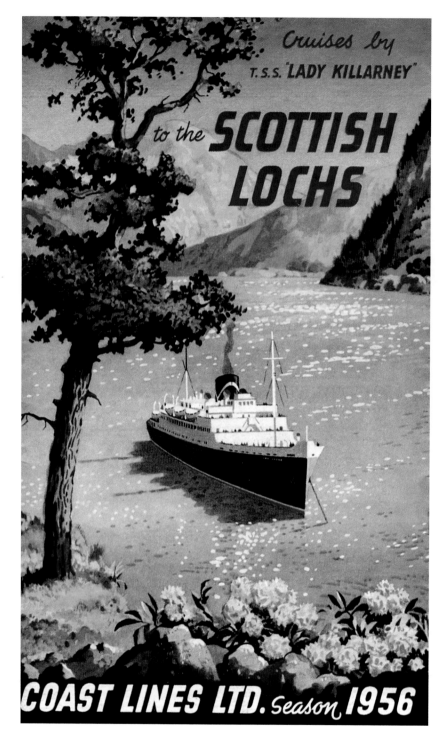

20. The leaflet for the final season of the Coast Lines cruises out of Liverpool by the TSS *Lady Killarney*. (For a detailed history see p.71.)

21. Many of the West Highland Railway stations had distinctive island platforms upon which were mounted Swiss-chalet-style buildings. An example was Rannoch, set amid the wilderness of the eponymous moor.

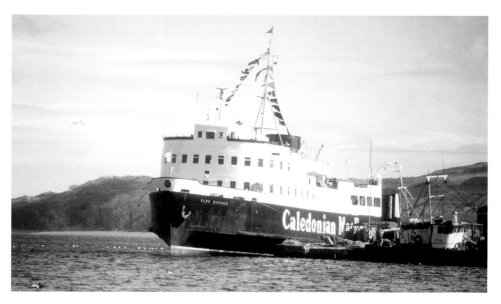

22. In her last seasons, *Glen Sannox* succeeded *Columba* as the enthusiast's ship in the fleet; indeed, she was seven years older anyway. This resulted in several sentimental cruises, particularly in 1987 for her thirtieth season. The picture shows the extremity of the special cruise offered on 8 April 1989 which took her to Campbeltown.

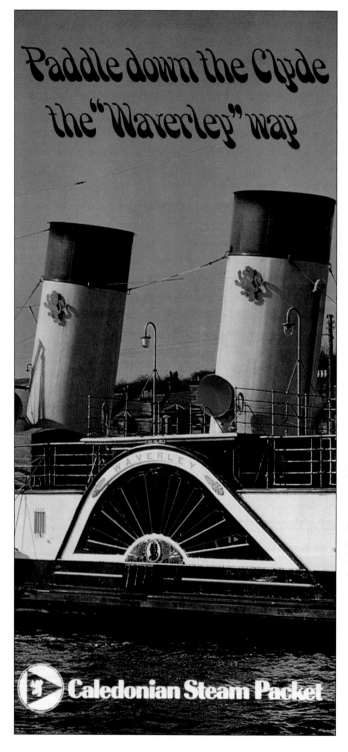

Paddle down the Clyde the "Waverley" way

WAVERLEY

Caledonian Steam Packet

23. As withdrawals of the steamers took place, the early 1970s saw rapid contraction. PS *Caledonia* went after the 1969 season, the *Duchess of Hamilton* after the 1970 season, leaving on the open Firth just the *Queen Mary II* and the PS *Waverley*. Nor was this situation stable. For a short while effort was put into selling the *Waverley*. She was, as glossy colour brochures (1972 shown) pointed out, now 'Europe's last sea-going paddle steamer'. Everyone was aware of her importance, C.S.P. even, as in this illustration, restored her LNER colours to the paddlebox, a rather subtle point which many of the 20,000 (its print run) recipients of the leaflet may have missed. For the last time, a C.S.P leaflet (indeed anyone's leaflet) featured Craigendoran Pier. In 1973 *Waverley* became a Caledonian MacBrayne vessel but after the end of the season, a November announcement from the company withdrew her from service. However, it was not the end of the story (see p.153).

IN THE PASS OF BRANDER

THE JOURNEY BETWEEN
GLASGOW AND OBAN
BY BRITISH RAILWAYS
INTERESTING FEATURES EN ROUTE

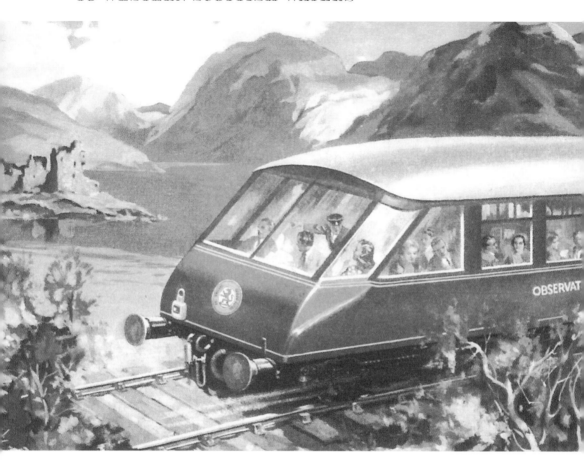

A specific operation over these lines leads to its own sequence of publicity. This was the concept of the observation car. The principle went back to 1914 and the Caledonian Railway/Pullman Car Company's joint operation of the *Maid of Morven* (*sic*) on the Oban route. The year before, the West Highland route proper had had some purpose-built coupé coaches. These had windows in the coach ends but only to benefit those in the end compartment. The CR car lasted until at least 1936. Some special publicity existed but none is available to your author. In particular, there was a series of Caledonian Railway-issued postcards of the journey 'as Viewed from the Pullman Observation Car *Maid of Morven*'. These can be found singularly and in booklet form. One of the most impressive shows the car with Connel Ferry viaduct in the background.

In 1956, the idea again surfaced, this time using cars of noteworthy origin. Two 'beavertail' streamlined cars (matching the LNER A4 Pacifics) had been built for the LNER *Coronation* train in 1937. War stopped this operation and the cars spent years in store. Then, in 1956, the idea of using them in Scotland took shape.

One printed source states very clearly that the two cars were rebuilt before operation in the West Highlands. I know of a variety of items showing the cars in use between 1956 and 1967. Early pieces use drawings showing the beavertail style in crimson and cream.

What is likely to be the earliest item is shown here (it is unfortunately undated). It uses the front cover drawing, but adds a back cover monochrome of the Lochy viaduct and Inverlochy Castle just outside Fort William (below). Trailing the train of four crimson and cream BR Standard coaches is a crimson and cream beavertail saloon.

Research shows that what happened was that one car ran in 1956 unaltered and in red/cream. Photographs and informants demonstrate that the other unaltered car ran in maroon on Oban line workings in 1957. Experience then indicated that a rebuild for better visibility was required. This was done over the winter of 1958/59 and created the now-familiar image (opposite).

Inside this item is a route guide just for the section from Fort William to Mallaig.

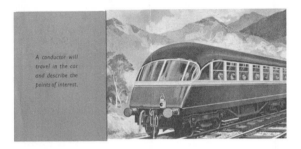

See the Bens and the Glens and other scenic features

between

FORT WILLIAM AND MALLAIG

from

THE STREAMLINED
OBSERVATION CAR

SUMMER SEASON

A conductor will travel in the car and describe the points of interest.

A SUPPLEMENTARY CHARGE IS
MADE FOR THE SINGLE
JOURNEY IN EACH DIRECTION

BRITISH RAILWAYS

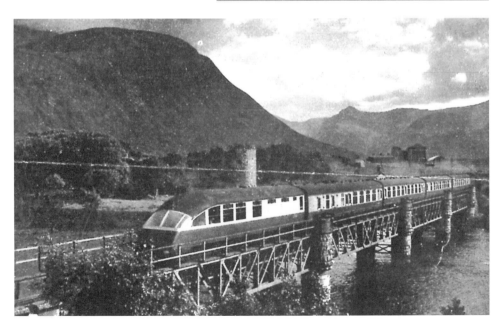

You see more . .

and enjoy greater

comfort by

travelling between

GLASGOW and OBAN

in the
Buffet
OBSERVATION CAR

DAILY SERVICE (except Sundays) 3 MAY to 18 SEPTEMBER, 1965

GLASGOW (Buchanan Street)leave	07 55
STIRLING ,,	08 49
OBANarrive	12 13
OBANleave	17 35
STIRLINGarrive	20 44
GLASGOW (Buchanan Street) ,,	21 34

Light refreshments can be obtained in the Buffet Observation Car

This luxury car, with large windows and comfortable armchair seats, is attached to the rear of the trains shown above.

Passengers travelling in the car, therefore, get the maximum pleasure from the ever-changing panorama of mountain, glen, loch and river that unfolds as the train speeds onward.

A CONDUCTOR WILL TRAVEL IN THE CAR BETWEEN STIRLING AND OBAN AND DESCRIBE THE POINTS OF INTEREST EN ROUTE

SUPPLEMENTARY CHARGE FOR THE SINGLE JOURNEY IN EITHER DIRECTION

5/-

ACCOMMODATION LIMITED

BOOK IN ADVANCE

at Glasgow (Buchanan Street) Station for the journey to Oban and at Oban Station for the journey from Oban—and avoid **disappointment.**

 British Rail

B.R. 35000—AF—April, 1965—B 38763 McCorquodale, Glasgow

In addition to the observation car line guide which was presumably available to observation car passengers and of which various types exist, each season a handbill was issued for each operation. This was available at stations to promote the cars. The example is the 1965 issue for the Oban service, which was the last time the full length of the Callander and Oban was in use.

In 1957, the two ex-LNER cars had worked Fort William-Mallaig and Glasgow-Oban runs. For the 1958 season, a third car was found and allocated to Glasgow-Oban, allowing one of the LNER cars to subsequently work Glasgow-Fort William. This third car was still running in 1965 and is the one featured in this handbill's drawing. This car had originated on the *Devon Belle* Pullman car train in 1947 and so produced the spectacle of the second Pullman observation car on the Oban line. *Maid of Morven* had been the first.

The last handbill was a transition piece produced to pre-corporate image standards but using the new double arrow symbol adopted by BR in 1965. The observation cars did not last beyond 1967 but in their final years, a near fully corporate image gloss leaflet was produced. This is 1965's and uses the Lochy viaduct pose for one of the rebuilt *Coronation* cars as running in maroon. They were not repainted in blue/grey so in that respect the publicity did not fully make it into corporate image! All three West Highland routes were covered which means some duplication with the previous item. Another leaflet in 1966 had the three routes, but by then all were starting at the same station – Glasgow Queen Street.

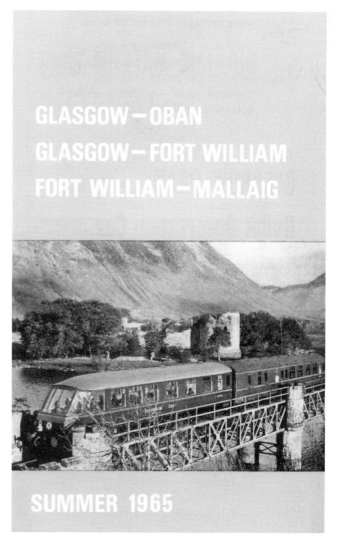

DAYS OUT FROM OBAN

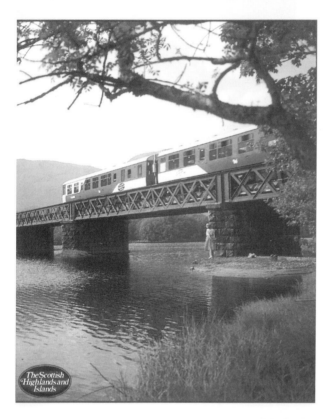

The Scottish Highlands and Islands

A Selection of scenic days out with ScotRail.

After years bereft of observation facilities, the principle again reappeared in the timetable between 1980 and 1986. This was done generally by hiring privately owned vehicles, which BR then tacked onto service trains between Fort William and Mallaig and Glasgow and Oban.

The Oban line developed another solution. Using an old DMU set, a design which had irregularly been used north of Craigendoran, this train was repainted in purple and white and allocated to Oban. Euphemistically called the 'Mexican Bean' as a result, it was used to work a series of Oban-based tours for a few seasons. This is the cover of the 1987 programme.

The eight-side, full-colour leaflet seemed to smack of the glory days. The train left Oban at 9.55 a.m.; its patrons were able to connect at Taynuilt for a Loch Etive cruise, and at the reopened Loch Awe join a *Lady Rowena* cruise, or carry onto Crianlarich.

Finally, with full Sprinterisation around 1990, all the wonderful views of the track have been lost save only to the patrons of the occasional exclusive privately promoted tour train for which observation cars are still available. The idea of using video cameras to screen the view into the Sprinter carriages was an odd substitute. Meanwhile, in the chaos that was privatisation, the railway promoted tours programme from Oban declined on occasion to a computer script sheet.

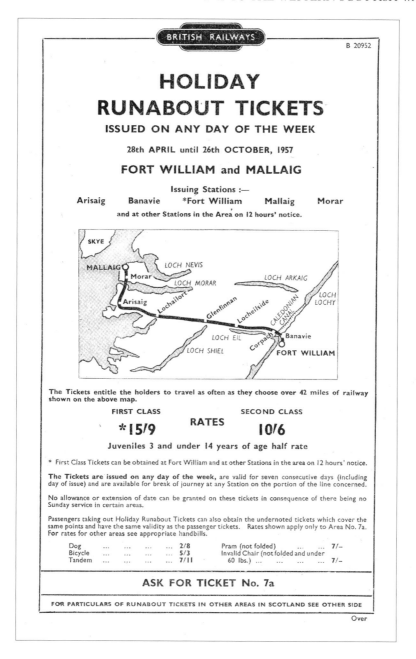

B 20952

HOLIDAY RUNABOUT TICKETS

ISSUED ON ANY DAY OF THE WEEK

28th APRIL until 26th OCTOBER, 1957

FORT WILLIAM and MALLAIG

Issuing Stations :—

Arisaig Banavie *Fort William Mallaig Morar

and at other Stations in the Area on 12 hours' notice.

The Tickets entitle the holders to travel as often as they choose over 42 miles of railway shown on the above map.

FIRST CLASS	RATES	SECOND CLASS
*15/9		10/6

Juveniles 3 and under 14 years of age half rate

* First Class Tickets can be obtained at Fort William and at other Stations in the area on 12 hours' notice.

The Tickets are issued on any day of the week, are valid for seven consecutive days (including day of issue) and are available for break of journey at any Station on the portion of the line concerned.

No allowance or extension of date can be granted on these tickets in consequence of there being no Sunday service in certain areas.

Passengers taking out Holiday Runabout Tickets can also obtain the undernoted tickets which cover the same points and have the same validity as the passenger tickets. Rates shown apply only to Area No. 7a. For rates for other areas see appropriate handbills.

Dog	2/8	Pram (not folded)	7/–
Bicycle	5/3	Invalid Chair (not folded and under			
Tandem	7/11	60 lbs.)	7/–

ASK FOR TICKET No. 7a

FOR PARTICULARS OF RUNABOUT TICKETS IN OTHER AREAS IN SCOTLAND SEE OTHER SIDE

Over

The potential for a West Highland lines publicity collection is simply vast and this is an instance of a humbler piece. The Holiday Runabout Ticket was a hardy annual and these individual handbills promoting the Fort William to Mallaig example ought to be encounterable being issued annually. This type of handbill was the standard form of leaflet used on the nationalised railway prior to the change to the corporate image from 1965. Its printer, as was so very often the case, was McCorquodale. Tickets 7 and 7b were other variants for the West Highland lines in 1957.

DAY EXCURSIONS and LAND CRUISES

BY DIESEL TRAIN

SEASON 1961

Advance information

This pamphlet gives advance information about the attractive programme of Excursions and Land Cruises by Diesel Trains from Glasgow and district stations during the 1961 season. All train times shown in this programme are approximate times only. Details of actual train times will be given in later announcements or can be obtained on application to E. Lees, District Passenger Manager, 87 Union Street, Glasgow. Telephone CITy 2911 (Extn. 18).

Special arrangements can be made for parties of 8 or more adults (2 children under 14 years, count as one adult) travelling together.

THESE ARE THE IDEAL EXCURSIONS FOR YOUR ASSOCIATION, GUILD OR CLUB OUTINGS.

BRITISH RAILWAYS

Left and opposite: Another in the handbill format but for an altogether grander concept is this Land Cruise leaflet for 1961. In 1933, the LNER's *Northern Belle* tour train had commenced visiting the West Highland. Anyone with literature for that operation would be singularly lucky. At the opposite end of the time spectrum but still in the category of the luxury sleep-aboard cruise train, the current *Royal Scotsman* operation produces lavish brochures.

In between came the idea of special land cruises for the day and targeted at the average Glaswegian. The technology that prompted this was the DMU or 'diesel multiple unit', the 'in-train' of the late 1950s, built by the thousand and featuring incomparable views straight through the driver's compartment.

The sets as a norm had limited use in our area but where they came into their own was in allowing BR to launch a programme of Land Cruises. BR named the premier one 'The Six Lochs Diesel Land Cruise', so playing on the steamer cruise names. Similiar trains on the circuit shown on the map had run as joint LMS/LNER excursions before the war. For a while, the DMU versions were very popular. On occasion, two six-car trains would set out for the day. In 1961, the Six Lochs ran every Sunday out of Glasgow from 21 May to 27 August. Additionally, on another twenty-five local holidays, it ran from origins as diverse as Gourock, Grangemouth and Strathaven.

The easy means by which the DMU could change direction was a boon, for the trains had to reverse at Crianlarich and again to traverse the Killin branch by which Loch Tay was enjoyed. Another option on the DMU worked excursion was to run a tour with two trains, one would go to Oban, the other to Fort William. The passengers then exchanged trains courtesy of a MacBraynes steamer cruise down Loch Linnhe. Truly, the DMU excursions took ordinary passengers to Western Scottish Waters.

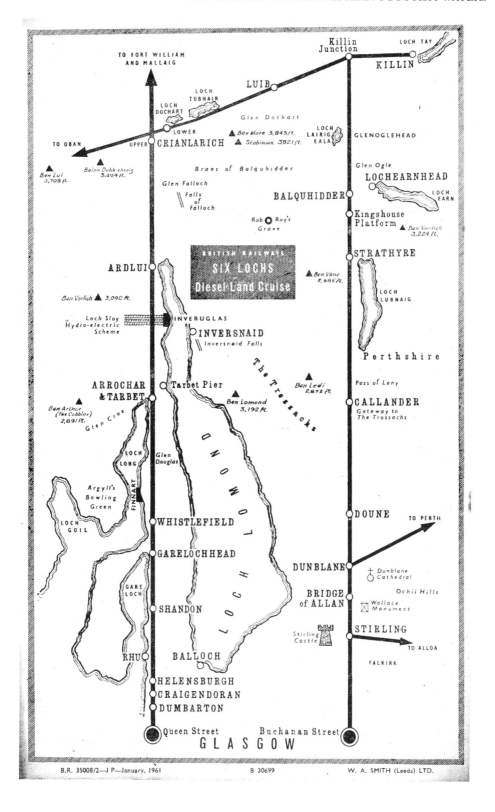

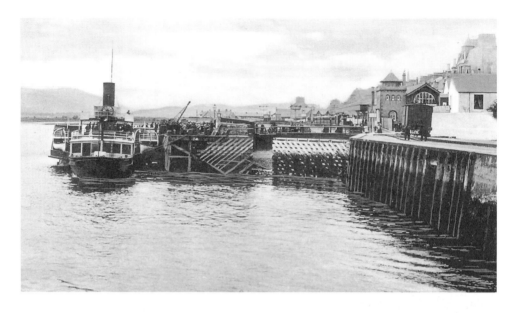

Along the line, significant physical changes have been wrought at both Oban and Fort William whose original terminal stations were destroyed by BR. Oban's is still on the same site. At Fort William in June 1975, the railway retreated half a mile. As a result, a town centre location beside the pier was relinquished to allow a road to be built!

This scene dated to about 1905 shows MacBraynes' *Fusilier* at the pier. The sheer convenience for the railway is apparent. The headshunt which ran onto its own quay is apparent to the left. At times, engines or carriages would stable here and passengers for the pier might find themselves nosing around the obstacles. Once motor buses arrived, a gaggle of MacBraynes coaches would often assemble on the pier itself, while only a couple of streets away was a bus depot.

Of the *Fusilier*, S. P. B. Mais, a great travel writer of the 1930s, wrote in *Isles of the Island*: 'The *Fusilier* looked much too small to put out in that boiling sea. I was glad not to be crossing the Minch (Mais was only going from Mallaig to Skye). For the first half hour, I postponed my luncheon and rolled about unsteadily on deck …'. The journey continued in this vein with a querulous houseparty boarding at Kyle of Lochalsh.

Opposite: This early 1970s picture captures the maritime flavour of Fort William's old station. The train is headed by a class 27 diesel. The stock is all BR Standard Mark One coaches in the corporate blue/grey. You could still lean out of these coaches and enjoy some fresh air. The old North British Railway lattice post semaphore signals controlled operations. In the left-hand distance, a large pier is visible. This once carried 3ft gauge steam trains.

The pier was completed in 1926 in connection with Fort William's new aluminium plant, which functions to this day. Until the early 1960s, the railway was a key link to coaster traffic. On the other side of the works, the railway continued into the mountains for miles as a Wild West affair used to maintain the pipelines until 1976. In the 1930s, this system crossed the West Highland for a second time, near Fersit.

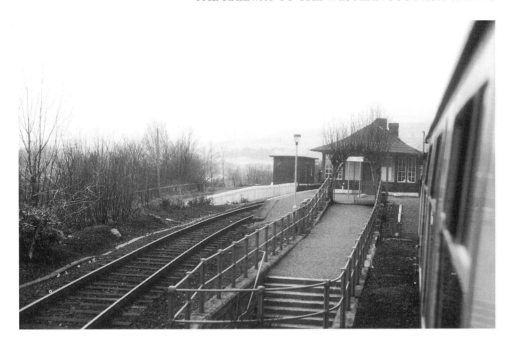

Many of the West Highland Railway stations had two distinctive trademarks. These were their island platforms upon which were mounted Swiss chalet-style buildings. A clear view of the principle is afforded in this view of Garelochead station taken from a passing train on 4 April 1987. By this time, the line was beginning to experience two significant changes. Radio signalling was replacing the mechanical signals and their cabins, while the Sprinter DMUs were less than two years away.

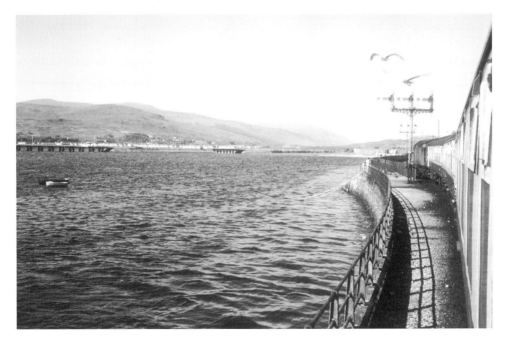

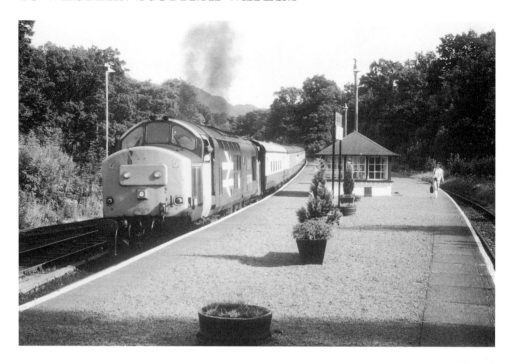

Since the first generation of DMU had not made great inroads into West Highland train operation, the area become one of the last areas of British Railways where a secondary train service was being exclusively run with locomotives and coaches. This persisted until the arrival of second generation Sprinter DMUs in the late 1980s.

In the high summer of 1989 on 22 July, I enjoyed one of these ordinary opportunities to travel by 'loco and stock' over the line. This was the scene at Ardlui. Here the chalet building had gone and the redundant signalbox had become a waiting shelter. The class 37 loco was of the type that finally dominated the passenger workings and which in 1999 still handled the freight and the sleeper train to London Euston. The sleeper is a very long tradition whose survival has at times been marginal and for which there is yet another group of publicity material.

The train in the picture caused its own publicity too. A full Sprinter timetable commenced, with all its own promotional literature, from 23 January 1989. However, it could easily be foreseen that summer conditions with trainloads of baggage-laden tourists would tax the new trains. 'A mobile Nevisport' was one verdict. For as long as stock remained available, Scotrail continued to run locomotive-hauled summer supplementary trains. These lasted until the end of the 1994 season and produced their own publicity complete with differing artwork covers. Some of the stock used was even painted in the traditional LNER tourist stock livery of green and cream. Such a rake was in use for this occasion. Another idiosyncrasy of the working was that to better provide connections from the south, the train had started at Glasgow Central High Level before traversing the suburban network including Queen Street Low Level station.

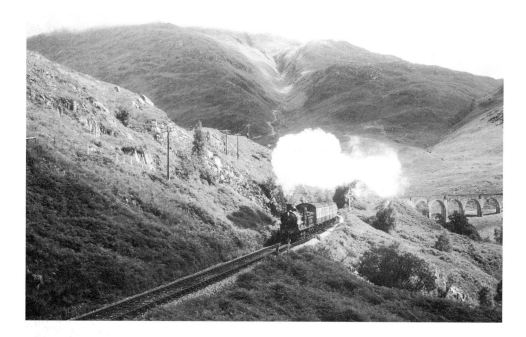

One more opportunity to travel in a classic train has continued to regularly exist, over the Fort William to Mallaig section. Since 1984 (a time when the new Scotrail management was willing to try out various projects), each summer has witnessed a timetabled steam train service and each year, of course, that has had its leaflet creating another fine run of collectables.

The engines and coaches used have varied. Often a common denominator has been a Black Five 4-6-0, once a commonplace on the line, which the drivers at Fort William were already familiar with, though as time has passed, brand-new steam drivers have had to be trained. The first year saw the most evocative loco drafted in, which sadly proved too small for regular use.

That engine was the former North British Railway *Maude*, seen in this picture near Glenfinnan viaduct on 13 July 1984. Built as NBR class C in 1891, *Maude's* ilk were a regular sight on the line from the outset until steam ended in the West Highlands (for the first time) in 1963. Her name denotes participation in First World War military service abroad.

INVERNESS – KYLE OF LOCHALSH
CAR CARRYING SERVICE
until 1 October 1966

Take your car by train and enjoy the scenery at leisure from the comfort of the Observation Car.

OUTWARD

Inverness	leave	10 40
Kyle of Lochalsh	arrive	13 40

INWARD

Kyle of Lochalsh	leave	17 50
Inverness	arrive	20 50

SINGLE JOURNEY, ALL-IN CHARGE
FOR CAR AND DRIVER
(including seat in Observation Car)

75/–

Pre-packed lunch can be provided by prior arrangement or booking for lunch can be made in Lochalsh Hotel.

Prior reservation for cars to be made at Manager's Office, Highland Lines, Inverness. Telephone ; Inverness 30961, Extn. 43.
or
Area Manager, Kyle of Lochalsh. Telephone : Kyle 4205.

 British Rail

BR.35000·B.1403·WA·June, 1966. Rep.U.64. McCorquodale, Glasgow.

Little more has been said about the Kyle line since before the First World War. It too could offer a wealth of material including the fending off of a formal closure proposal. Space demands that we can just demonstrate the evidence for a very short-lived attempt to compete with the tarmac between Inverness and Kyle.

I know of a few more uninspiring pieces of railway salesmanship, but this example is pretty much the nadir. In the 1960s, Car-Carrying or Motorail services had developed rapidly. This was a small-scale example that I suspect only ran in the summer of 1966 to try and take cars off the A890. The old regional handbills were never the best sales tool and when used in such a plain form in an attempt at the corporate image, the result must have been most discouraging to a potential patron.

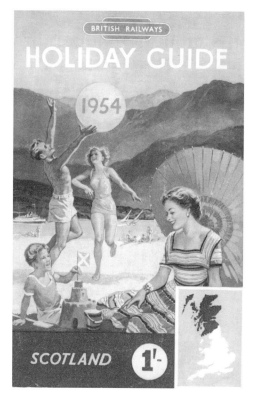
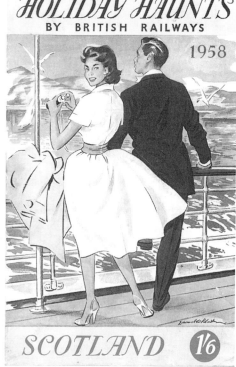

Before leaving the railway for railway-owned shipping, one piece of publicity must be mentioned. The best-known BR heavyweight publication was the regional and later the all lines timetable volumes. There were other heavyweight sequences: one was the *Holiday Guide*, another was *Holiday Haunts*. These were annually published books issued on a regional basis. They are potentially both attractive collectables and a valuable resource. Mint copies should retain their folding system maps. They had their origins in publications issued by the pre-nationalisation companies which BR kept going into the early 1960s.

The Scottish affair was a substantial volume of about 250 pages with illustrations, maps, directories of accommodation, and suggestions for travel. Naturally, the ships figured well and the 1958 cover shown here was clearly set on board. In 1958, virtually every train was steam and the image already seen at the Lochy Viaduct was inside, along with a host of steam-hauled named trains. Some of the vessels shown included the MV *Arran*, the TSS *Queen Mary II* and MV *Maid of Skelmorlie*. Tucked into the adverts were such informative gems as an illustration of the MV *Blaven* at work, which adds to that narrative the nuance that Mr MacLennan was the proprietor of Mallaig's temperance Marine Hotel, as well as a ferryman. A copy of *Holiday Haunts* is ideal for a trip into nostalgia but its paperback binding makes reproductions problematic, by which excuse the narrative can turn exclusively to some Caledonian Steam Packet publicity.

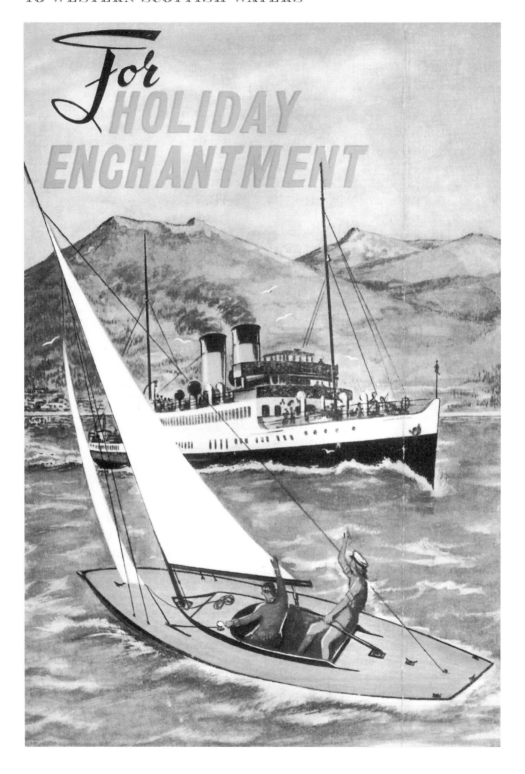

8

CALEDONIAN STEAM PACKET NATIONALISED

After the traumas of war, the early years of nationalisation in the relatively stable 'you've never had it so good' 1950s appeared to foresee a new Golden Age. For a while, this seemed backed up by fact. The LMS-originated Caledonian Steam Packet became the arm of British Railways shipping throughout the Firth of Clyde, absorbing the LNER ships. The latter was not completed in legal terms until 5 November 1951. For a period from 1952, the C.S.P. image was subsumed in a Clyde Shipping Services title.

An undated leaflet (opposite), which is likely to come from the late 1950s, well expresses the atmosphere. The accompanying map (below) could show routes criss-crossing the Firth. Reflecting on just how many piers were in use for services on the east coast of the Firth shows how generous the provision was. Ayr, Troon, Ardrossan, Fairlie, Largs, Wemyss Bay, Gourock and Glasgow were all in use by C.S.P. In 1999, four out of those eight had long since been left behind by Caledonian MacBrayne.

The cover juxtaposes one of the Duchesses with a sailing boat, then as now such a common sight, even if the classic wooden designs of Fife of Fairlie and the like are something of a rarity on the water today.

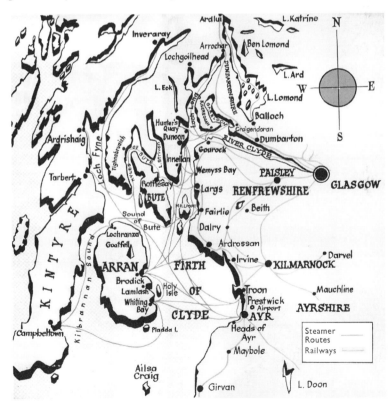

CLYDE COAST STEAMER SERVICES

28th MAY until 30th SEPTEMBER 1955

BRITISH RAILWAYS

GRATUITOUS

One of the core pieces of publicity was Caledonian Steam Packet's own timetable. This appeared in two forms through the year until the amalgamation with MacBraynes. For the summer season a substantial booklet was issued complete with varying cover artwork. At a time when the owning British Railways timetable volumes were very restrained, the C.S.P. covers could be positively riotous. Outside the summer, winter and spring timetables followed the basic BR handbill format until becoming a leaflet from 1966 as BR corporate image policies took effect. A map of the routes and detailed fleet list were usually included. In 1955 and 1956, it was a Duchess which did the honours on the cover.

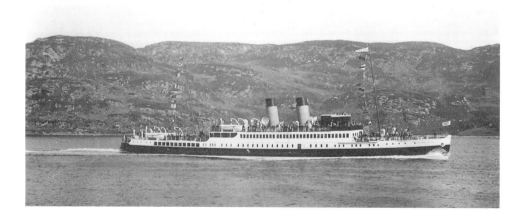

This photograph of the *Duchess of Hamilton* shows the cover artist's impeccable attention to detail.

Between at least 1959 and 1962, another vessel graced the summer covers. New ships had been built since the war, the list being PS *Waverley* of 1947 (replacing a tragic Dunkirk war loss), PS *Maid of the Loch* in 1953, the four diesel Maids, the A.B.C. car ferries and then, in 1957, the *Glen Sannox*. The first two in the list can still be seen in the area, although their survival is anachronistic, indeed they were such when built. The future for mainstream commercial ferries lay in vehicle transport and by 1957, when MV *Glen Sannox* was built, British Railways knew just that. Despite the paradox, her owners were very proud of her and she proved successful in service. The result was that she was widely featured on publicity. A long life followed, which justifies a special look at her later.

Enthusiasts were spoilt for choice over which vessel to adore right until the late 1960s. Even so, the TSS *Queen Mary II* was usually accorded a special place and it is not difficult to find her in the publicity until her demise in 1977. This use on the cover of the main timetable for the summer of 1963 was forceful. From 1964, the covers changed each year. *Queen Mary II* returned in rather bastardised form, to grace a late Caledonian Steam Packet production for the summer of 1970. That timetable had a back cover map showing 'Operational Areas of the Scottish Transport Group' marking the end of railway (but not state) ownership, which took effect from 1 January 1969. Caledonian Steam Packet literature continued to be issued until the start of 1973 when the amalgamation with MacBraynes was effected.

The winter and spring issue timetables were the simplest of productions revolving around the classic railway handbill format. Indeed in the early 1950s, they were only headed 'British Railways Clyde Coast Steamer Services' and they had no illustrations. The C.S.P. logo did reappear on these items and this was followed in the mid-1960s by the regular use of this block of the *Queen Mary II*. It will be appreciated that these images showed her in latter-day condition with one funnel. The last version of this handbill used the railway company's double arrow, since between 1965 and 1969, Caledonian Steam Packet gained the railway's new image. This led most visibly to rail-blue hulls on the ships.

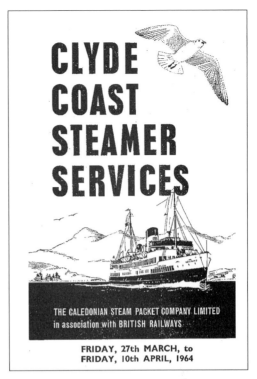

The handbill design was abandoned in October 1965. The fold-out leaflet was then introduced and it would become very familiar. Until 1969, these were British Rail productions very much in the form of other Scottish Region literature. Showing a winter timetable (in this case for 1968) allows the introduction of another group of vessels. The Maids were not often visually prominent in the publicity but they did manage the cover of the winter 1968 and, with another image, the winter 1969 timetable leaflets. Prior to their appearance, the winter before had seen PS *Caledonia*. The Maids were in a tradition of smallish passenger-only motor ships that had included the *Countess of Breadalbane*, the *Leven* and the *Ashton*. There were four Maids appearing in 1953 for passenger-only services like Millport. Before long, they were chasing after work. Despite being visually attractive and easy to handle, that was of no account when people wanted to take their cars. Between 1972 and 1978, the four Maids were disposed of. On this leaflet is *Maid of Ashton*, which was the first to go.

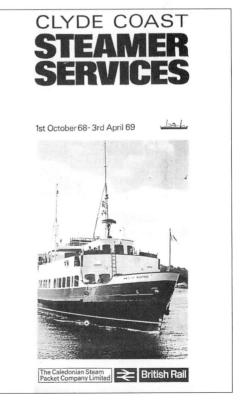

117

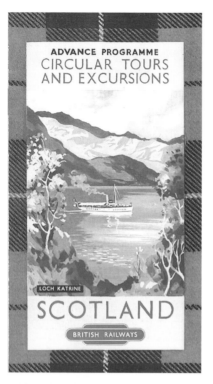

Just as MacBraynes had backed up their basic timetable provision with copious literature dedicated to the tours, the same principle applied to the railway-owned ships. There was a subtle nuance. At least until the Scottish Transport Group takeover, and actually for a while beyond, the C.S.P. tours were part of a larger national offering by British Railways which went under the guise of 'Circular Tours and Excursions'. Publicity was regularly produced at three different levels for these tours. Each year would see a glossy leaflet giving brief details of all the tours which were numerically referenced and given titles. A substantial booklet was issued as well, giving very full information about each tour. Finally, standard railway handbills existed for individual tours or small groups thereof.

Shown here is the cover of the gloss leaflet for the 1957 season. Aside from the helpful 'Loch Katrine' caption, the ship herself gives the location away. The awning-bedecked steamer can only be *Sir Walter Scott*.

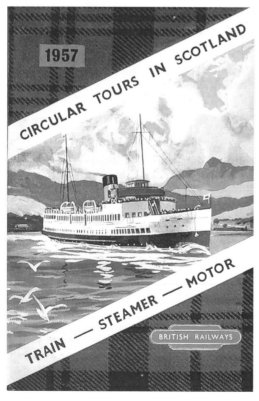

The full programme for 1957 was a 112-page volume and a string of these constitute a fine collection. The image, down to a different tartan, was completely different from the partnered leaflet. The steamer took pride of place leaving a motor coach and steam train to occupy the dim distance. There was no denying the pride of the railway in its ships.

It will be no surprise to learn that the steamer is the *Queen Mary II*. What is noteworthy is that it was only during that spring that she had been re-boilered and assumed her one-funneled appearance. Despite the traditional sense of the publicity, it was actually completely up to the minute.

ON MONDAYS and WEDNESDAYS **TOUR No. 24**
3rd June until 18th September

OBAN, IONA, STAFFA AND FORT WILLIAM DAY TOUR

MOTOR TO BALLACHULISH (GLENCOE) ; TRAIN TO OBAN ; MESSRS. MACBRAYNE'S STEAMER ROUND MULL TO IONA AND STAFFA AND BACK TO FORT WILLIAM AND MOTOR HOME

Note:—Weather and circumstances permitting, passengers will be allowed ashore at Iona and Staffa.

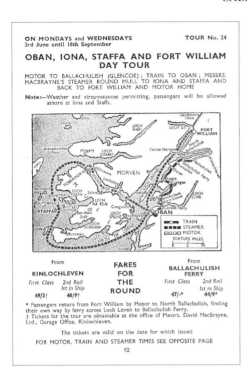

	FARES	
From **KINLOCHLEVEN**	**FOR THE ROUND**	From **BALLACHULISH FERRY**
First Class 2nd Rail 1st in Ship		First Class 2nd Rail 1st in Ship
49/3† 46/9†		47/-* 44/9*

* Passengers return from Fort William by Motor to North Ballachulish, finding their own way by ferry across Loch Leven to Ballachulish Ferry.
† Tickets for the tour are obtainable at the office of Messrs. David MacBrayne, Ltd., Garage Office, Kinlochleven.

The tickets are valid on the date for which issued
FOR MOTOR, TRAIN AND STEAMER TIMES SEE OPPOSITE PAGE
92

ON TUESDAYS, 4th June until 17th September, also **TOUR No. 4**
ON THURSDAYS, 27th June until 29th August
(For route map and fares see opposite page)

INVERARAY, LOCH ECK AND DUNOON DAY TOUR

TRAIN, STEAMER AND MOTOR TIMES

TRAIN

			a.m.	a.m.	a.m.
Edinburgh (Princes Street)	leave	—	—	6 24
Glasgow (Central)	arrive	—	—	8 8
Glasgow (Queen Street Low Level)	leave	7 38	—	—
Port Glasgow	,,	—	7 40	8 30
Paisley (Gilmour Street)	,,	—	7 53	8 43
Upper Greenock	,,	—	8 25	—
Greenock (Central)	,,	—	—	9 17
Greenock (West)	,,	—	8 34	—
Gourock	arrive	—	8 38	—
Craigendoran	,,	8 32	8 46	—
Wemyss Bay	,,	—	—	9 34

STEAMER

			a.m.		
Craigendoran	leave	8 40		
Gourock	,,	8 55		
Dunoon	,,	9 15		
Innellan	,,	9 35		
Largs	,,	9 15		
Wemyss Bay	,,	9 40		
Rothesay	,,	10 15		
Tighnabruaich	,,	11 5		
Inveraray	arrive	1 30p		

LOCH ECK MOTOR

			p.m.		
Inveraray	leave	2 15		
Dunoon	arrive	4 15		

STEAMER

			p.m.		
Dunoon	leave	5 0	4†45	5 45
Gourock	arrive	5 25	—	—
Craigendoran	,,	5 50	—	—
Innellan	,,	—	—	6* 5
Rothesay	,,	—	—	6¶35
Wemyss Bay	,,	—	5† 5	—
Largs	,,	—	5†35	—

TRAIN

Gourock	leave	5 37	—	—
Craigendoran	,,	—	6 10	—
Wemyss Bay	,,	—	—	5D30
Upper Greenock	,,	—	—	5D49
Greenock (West)	,,	5 45	—	—
Greenock (Central)	,,	5 47	—	—
Port Glasgow	,,	5 59	—	—
Paisley (Gilmour Street)	,,	6 23	6D16	—
Glasgow (Central)	,,	6 41	—	—
Glasgow (Queen Street Low Level)	,,	—	7 1	—
Glasgow (Central)	,,	—	6D32	—
Edinburgh (Princes Street)	arrive	8 23	—	—

* Ceases after 10th September. † On Tuesday, 17th September passengers for Wemyss Bay and Largs leave Dunoon at 5.45 and arrive Wemyss Bay 6.5 and Largs 6.30 p.m. ‡ On Tuesday, 17th September passengers for Rothesay change at Wemyss Bay and arrive Rothesay 6.50 p.m. ‡ No connection after 10th September—passengers change at Rothesay. C Change at Port Glasgow. D On 10th and 17th September leaves Wemyss Bay 6.18. p.m. arriving Upper Greenock 6.38 p.m., Paisley (Gilmour Street) 7.6 p.m. and Glasgow (Central) 7.22 p.m. M Runs on Tuesdays only—passengers change at Rothesay.
39

Inside, these booklets were crammed full of the details for the tours. Numbers of these had nothing to do with Caledonian Steam Packet. Tour 24 was British Railways' version of The Sacred Isle. It involved a coach between Kinlochleven and Ballachulish, the train from Ballachulish to Oban, thence the *King George V* around Mull as usual, and then the steam up Loch Linnhe to Fort William, thence a coach back to Kinlochleven. Note that this tour, the subject of a British Railways ticket, was offered from a community which had never been on the railway. Priced at under 50s, you enjoyed a 14-hour day. A very few tours never took to the water like Number 6 to Braemar, though even Number 18, the Forth Bridge Day Tour, ensured that its patrons used a Denny-built and -owned car ferry.

The itinerary shown on the right is for one of the classics. The Loch Eck tour was Number 4 and its earlier history has been examined. The steamer used in 1957 was the *Duchess of Montrose* and when the tour operated, it meant that the Duchess was virtually following the *Saint Columba* through the Kyles of Bute until the latter veered off to Ardrishaig. The 11.05 a.m. call at Tighnabruaich had not changed in fifty-three years.

The Loch Eck tour continued into the 1970s. The *Duchess of Hamilton* handled it until her withdrawal after the 1970 season whereupon the *Queen Mary II* took over. After 1973, the Inveraray sailings and thence the tour were abandoned.

LOCH ECK COACHES.

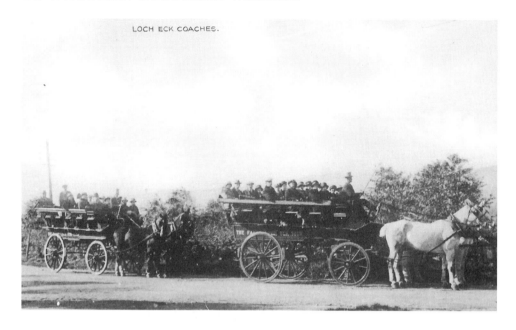

Here is a visual glance at the Loch Eck tour, perhaps at the end of the Edwardian period. The horse-drawn wagonettes are actually inscribed 'The Famed Loch Eck Tour'. Part of this tour's particular fame is that it could trace its roots back to 1827 and a short-lived initiative by David Napier that put both a steamer on Loch Eck and connecting steam coaches. The core history of the tour ran from 1878 to 1973; the Loch Eck sailings were abandoned in the 1920s, as I presume were the horse buses in favour of motor vehicles.

HOTEL ST CATHERINES, LOCH FYNE.

By the 1920s, motors had replaced coaches, as shown in this view at Loch Fyne.

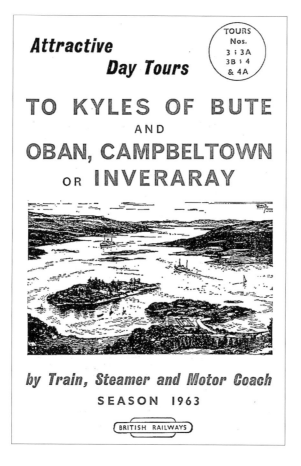

The third category of circular-tour promotional literature was the handbill. The issue shown covered the tours through the Kyles of Bute for 1963, hence the Loch Eck tours are present as 4 & 4A, anticlockwise or clockwise. Handbills could be produced as small booklets in handbill size and design, which is the case here with eight pages. Very often they were punched at the top left and strung up leaving many survivors with torn covers. Stored poorly and their paper deteriorates quickly. A mint handbill is therefore quite a find. The British Rail corporate image despatched them around 1966.

A variety of handbills were used for the steamers and during the mid-1960s their cover details were in constant flux. For the tours a point of interest lies in the covers. Illustrations relevant to the steamers were used of Castle Moil Kyleakin, the MV *Glen Sannox*, the PS *Maid of the Loch* and of the Burnt Islands in the Kyles of Bute as shown here.

The image is signed top right by John S. Smith – who did other work for British Railways. It was composed from the hills above the Kyles which a driver on the A8003 into Tighnabruaich would recognise. To the right is Buttock Point, the northernmost part of Bute. The small islands are the Burnt Islands. In the foreground is Eilean Dubh (Black Island) guarding the private Caladh Harbour which was one of the locations in the 1990s television version of *Para Handy*. The steamers seem inspired by *Queen Mary II* and a diesel Maid. The original uses blue and green print.

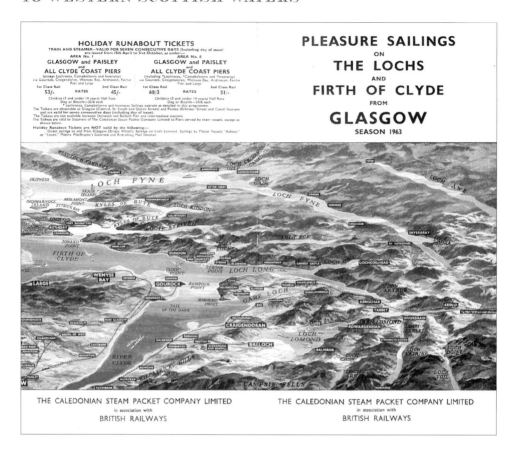

A further source of information about the steamer programmes comes in the 'map' leaflets. The concept of using an aerial view of the coast as a piece of artwork was well established. Between at least 1953 and 1964, a section of the Nicholson map artwork was used in a full-colour glossy leaflet to handbill dimensions. It was used for two sequences: one was an annual announcement available in advance for the summer programme; the second was for a series of leaflets issued on a resort by resort basis. I know of these for Ayr, Largs, and Glasgow, but there were probably others.

The BR version of the view can be encountered in other locations. One such use was to allow its reproduction in resort guides. Those form a whole subject in themselves and as they are not official shipping publicity, space cannot be devoted to them here. Suffice to mention one example. Maurice Lindsay, a latter-day Eyre-Todd wrote 'Dunoon The Gem of the Clyde Coast' around 1960. Its 148 pages are a treat for the steamer lover including a fold-out of the aerial view map, full-page adverts for both MacBraynes and C.S.P., not to forget Dunoon Motor Services or Goldline Luxury Coaches. With six of the C.S.P. fleet illustrated and the steamer tours itemised, such a guide can be useful.

During 1964, the 'map' brochures were replaced as a combination of the imminent move to corporate image on British Railways and the general adoption of glossy leaflets against the older handbills created major changes to Caledonian Steam Packet publicity. During the dying years of the traditional steamers, there would actually be more, not fewer, chances to appear in print.

A feature of the result in 1964-65 was this artwork used for several items. The location is the Cloch Lighthouse with Hunter's Quay across the Firth. The steamers are the ubiquitous *Queen Mary II* and one of the A.B.C. car ferries shuttling from Dunoon to Gourock. A piece like this with a February 1965 print date has particular significance since no actual evidence of the corporate image like the double arrow or British Rail title is used. The new corporate image had quite literally just been announced and the result had to wait for the summer programme of 1965.

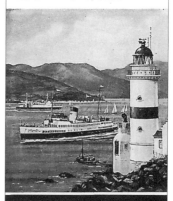

Pleasure Sailings, Excursions and Tours 1965

ADVANCE PROGRAMME for
Firth of Clyde and **Loch Lomond**

The Caledonian Steam Packet Company Limited in association with British Railways

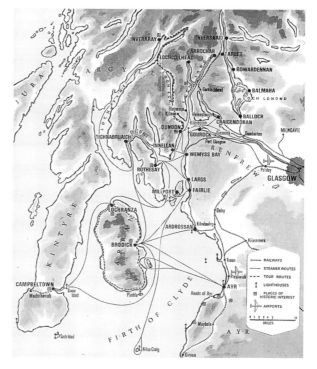

Inside was a route map. Although retrenchment had a long way to go, it had started. Troon and Whiting Bay had gone. The Holy Loch was under threat. It was perhaps rather mean of the C.S.P. not to show that the Ardrishaig route of MacBraynes was still functioning. It would still run until the end of the 1969 season.

A reminder of this period, when many of the favourite routes dating back into Victorian times were still functioning, comes in this picture. The *Duchess of Montrose* had gone at the end of the 1964 season; her sister the *Duchess of Hamilton* survived through to 1970. This picture from 1969 shows her in the twilight of her career berthing for 1.10 p.m. at Ayr. That year, Ayr was only served on a Friday with a cruise from Gourock calling at the Firth resorts before spending three hours in Ayr, which allowed an option on a coach tour of Burns Country.

Children of the 1960s, including my wife (featured), grew up in a chameleon-like age. In 1960, vast amounts of what was fundamentally Victoriana in concept and sometimes in fact still functioned. Steam engines built seventy years before were still considered adequate for the job not only on the railways but also on water too. In a jet age, steam was still king in many parts of the Highlands. By 1970, what was left was entering a future in which it would only survive on sentiment.

Despite the dramatic changes, the link between the railway and the steamers would not be forgotten. It was well maintained in publicity terms in 1999. The leaflet shown is one from a run current in at least 1972-74 using the Rail Sail slogan. Externally, the attraction is a drawing combining the old and the new eras. *Waverley* stands for the old, the electric Blue Train headed for Gourock is the new. In hard fact, only thirteen years actually separate the two: 1947 versus 1960. The detail of the cover design was printed in blue and black on white. It had to reflect the pace of change. 1972 had British Rail in association with the Caledonian Steam Packet; 1973 changed this to Caledonian MacBrayne. Owing to *Waverley*'s withdrawal 1974's cover illustrations had to be redesigned. An image, looking much more hurried, was drawn to combine the Blue Train and the *Queen Mary II*.

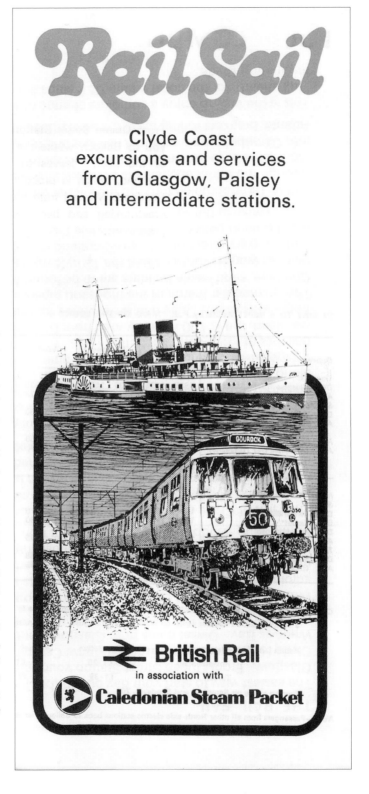

Rail Sail

Clyde Coast excursions and services from Glasgow, Paisley and intermediate stations.

British Rail
in association with
Caledonian Steam Packet

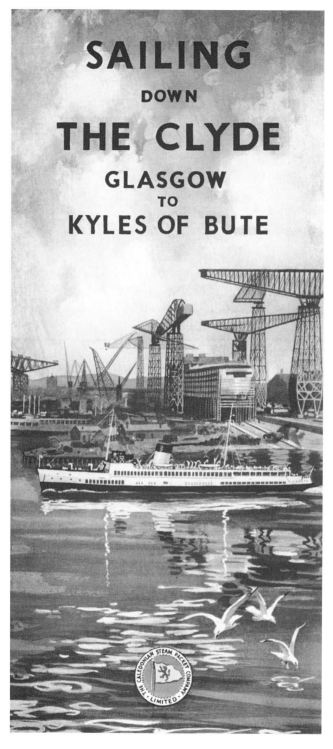

Away from the generic publicity introducing the spread of the services, there was a considerable amount of miscellania. Some of this material was well known, some of it short-lived in time and circulation. Perhaps the most dramatic example was the Caledonian Steam Packet equivalent to MacBraynes' guide for the *Saint Columba*'s sail down the Clyde. The C.S.P. parallel was the 'All the Way Sailing'.

In 1952, quite a simple folder on poor-quality paper was available for the cruise but it included a route map. There were probably several editions of that, but by 1958 a spectacular piece was available. It attracted a cover charge of *6d* for a sixteen-page fully colour printed guide. Note the C.S.P. logo which had only lately reappeared on publicity. It is a pity that the cover artist is not recorded. Once again, the image reminds me of Auden who on his journeys to teach at Helensburgh around 1930 found the shipyard cranes very poignant.

Even a humble handbill existed each year to promote the 'All The Way Sailing'. This example in blue on white comes from 1957. The last 'All The Way' excursions were withdrawn after 1969 and, judging by a very poorly produced handbill which was current in 1966, an air of defeatism had latterly crept in.

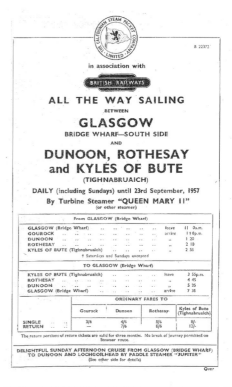

Queen Mary II, however, had quite a bit of life remaining after 1969. She was extensively refitted in 1970-71 to succeed to the *Duchess of Hamilton*. Grant aid was sought and obtained and the ship once again became the *Queen Mary*. In 1976, Glasgow sailings recommenced, including an 'All The Way' trip to the Kyles. Elaborate publicity solely for her was a result in the mid-1970s. The brochure for 1977 was not actually full colour, but that could be excused as a silver-and-blue theme created an image totally congruent with the jubilee-year theme. It all looked most impressive with an eight-page programme ranging from Tighnabruaich to Ailsa Craig and Campbeltown.

Yet it was the end. She was simply far too expensive and a more economical alternative was in the wings for 1978. The old lady eventually went off into retirement as a restaurant ship in London.

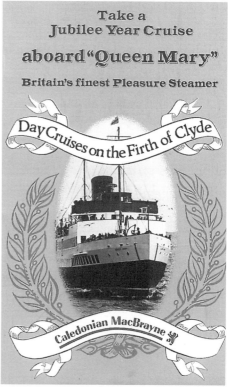

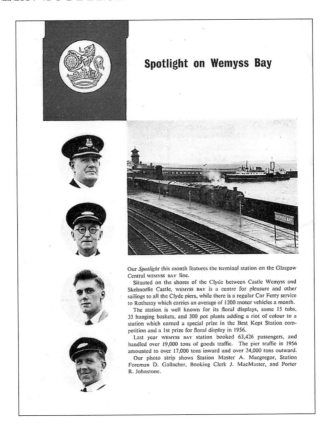

Spotlight on Wemyss Bay

Our *Spotlight* this month features the terminal station on the Glasgow Central WEMYSS BAY line.

Situated on the shores of the Clyde between Castle Wemyss and Skelmorlie Castle, WEMYSS BAY is a centre for pleasure and other sailings to all the Clyde piers, while there is a regular Car Ferry service to Rothesay which carries an average of 1200 motor vehicles a month.

The station is well known for its floral displays, some 15 tubs, 33 hanging baskets, and 300 pot plants adding a riot of colour to a station which earned a special prize in the Best Kept Station competition and a 1st prize for floral display in 1956.

Last year WEMYSS BAY station booked 63,426 passengers, and handled over 19,000 tons of goods traffic. The pier traffic in 1956 amounted to over 17,000 tons inward and over 24,000 tons outward.

Our photo strip shows Station Master A. Macgregor, Station Foreman D. Gallacher, Booking Clerk J. MacMaster, and Porter R. Johnstone.

British Railways were responsible for a further regular source of shipping information in one of those locations which the student of the subject might not always consider. From 1950 until 1963, they published a series of regional magazines. That for the Scottish Region contains much that will appeal to the shipping lover and some examples will be seen in the rest of this volume. A regular-back page slot was devoted to 'Spotlight on ...'. In this case for May 1957, the spotlight was on Wemyss Bay. A BR Standard 4 2-6-4T is in the platform. The first two coaches would be recent construction BR Standard suburban stock. These all compartment coaches were out of date as they were built, but such a combination of steam and compartment coaches were not totally replaced by electrics on this run until mid-1967. This was a very late date for the transition from steam. The vessel in the background is one of the A.B.C. car ferries.

Opposite: Wemyss Bay as a community owes itself entirely to the railway having developed since the latter's arrival in 1865. The station is a spectacular symphony in metal, glass and stone. It is turn-of-the-century Tudor designed by James Miller in 1903-04. This shot shows the structure on 31 January 1987. A £1.5 million restoration was undertaken prior to 1994, the celebration of which produced its own awards, publicity and official postcards. Possibly it will never be so flower bedecked as it apparently was between the wars or when it earned a First Prize for floral display, but the structure should enjoy a long future yet as a key spot in the journey to Bute.

Every now and again, some spectacular event enables a special cruise to be justified. The Cowal Highland Games at Dunoon did that each year from 1894 on the last Friday and Saturday of August. The return of the QE2 in July 1990 was another excuse to justify cruises from Gourock. The rather humble and flimsy leaflet shown here marked the C.S.P.'s response to postwar Clydeside's most momentous occasion. The publicity may have been flimsy but the response was not. Two steamers were given special billing to see the Q4 (as she was prior to her naming; Q3 was an unfulfilled plan and Q1-2, were the pre-war Cunard Queens). Patrons were promised a grandstand view.

*Special Launch-day cruise

BE THERE – AT THE
LAUNCHING OF THE
Q4

Wednesday 20 September 67

View this historic launch from the deck of the Caledonian Steam Packet Co. vessels

P.S. Caledonia and
T.S. Duchess of Hamilton

SPECIAL LAUNCH DAY CRUISES
from : Millport, Largs, Rothesay, Dunoon and Gourock.
on the **T.S. "DUCHESS OF HAMILTON "**
and from **GLASGOW (Bridge Wharf Southside)** on the **P.S. "CALEDONIA"**

Both steamers will berth at the entrance to Rothesay Dock (beside John Brown's Shipyard). You are assured of an excellent view of this memorable occasion.

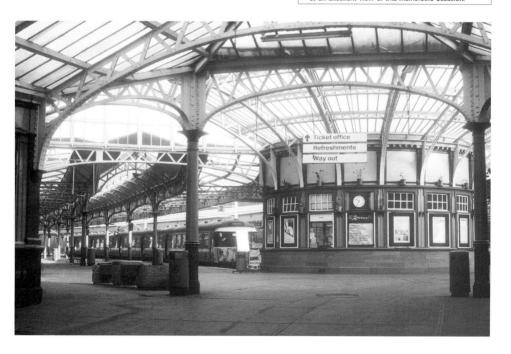

GLASGOW GARDEN FESTIVAL CRUISES

BY M.V. "KEPPEL"

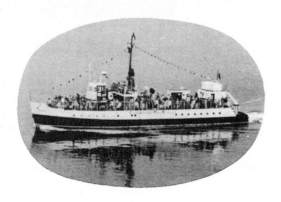

from

GOUROCK
KILCREGGAN
HELENSBURGH
GLASGOW

Another red-letter event on the Clyde was the 1988 Garden Festival and this prompted an interesting response from what was then Caledonian MacBrayne. It was a response with twofold roots back into the company's ancestry. Festivals at Glasgow were not new: the 1938 Empire Exhibition in Bellahouston Park had seen Caledonian Steam Packet put the *Leven* and the *Ashton* into service on cruises from Glasgow. They were small motor vessels not dissimiliar in size to the vessel Caledonian MacBrayne had to hand in 1988.

After the *Queen Mary* was withdrawn, *Glen Sannox* had assumed the cruising role until 1981. Her successor was the *Keppel*, a passenger ferry with less and less to do on her Largs-Millport run which she entirely gave up in 1986. *Keppel* ran a cruise programme until the end of the 1992 season, by which time she was the company's last all-passenger vessel. It was an obvious feature for the 1988 season to run cruises to the Garden Festival. They were scheduled at weekends only and their distinction was to bring passengers up river from Firth resorts like Kilcreggan and Helensburgh straight into a berth at the Garden Festival itself.

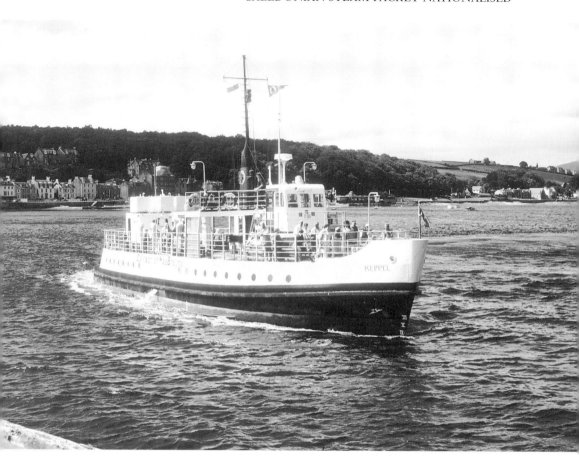

Keppel's core weekday programme was bounded by Millport, Tighnabruaich and the Gareloch, between which points she was a familiar sight at those piers still open. This view of her taken on 2 July 1990 has her about to berth at Rothesay. Small and somewhat slow, *Keppel* had an interesting pedigree. She had been built by White's of Southampton in 1961 with two sisters in order to modernise the railway-owned Tilbury-Gravesend ferry on the Thames. That run did not really need three vessels, and in 1967, Caledonian Steam Packet acquired *Keppel* to serve Millport.

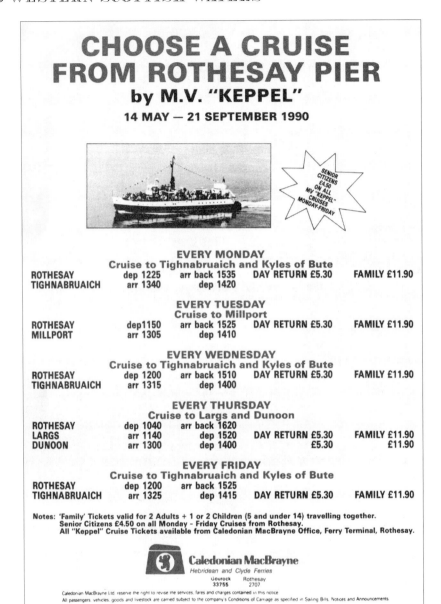

CHOOSE A CRUISE FROM ROTHESAY PIER
by M.V. "KEPPEL"
14 MAY — 21 SEPTEMBER 1990

SENIOR CITIZENS £4.50 ON ALL MV "KEPPEL" CRUISES MONDAY-FRIDAY

EVERY MONDAY
Cruise to Tighnabruaich and Kyles of Bute

ROTHESAY	dep 1225	arr back 1535	DAY RETURN £5.30	FAMILY £11.90
TIGHNABRUAICH	arr 1340	dep 1420		

EVERY TUESDAY
Cruise to Millport

ROTHESAY	dep1150	arr back 1525	DAY RETURN £5.30	FAMILY £11.90
MILLPORT	arr 1305	dep 1410		

EVERY WEDNESDAY
Cruise to Tighnabruaich and Kyles of Bute

ROTHESAY	dep 1200	arr back 1510	DAY RETURN £5.30	FAMILY £11.90
TIGHNABRUAICH	arr 1315	dep 1400		

EVERY THURSDAY
Cruise to Largs and Dunoon

ROTHESAY	dep 1040	arr back 1620		
LARGS	arr 1140	dep 1520	DAY RETURN £5.30	FAMILY £11.90
DUNOON	arr 1300	dep 1400	£5.30	£11.90

EVERY FRIDAY
Cruise to Tighnabruaich and Kyles of Bute

ROTHESAY	dep 1200	arr back 1525		
TIGHNABRUAICH	arr 1325	dep 1415	DAY RETURN £5.30	FAMILY £11.90

Notes: 'Family' Tickets valid for 2 Adults + 1 or 2 Children (5 and under 14) travelling together.
Senior Citizens £4.50 on all Monday - Friday Cruises from Rothesay.
All "Keppel" Cruise Tickets available from Caledonian MacBrayne Office, Ferry Terminal, Rothesay.

Caledonian MacBrayne
Hebridean and Clyde Ferries
Gourock Rothesay
33755 2707

Caledonian MacBrayne Ltd. reserve the right to revise the services, fares and charges contained in this notice
All passengers, vehicles, goods and livestock are carried subject to the company's Conditions of Carriage as specified in Sailing Bills, Notices and Announcements

Extensive publicity for *Keppel*'s cruises existed, most notably in a long-running series of 'Cruises & Crossings........' brochures that Caledonian MacBrayne produce for various ports throughout their empire. From that series, the Firth of Clyde title featured *Keppel*. She was on their covers in 1986 and 1987. In addition to the Garden Festival brochure, publicity solely dedicated to the *Keppel* cruises existed. Under the 'Choose a Cruise' theme, A5-sized handbills and larger A3 posters were produced for local distribution at the terminals she was using. This example is the Rothesay handbill of 1990. Over the years, the *Keppel* proved capable of handling 20-30,000 people a year on the cruise programme, which was not enough for indefinite viability.

9

CAR FERRY FOCUS

By looking at the *Keppel*, the account has nearly reached the present (2000), though her origins were firmly with British Railways and Caledonian Steam Packet. It is not the purpose of this volume to look closely at innovations of the Caledonian MacBrayne period. Since 1973, right up to the present day, a wide range of very fine publicity has existed, in addition to a standard issue series of un-illustrated timetable brochures available for the winter and summer seasons. For the last fifteen years or so, fully colour printed A4 brochures have been a strong sight on travel agents' shelves promoting the summer season programme across the length and breadth of Britain. Quite apart from their visual interest, the content has often had nuances appealing to the ship lover. *Keppel*'s programme was usually slotted in and during the 1990s the company's varied involvement in operations reaching to the Isle of Man, Rathlin Island and Ballycastle ensured something worth hunting for.

One example of the core issue from the post-1973 concern is shown in a typical mid-1970s product. By this time, full colour was in general use but larger lavish productions were in abeyance. What was immediately striking is that whilst in 1970, it was appropriate to use a withdrawn turbine steamer on a cover, by 1977, the image was completely up to date. Two stern-loading car ferries did the honours, each representing one half of the company. *Juno* or *Jupiter*, each a 1974 product, stood for the company's core car-ferry run from Gourock to Dunoon, whilst from the same year *Pioneer* was the new Islay ferry. Inside there was still room to show the *Columba*, *Queen Mary* and *Maid of the Loch*. In the sense that economy was the watchword, the timetables were provided by inserting the standard folders into a rear cover wallet.

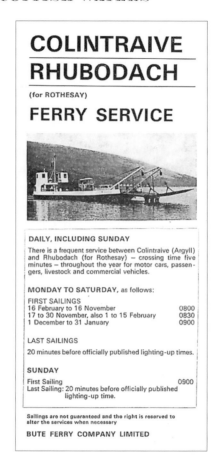

The last item has revealed that, by the mid-1970s, the car ferry was at the heart of the company's operations whether large or small. Gourock-Dunoon was the main line service of all, with large ferries running every half hour linking the Cowal Penninsula and its naval base, in addition to all its tourist attractions, to Gourock and thence Glasgow. How this had come to be, together with an examination of the growth of competition from the upstart Western Ferries on the company's front door, will be examined from here.

The first car-ferry route into Cowal did not operate from Gourock. The phrase 'back door route' has sometimes been applied to Western Scottish car-ferry routes. This means that sometimes operational reasons like provisions of terminal, or the benefits of short crossings might result in a crossing becoming established in an unlikely setting. The first car ferry within the Firth came into this category.

An idea for a simple car ferry across the Kyles of Bute between Colintraive on Cowal and Rhubodach on Bute had surfaced in 1939. It was 13 July 1950 before the Bute Ferry Company were able to inaugurate it. The service remained independent until Caledonian Steam Packet gained control at the start of 1970. The simple leaflet reproduced was current exactly a year later and was still marked Bute Ferry Company. Evidence of the takeover comes from the vessel illustrated. This was the newly rebuilt *Portree* which was transferred in during June 1970.

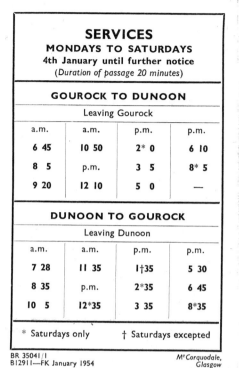

Caledonian Steam Packet really got to grips with car ferries as part of the 1951 million pound programme that produced the four Maids and the three A.B.C. vessels: *Arran*, *Bute* and *Cowal*. All were motor ships and the A.B.C.s were substantial side-loading car ferries intended to revolutionise getting to Dunoon, Brodick and Rothesay. The Denny-built *Arran* was first into service from 4 January 1954 on the Gourock-Dunoon run. This simple black on yellow timetable card owes its significance to marking the outset of this operation. Subsequently, many similar such pocket timetables were issued for the route, a process which continued in the 1990s.

Spotlight on Motor Vessel "Cowal"

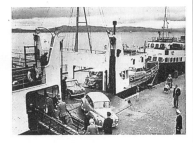

Launched at the Troon yard of the Ailsa Shipbuilding Company Limited in January 1954 the *Cowal* was the second of the dual purpose vessels to go into service on the Clyde. Specially designed for the conveyance of passengers, cargo, motor vehicles and cattle, the ship serves Dunoon and Rothesay from Gourock and Wemyss Bay.

The ship has accommodation for 650 passengers and 34 cars. In its original form the *Cowal* had space for only 26 cars but in 1959 alterations were made to the after-deck and increased the car capacity to 34.

The picture strip shows Captain A. Downie; Chief Engineer K. H. Drummond; Stewardess Miss M. Farrell, and Seaman A. MacKinnon.

It stands to reason that all sorts of attractive collectables appeared at the outset of the A.B.C. ships but that is now fifty-five years ago and nothing more from their outset is to hand with us. The Scottish Region magazine ran a small feature in their September 1962 issue which is of interest in showing the loading arrangements and a passenger-only Maid tied up behind. *Cowal* was available for use until 1978. *Arran* was the last in service in 1979. Thereafter she was involved in a sad saga of failed restaurant ship conversions culminating in her scrapping in Manchester in 1993. In this period, one of her owners was Eamonn Andrews.

Scottish Region News

Regional Editor, 179 Howard Street, Glasgow C1
Douglas 2900 Ext. 115

Launch of the Glen Sannox

In perfect weather Mrs James Ness, wife of our General Manager, performed the launching ceremony of the *Glen Sannox* at Troon on 30 April.

Accompanying Mrs Ness were Mr W. P. Allen, Manpower Adviser, B T C; Mr M. H. B Gilmour, Chief Solicitor and Legal Adviser, B T C; Sir Ian Bolton, Bt, Chairman, Scottish Area Board; Mr Peter Meldrum, Member; Mr G. W. Stewart, Assistant General Manager; Mr A. Stewart, General Manager, Caledonian Steam Packet Company, and a number of Regional Officers.

On arrival at Troon the party was met by Mr James Ritchie, Managing Director of the Ailsa Shipbuilding Co Ltd, the builders of the vessel.

At the foot of the stairs leading to the launching platform young Jimmy Crombie, an apprentice with the firm, presented Mrs Ness with a bouquet of pink roses and carnations.

When the *Glen Sannox* goes into service this summer she will make a notable addition to the British Railways fleet now operating on the Clyde.

This new general purpose vessel is similar in construction but considerably larger than the general purpose vessels at present maintaining the Gourock-Dunoon and Wemyss Bay-Rothesay services.

She will have accommodation for 1000 passengers as well as 40 cars and 40 tons of cargo. When cargo is not carried space will be available for an additional 20 cars.

The new vessel will provide an improved service to and from Arran.

Principal particulars:
Length 238 feet; *Breadth* 44 feet; *Draught* 7 feet, 4 inches.

The *Glen Sannox* is engined by two Sulzer two-stroke reversible marine engines developing 2420 b h p at about 372 r p m.

The service speed of the vessel is 17½ knots per hour.

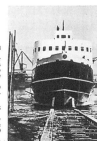

In the pictures on this page our photographer has caught the moment when the Glen Sannox enters the water for the first time, and a pleasant little ceremony carried out prior to the launching of the ship by Mrs James Ness when young Jimmy Crombie, apprentice with the Ailsa Shipbuilding Company, presents Mrs Ness with a bouquet of carnations and roses at the foot of the gangway leading to the launching platform. Other pictures on page 153.

c

The three A.B.C. ships were rather overtaken by the next car ferry. In the mid-1950s, traffic soared although the shipping services still made a loss. In 1955, the Clyde services carried four million people and 51,000 cars. The three A.B.C.s had no relief vessel on their routes. Matters were hectic and that year BR announced the order of a larger version. This ship would become the *Glen Sannox* (the third such) to take the lead on the Arran services. From start to finish over thirty years later, her owners were consistently proud of her. Her launch from the Ailsa yard at Troon on 30 April 1957 was worth a full-page spread in the Scottish Region magazine for June 1957.

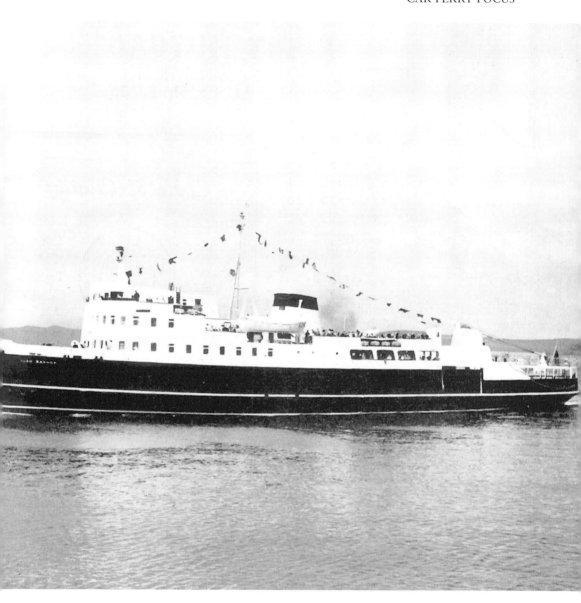

She continued to gain attention in the regional magazine. The June 1958 issue gave her the cover and a feature inside. This quoted the modernisation programme cost for the Clyde fleet at £2 million, a nice doubling from the original 1951 estimate. The *Glen Sannox* contributed £468,000 of that. Her appearance with a Caledonian Steam Packet company houseflag on her bows was part of the deliberate 1957 revival of the public face of the old company. As a result of her arrival, passenger traffic to Arran grew by more than 12 per cent in a year, and the numbers of vehicles taken doubled in the same time to 6,160. The cover image reproduced here showed her dressed overall for the inaugural sailing of 29 June 1957 from Ardrossan to Brodick.

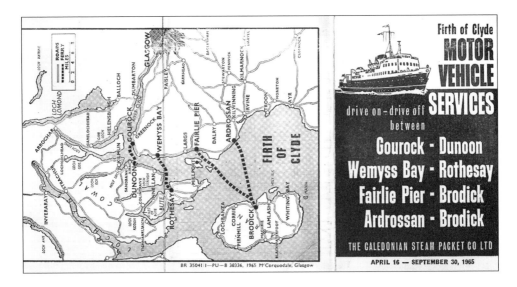

Firth of Clyde
MOTOR VEHICLE SERVICES
drive on – drive off

between

Gourock - Dunoon
Wemyss Bay - Rothesay
Fairlie Pier - Brodick
Ardrossan - Brodick

THE CALEDONIAN STEAM PACKET CO LTD

APRIL 16 — SEPTEMBER 30, 1965

Glen Sannox was never far from the limelight. Her use on the cover of the C.S.P. master timetable has been seen. During the 1960s, the Clyde car ferry pocket timetable had an illustrated cover. These included photos of the *Glen Sannox* and an A.B.C. ship. In 1965, it was a drawing of the *Glen Sannox*. The simple route map made the location of the four routes then in operation very clear.

Opposite: The swinging sixties were even reflected by the covers of this humble piece. The era managed to make an impact on the marketing of the *Maid of the Loch* too (more in the next chapter) and the company had a brief vogue for hostesses. Internally, a noteworthy feature was that, if you wanted to get a car to Millport that winter of 1968, you only had one bite at the cherry with a 1.35 p.m. sailing from Wemyss Bay three days a week. Cumbrae badly needed the radical changes that a car ferry from Largs soon brought.

CAST OFF.
ON THE CLYDE
CAR FERRY SERVICES
1 October 68 to 3 April 69

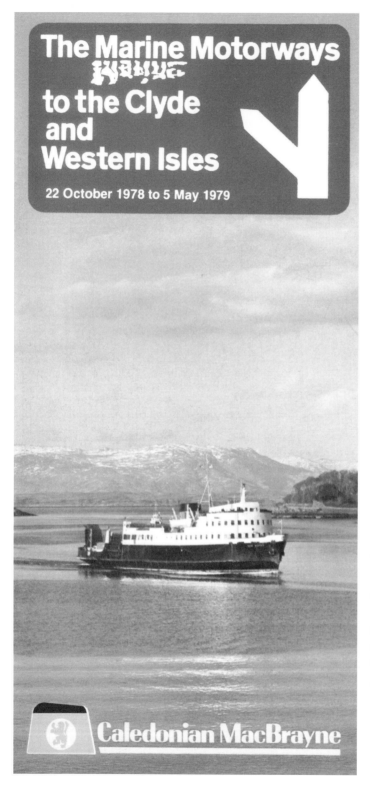

The Marine Motorways
to the Clyde
and
Western Isles

22 October 1978 to 5 May 1979

Caledonian MacBrayne

After twenty years car carrying, there was new blood in the fleet. The *Glen Sannox* was turned into a cruise ship for the 1978 season to replace *Queen Mary*. Her open rear car deck gained awnings and plastic chairs for the view. In the next four seasons, her carryings were roughly 30,000 people each season and she lost three times as much money as she earnt. Out of season, she found ready employment as a relief vessel and even became a regular sight working out of Oban. Indicating this, a wintry image bedecked the company's timetable for the winter of 1978 complete with snowcapped mountain backdrop. This use sustained the ship until her final demise when sold in 1990 (a 1989 cruise is shown on p.15 of the colour section). She then went off to the Mediterranean.

10
LOCH LOMOND

One cause célèbre has hardly been mentioned so far and it is well worth some space. The isolated sailings on Loch Lomond have attracted much debate in West of Scotland newspapers over the decades and a vast amount of publicity has been produced along the way.

The situation British Railways inherited on the loch was not healthy. Steamer services had commenced in 1817, obviously with no railway involvement. That came in 1888 in the shape of North British ownership, which changed again in 1896 when the loch steamers and accompanying railway line from Dumbarton to Balloch Pier became a joint entity between the North British and the Caledonian. In 1948, therefore, BR inherited a joint operation from the LNER and the LMS. They also inherited two paddlers, the 1899 *Princess May* and the 1911 *Prince Edward* operating what, since 1933, had been a summer-only service.

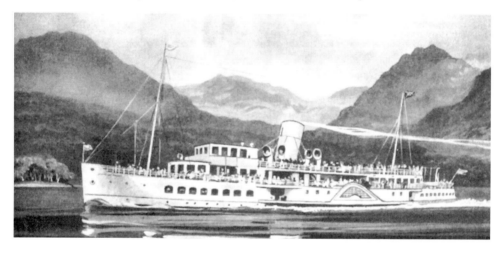

The solution adopted was dramatic. Between 1950 and 1953, Inglis at Pointhouse created Britain's (and Europe's) last paddle steamer of any size to be built. Despite steam propulsion, the amount of aluminium in her superstructure would not have disgraced a jet airliner. *Maid of the Loch* was far larger than anything previously on the loch, having a passenger complement of 1,000, and would not have been out of place in the Firth. She became Britain's largest inland steamer ever.

The *Maid* was a beauty and quickly won the hearts and minds of loch enthusiasts. Her physical attractions ('Too Buxom a Maid?' being a phrase once coined) have ever since blinded her admirers to another of her characteristics. She was far too large for the traffic on offer and for most of her life has been an economic white elephant. Accordingly, a great effort has had to go into selling her wares (shown is the cover illustration of the leaflet, *c.* 1960). The essence of her business was to use the rail link to tap into the Clydeside market and to make the *Maid* a core component of the 'Circular' tours that the railway operated. No tourist would escape the notion that a Scottish visit was incomplete without a sail on Loch Lomond.

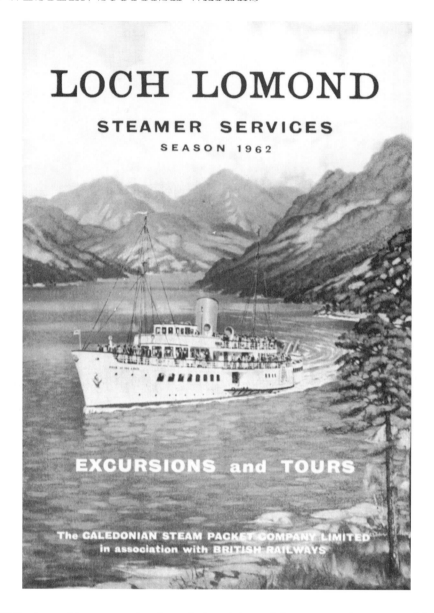

By 1962, the problems were already surfacing. A loss of £61,000 was being carried by the service in 1961. Beeching, in 1963, slated the service for withdrawal which provoked an outcry and the result was a renewed drive in the mid-1960s. Provision of full-colour-artist-originated covers on the brochure took place, as in this 1962 example of the brochure. The ship is positively swelling with passengers. The reality of the numbers game was different. In the pre-BR heyday, up to half a million people had been carried on the Loch Lomond vessels in a year. The *Maid*'s carryings yawed alarmingly. In 1952, before she started, the figure was 125,000. At one time in the 1960s, it was pushed up to 192,000; 1974 was a nadir at 89,000 and 1975 swung back to 126,000. 126,000 is 126 days at her full capacity; play with these figures and it is evident that she was simply too large for the traffic on offer.

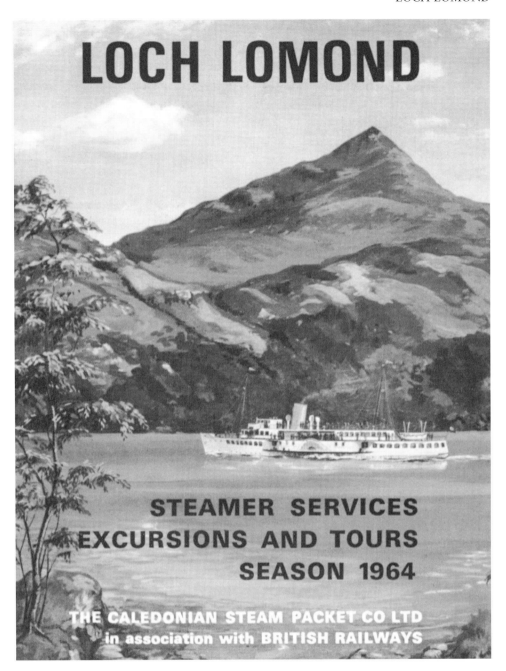

The incentive not to admit defeat with the *Maid* certainly resulted in great efforts with the publicity. In 1963, the brochure used a colour transparency on the cover for the first time. In 1964, it was back to another painting. In 1965, there were actually two covers in the year corporate image appeared. The first issue (with all the new logos) simply used a monochrome image of the vessel. Later that season, a hostess appeared on board entitled *Maid of the Loch* and a new cover featuring the good lady inside a lifebelt appeared.

Spotlight on Balloch

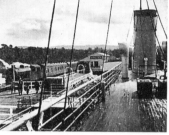

BALLOCH PIER station is the starting point for the British Railways steamer service on Loch Lomond.

Known the world over in song and poetry, beautiful Loch Lomond and the steamer service provide relaxation and inspiration to thousands of visitors from every part of the world during the summer season which commences in May and terminates in September.

Within nineteen miles of Glasgow, BALLOCH has a good service of trains from Glasgow Central and Queen Street stations which carry during the season 250,000 passengers, 200,000 of which use the steamer service.

There are two stations at BALLOCH, the " Pier " and the " Central ", and apart from passenger traffic at the former, BALLOCH CENTRAL station is the goods accountancy centre and railhead for six stations in the area. Some 40,000 parcels are dealt with annually for the Loch Lomond and Leven Valley area, while 25,000 goods consignments are handled.

The local industries include textiles, hosiery, silk, and cotton and wool dyeing.

Our photo-strip shows Mr. W. Patterson, Station Master, Mr. D. Ferguson, Station Foreman, Mr. D. McLay, Goods Clerk, and Mr. J. Britton, Porter.

In June 1957, the Scottish Region magazine ran one of its Spotlight series on Balloch. The image was taken from the *Maid*'s deck and the quoted figure (rounded up?) of 200,000 people using her must have represented the mid-1950s maxima. With the Blue Train electrics coming to the pier in 1960, a new sense of hope was engendered. A number of images conjoining electrics and steamer existed. These included a favourite on the inside cover of the annual brochure, and a dedicated 'Blue Trains Services to the Clyde Coast via Craigendoran and Loch Lomond Steamer Services' leaflet issued over several seasons.

The service to the pier was maintained to the end of the *Maid*'s sailings in 1981. Indeed it continued until 29 September 1986 in conjunction with her successor. Since then, the Balloch Central station has been relocated across the road and a restored service to the pier seems unlikely.

Opposite: One of the stalwarts of the Circular Tour programme was the '3 – Lochs' itinerary. In 1966, its promotion still used a handbill which had this maroon on white cover. The idea was that you took a Blue Train to Craigendoran, thence a sail in *Waverley* on Lochs Goil and Long to Arrochar at lunchtime. You then had an hour and ten minutes to yourself during which the passenger had to negotiate the two-mile isthmus between Arrochar and Tarbet piers (ignoring the eponymous West Highland station in between). Then the *Maid* transported you for an hour and a half on Loch Lomond whence an electric took you home from Balloch Pier. What brought about the demise of this was the closure of Arrochar's pier in September 1972.

A popular and interesting
DAY CIRCULAR TOUR
to the

3-LOCHS

LOCH LONG, LOCH GOIL
AND LOCH LOMOND

TOUR No. 5

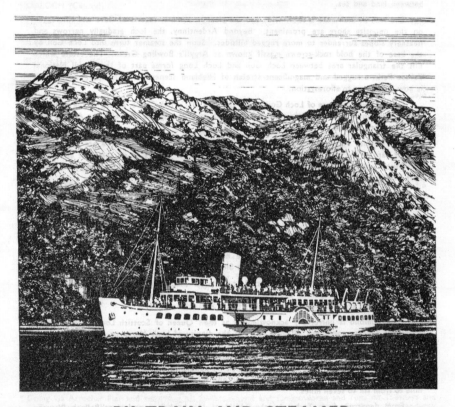

BY TRAIN AND STEAMER

Season 1963

BRITISH RAILWAYS

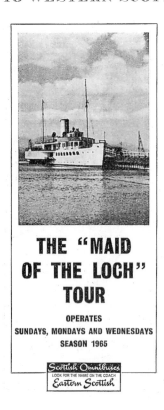

THE "MAID OF THE LOCH" TOUR

OPERATES
SUNDAYS, MONDAYS AND WEDNESDAYS
SEASON 1965

Scottish Omnibuses
LOOK FOR THE NAME ON THE COACH
Eastern Scottish

The *Maid*'s owners wanted passengers from any quarter and a motor coach was as much an opportunity as a train (or a car), especially those operators whose tours were marketed to visitors from further afield. Tours out of Edinburgh were one such target and this leaflet featuring the *Maid* at Balloch Pier was the product of the ambivalently named but very influential Eastern Scottish/ Scottish Omnibuses in 1965. The key aspects were the use of high specification coaches, a full sail to the Head of the Loch using the 2.30 p.m. sailing which did not return to Balloch until 6.45 p.m., and promotion that took this humble leaflet as far as London. Over the years, the *Maid* was to feature in many coach tour operators' programmes and they represent a source the enthusiast should not forget. This black on pink example helpfully gave a print run of 20,000, of which would it be fortunate if 1 per cent – or 200 – survive forty-five years later.

In 1966-67, hostesses dominated the covers of the *Maid*'s literature as a marketing drive in the mood of the Swinging Sixties was pushed along. They were not the only manifestation of that era on board. Music had not been far from the steamers of old, nor is it alien aboard the *Waverley* today.

The concept that a boat could become a club venue seemed a bright idea; some decades later MV *Caledonian Princess* took this role on full time. In 1967, the offering was a two-hour evening cruise hosted by Archie McCulloch and a top-class cabaret. Figures carried certainly soared but the boat still did not make money. The Showboat cruises were thereafter established in the programme. Meantime, the annual leaflet commenced a long run as an individual colour leaflet for the *Maid*.

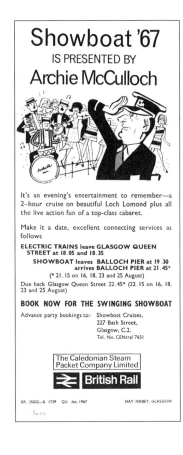

Showboat '67

IS PRESENTED BY

Archie McCulloch

It's an evening's entertainment to remember—a 2-hour cruise on beautiful Loch Lomond plus all the live action fun of a top-class cabaret.

Make it a date, excellent connecting services as follows

ELECTRIC TRAINS leave GLASGOW QUEEN STREET at 18.05 and 18.35

**SHOWBOAT leaves BALLOCH PIER at 19.30
arrives BALLOCH PIER at 21.45***
(* 21.15 on 16, 18, 23 and 25 August)
Due back Glasgow Queen Street 22.45* (22.15 on 16, 18, 23 and 25 August)

BOOK NOW FOR THE SWINGING SHOWBOAT

Advance party bookings to: Showboat Cruises,
227 Bath Street,
Glasgow, C.2.
Tel. No. CENtral 7651

The Caledonian Steam
Packet Company Limited
British Rail

BR. 35022—B. 1739 QU Jan. 1967 HAY NISBET, GLASGOW

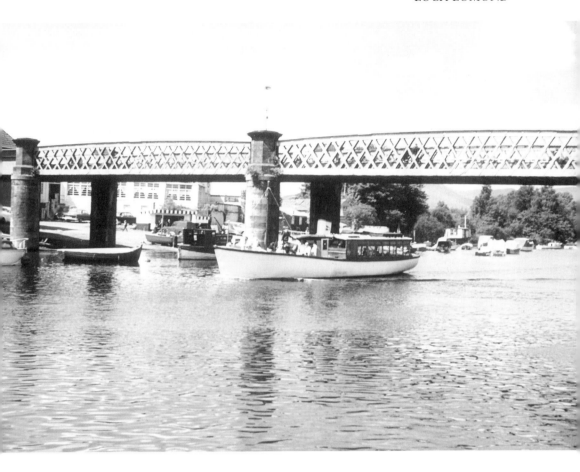

The *Maid* faced a detail of geography at Balloch that acted against her. True, the trains went to her side, but this was half a mile north of the centre of the community. In a road vehicle, the access to the Pier often resembled a pitted track. Many visitors came to Balloch's heart; they saw at the bridge the glistening waters of the River Leven dotted with boats and no sign of the *Maid*. Instead, the illustration shows what increasingly from the 1960s onward became a potent threat to the *Maid*. Much more economical passenger launches of various operators ran from the centre of Balloch. Certainly they did not go all the way up the loch, generally making for the islands, but for many visitors, that taster of the loch was all that was needed. Over the years, this competition became more and more effective. This was especially true in 1974 with the introduction of two new purpose-built cruisers called the *Lomond Princess* and *Lomond Duchess*. Colour leaflets were produced for this pair. The wooden vessel in the picture is rather more dated and was operating around 1969.

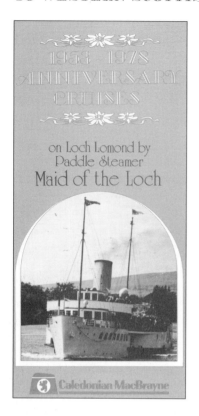

By the *Maid*'s 25th birthday in 1978, the competition was well established. The *Maid* was now surviving only with substantial grant aid from Strathclyde Regional Council given since 1976. In the 1978 season, she became the last steamer in what was now the Caledonian MacBrayne fleet. Despite her losses, consultants suggested ways in which to improve her operation which were taken up and her passenger figures grew again. Half a million pounds was found to renovate four of the piers such that in 1979 calls recommenced at Luss, never before used by the *Maid*.

When this Silver Jubilee anniversary leaflet was published with its silver finish like the previous year's *Queen Mary* programme, it came out in optimistic vein. In another parallel to the other steamer, *Maid of the Loch* became the subject of an eponymous company published booklet issued in 1979.

Only two years later and it was all over, bar the shouting, and that has gone on ever since. She lost more than £73,000 in 1981 and Strathclyde were not prepared to underwrite that. The *Maid* last sailed on 30 August 1981. Caledonian MacBrayne were subsequently very lucky for they managed to sell her to the Alloa Brewery in early 1982. The story since has been a complex tale involving a sequence of owners and at times some renovation of the lady. The constant is that she has not steamed again and instead another vessel became involved in working the service through the 1980s. This is the cover of the timetable for the first season (1982) of Alloa Brewery's use of *Countess Fiona* on the loch. *Countess Fiona* was none other than the erstwhile *Countess of Breadalbane* built for C.S.P. in 1936. She had been out of their fleet since 1971 and proved more appropriate in size for the traffic Loch Lomond had to offer.

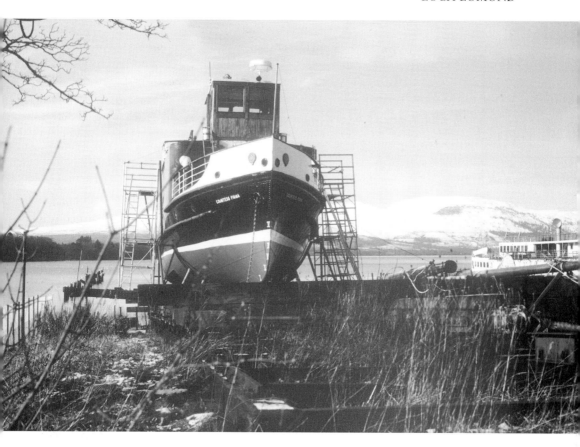

A run of eight annual Alloa Brewery leaflets followed. The last was issued in 1989. That turned out to be the final year in which lengthy sails of the loch operated and the last in which either the *Countess Fiona* or the *Maid* worked. Ever since then they have both been laid up at Balloch Pier and the other private operators have reaped the reward. Despite their lay up, the two vessels have continued to stimulate collectable publicity in the continuing proposals to revive them. A colour piece from the next owners *Maid of the Loch* Limited even promised a new 350-seat catamaran *Lady of the Loch* from Australia to arrive in 1989. The picture chosen shows *Countess Fiona* on the Balloch Slip with the *Maid* tied up in the background on 26 February 1989.

Countess Fiona rotted on the slip for many years awaiting the repairs that never came. In controversial circumstances she was scrapped *in situ* in 1999. The years since 2000 have been happier for the *Maid*. Thanks to lottery money, the vessel has been much refurbished and now functions as a restaurant ship. Those in charge are determined she will steam again. The Loch Lomond Steamship Company, who operate her, maintain a comprehensive website which details the recent story: http://www.maidoftheloch.co.uk. The lottery interest has included the restoration of the slipway and, on 27 June 2006, the *Maid* went out and back into the water for the first time in over a quarter of a century.

B. 10919

TROSSACHS, LOCH KATRINE and LOCH LOMOND

CIRCULAR TOURS

AND

EXCURSIONS

TRAIN — MOTOR — STEAMER

MAY TO SEPTEMBER, 1953

STRONACHLACHAR, LOCH KATRINE

EDWARD LAWSON

Opposite: Closely associated for many years with the Loch Lomond sailings was another isolated loch and its steamer. There, at least, the story happily continues to this day. The loch is Loch Katrine in the Trossachs and the steamer is Denny's 1900-built SS *Sir Walter Scott*. Add in the Rob Roy connection and a galaxy of Scottish icons revolve around Loch Katrine, not to mention Glasgow's water supply, which latter has directly resulted in the steamer's longevity.

From 1859, the City of Glasgow controlled Loch Katrine for water supply but steamers were active before then. *Sir Walter Scott* was built for private owners but came to be owned by the city and thence a succession of water authorities after 1969. Due to the tight controls on pollution, her continued operation using smokeless fuel is attractive. These controls have prevented competition. The result for publicity has been strange and a complete contrast to the effort required over the hill on Loch Lomond.

In-house publicity sat on a captive market, but another category did produce more attractive material. The loch was involved in railway-promoted Circular Tours which even commissioned artwork involving this non-railway steamer (a 1957 BR leaflet is shown on p.118). The example shown here is the cover for the handbill of the Trossachs group of BR tours in 1953. These were traditionally numbered as Tour 1 and its subsidiaries 1A-C. That role at the start of the Circular Tour programme has its own message for the iconographic significance of the area. So too does the provision of an Edward Lawson signed cover (green on white) showing a view that has hardly changed since, in which the steamer is rather insignificant in the face of the magnificence of the natural surrounds. A different signed cover was being used on this handbill in 1966, which must have been the final year of its issue in that format.

Stronachlachar was hardly anything more than the pier, hotel and a post office but from there the minor road went through to Inversnaid on Loch Lomond and that was the crucial link in so many tours. For many years, this enabled a bus company to make a living entitled Loch Lomond – Loch Katrine Services Ltd. The route had once used horse-drawn vehicles and before that the visitors were put on ponies for the transit.

SUMMER, 1954

TIME-TABLE OF
SAILINGS ON LOCH KATRINE
BY
S.S. "SIR WALTER SCOTT"

	Trossachs Tour		Evening Cruise
	1st June to 10th September	14th May to 30th Sept.	13th June to 29th August
	Daily (except Saturdays & Sundays)	Daily (incl. Saturdays & Sundays)	Tuesdays, Wednesdays, Thursdays and Sundays only
Leave Trossachs Pier	11.00 a.m.	2.30 p.m.	6.00 p.m.
Arrive Stronachlachar	11.45 a.m.	3.15 p.m.	—
Leave do.	12 noon	3.30 p.m.	—
Arrive Trossachs Pier	12.45 p.m.	4.15 p.m.	7.00 p.m.

		Trossachs Tour		Evening Cruise
		Single	Return	
Fares :	Adults	3/-	4/-	2/6
	Juveniles	1/6	2/-	1/3
	Cycles	1/-		

Bookings for parties to be made to—
Messrs. J. & W. McMichael, Main Street, Callander
Telephone, Callander 14

Catering facilities are available at the
TROSSACHS TEA ROOMS
adjoining the Trossachs Pier. (Bookings to The Manageress, Trossachs Tea Rooms, by Callander—Telephone, Trossachs 35)
W6207

With no competition and with such a location, the owners of *Sir Walter Scott* enjoyed coachloads of visitors, who were sold the visit through other operators' publicity and hardly needed to invest in publicity. Only with the need to directly sell to families who would drive to Trossachs Pier in the family saloon was there a requirement to market the operation more aggressively. Between 1953 and 1980, the publicity that the vessel's owners produced was essentially a simple one-sided text handbill. Year after year, they looked almost identical to this 1954 example which initiated the vignette still used in 1980. One-sided A5-sized handbills with a bit more in the way of visual impact were used through to 1991, when things finally changed: the 1993 (or 1992?) issue was the first in a series of typically varied modern colour leaflets.

Faced with such a popular operation, yet one whose publicity might almost be called boring, one is reminded of another source. This is the guidebook independent of the tour operator. One from the early days of steamers was Anderson's *Guide to the Highlands and Islands of Scotland*. Published by A&C Black, it was in its third edition by 1850 and for serious work on early tourism and steamer services it is invaluable. Little snippits contained within reveal that Balloch Bridge was once a suspension bridge and some space is also given to the Loch Lomond steamers. The guide advised that 'There is now a small steamer on Loch Catrine and a keen competition in coaching is kept up to and from Stirling.'

11

THEY ALSO SERVED THE CLYDE

Consideration of Loch Katrine has introduced one of the smaller non-railway-financed steamer services easily accessible from Glasgow. Despite the big operators, other concerns have been around with fluctuating fortunes. One example of a new operator in the 1970s had definite links to the old establishment.

Earlier, the pull-out of Caledonian Steam Packet from the major resort of Ayr and the 1973 withdrawal of PS *Waverley* (see colour section p.16) have been examined. The story went on to a most unusual conclusion that would link port and ship in a manner they had not previously had. *Waverley* had never under its previous owners regularly served Ayr.

During 1974, *Waverley* was laid up but on 8 August 1974, she became for a £1 the property of *Waverley* Steam Navigation Company, an offshoot of the Paddle Steamer Preservation Society. On 10 May 1975, she steamed again. A cruise programme was announced centred on Glasgow and Ayr to avoid competing with her previous owners. Initial seasons had their moments but in general *Waverley* has never looked back and in high summer remains a feature of the Clyde scene. At other times of the year, she works the coasts and resorts around Britain.

A file could fill purely with *Waverley* material. Our sample reflects a run of leaflets produced by the Largs Tourist Office. As its cover suggests, these can often contain something for the steamer enthusiast since the cover and much of the interior was given to the detail of the two itineraries competing for the attention of tourists at Largs in August 1976. Despite the intention that *Waverley* and *Queen Mary* should not compete, at Largs, competition was real. During that week, eight cruises by *Queen Mary* and four by *Waverley* were scheduled in.

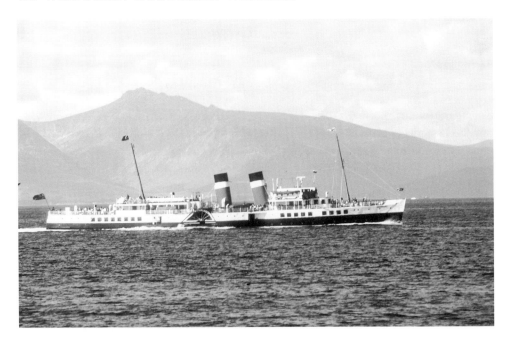

Even though a new millenium has dawned, it is still possible to take views of a paddler with classic Western Scottish backdrops. It will be *Waverley* and her supporters alone that will enable this to happen, unless the *Maid of the Loch* is revived. This shot, taken on 18 July 1987, saw *Waverley* off Portencross Point with the peaks of Arran behind as she was on a morning run from Ayr to Largs.

Opposite: Waverley is the only vessel remaining on the Firth with such a pedigree of steam, paddles and railway origins. From this account, it will have been evident that any remaining vessels of Denny of Dumbarton pedigree would also be noteworthy. One is still regularly plying the Firth and, despite her smaller size, she is an effective monument to the Denny tradition. *The Second Snark* introduces the Clyde Marine Motoring Company. Their annual leaflets are a regular feature in the Largs Tourist Office and elsewhere.

The company was already established when, in 1964, they became more prominent with the new vessel *Rover*. In 1969, *The Second Snark* was purchased and their cruise programme in the Upper Firth has gradually grown ever since. The vessel was built in 1936 as the 'yard boat' providing a tender function in the Dumbarton area for the company. Her finish was usually of the best, a tradition that her current owners maintain, as seen in this view of her at Gourock on 29 January 1987 waiting to take a service to Kilcreggan. That run, while still in the Caledonian MacBrayne timetable, has for many years been performed for the most part by Clyde Marine Motoring vessels. The MV *Kenilworth* is often used which is a revival of an old North British name with Walter Scott associations.

The student of popular culture, for which we have some sensitivity, will realise that Gregor Fisher, whether in the guise of Para Handy or as the Govan archetype Rab C. Nesbitt has come to recent prominence. The script for the latter in 1998 even saw a trip 'doon the watter' for the Nesbitt entourage to Millport Pier aboard *The Second Snark*.

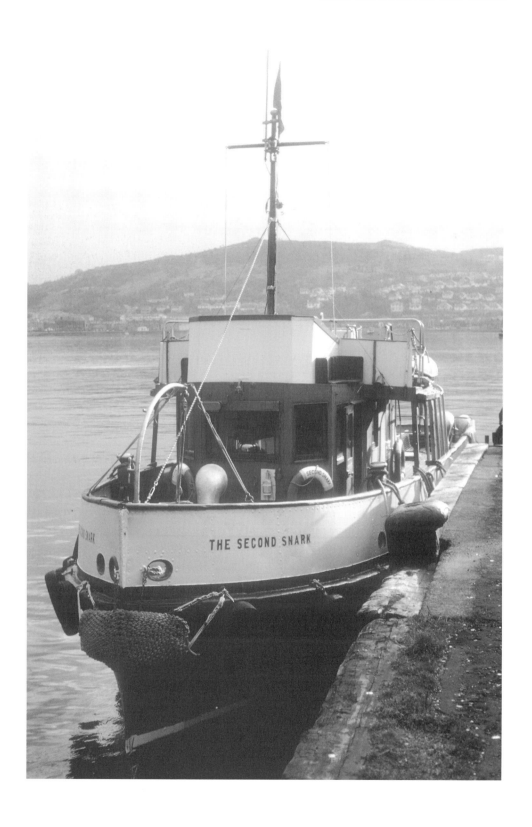

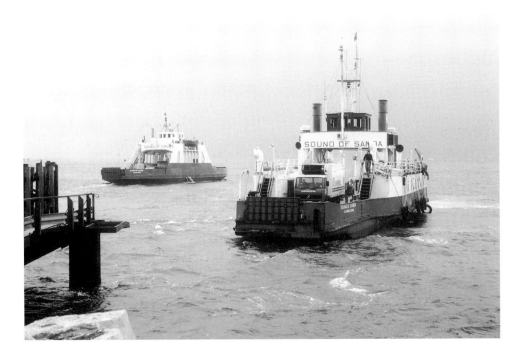

A while back, mention was made of competition on Caledonian MacBrayne's key crossing to Dunoon. The company involved was Western Ferries already encountered beyond Kintyre. On the Clyde, their activities commenced in 1973 with a new service from McInroy's Point, Gourock, to Hunter's Quay, Dunoon. This has been maintained ever since, at times with a fifteen minute frequency. The service has always used secondhand car ferries of Scandinavian, Dutch or British Railways origins. It has proved very popular as a no frills operation and with the terminal on the coast road it requires the minimum of publicity. Small A7-sized timetable cards, often undated, provide a poor souvenir, certainly nothing to compare with some of their exotica from beyond Kintyre.

For the enthusiast, the distinctively different vessels with their red hulls to contrast with Caledonian MacBraynes black are compensation. For a long time, the interest was focused on the two former British Railways vessels in the fleet.

In this view at McInroy's Point on a foggy 19 October 1988, two of the fleet are jostling by the linkspan and a Caledonian MacBrayne vessel is just discernible in the murk to the right of *Sound of Sanda*. A newer ferry now carries that name but the vessel current in 1988 had been built as MV *Lymington* in 1938 by Denny for the Southern Railway's Isle of Wight services. She was a British pioneer of Voith-Schneider propulsion making her exceedingly handy. When redundant with British Railways, she was sold in 1974 to Western Ferries and gave them a further twenty or so years of service. The *Sound of Shuna* to her left had been built in 1962 for Swedish service and was one of the first vessels bought for this run.

Although very uncommon, it is actually possible to find Western Ferries handbills from 1985-86 advertising Clyde cruises aboard the *Sound of Sanda*. These were run on summer evenings and in shades of Caledonian MacBrayne Showboats advertised music. Was it dancing on the car deck during a perambulation of Loch Goil?

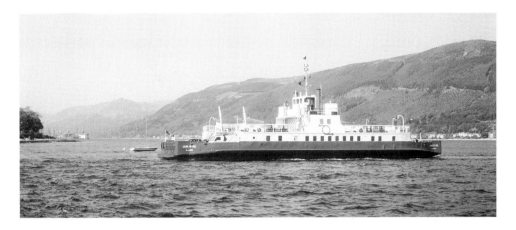

In 1986, another former Isle of Wight ferry arrived for Western Ferries' use. This time, it had started life in 1959 at Ailsa's of Troon as the MV *Freshwater* for BR. In this view, it is off Hunter's Quay on 24 May 1987 having become the *Sound of Seil*. The Holy Loch is in the background which then still maintained a United States Navy base. This ferry was sold for scrap in 1997.

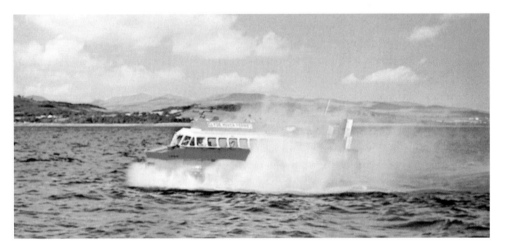

The final vessel certainly does represent exotica. Any publicity surviving for this would be a catch. What is illustrated is a postcard. Hovercraft services have never really proved suitable for the waters of Western Scotland. Two serious attempts were made. The first, shown here, was by Clyde Hover Ferries Ltd associated with the owners of the Dickie yard at Tarbert. Two Westland SRN6 craft were obtained in 1965 and a variety of services in that season operated. Their 64-knot maximum speed was dramatic, and even the newest generation of high-speed ferries seen at Stranraer or Troon on the Irish sailings do not begin to approach this.

Another attempt at the technology was made by Caledonian Steam Packet themselves. During the 1970 season, they had use of a Hovermarine HM-2 craft, but although used in passenger service, it did not progress beyond an experiment. Once again, the thought of C.S.P. Hovercraft literature excites the hunter instinct.

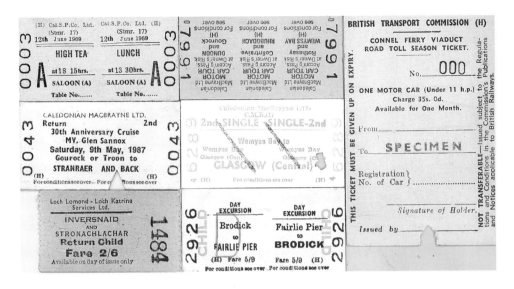

The round of what can be achieved by combining an interest in the shipping and railways of Western Scottish Waters with what the ordinary enthusiast can cover by seeking out their publicity materials is almost over. Posters, postcards, guidebooks, the huge array of flimsy leaflets and handbills can do much to remind one of what has been. One significant area of such small collectables has not been mentioned and is worth the concluding glance.

Collecting tickets has long been recognised as its own hobby, having in the Transport Ticket Society an effective umbrella operation, whose members are often offered amazing assortments of past gems squirrelled from diverse locations.

Just a few examples are shown here to represent yet more collecting possibilities. One irony is that a ticket can often retain more monetary value than the visually more attractive and informative leaflet.

The examples shown are mainly Edmondson cards. These were a design of ticket made popular by the nineteenth-century railway and which were then naturally adopted on the Clyde. So attached were Caledonian MacBrayne to these that they continued to be used into 1989, after their use was abandoned by BR. Since some of the issues included tickets sold for railway journeys like Gourock to Glasgow but bought on board, these took the Edmondson card ticket's use on the national network virtually to its conclusion. One such is shown. Thereafter, like almost everywhere else, computer-based ticketing finally made its appearance at Caledonian MacBrayne.

Two exceptions include a bus ticket for the Loch Katrine to Loch Lomond link and a season ticket intended for car owners using the Connel Ferry Viaduct in the days of its combined road and rail use. The latter may seem a dull piece of card but it neatly brings all three modes of road, rail and water transport together, at a point where the ingenuity of man and the drama of nature combined to produce what remains one of the classic settings in Western Scottish Waters.

BIBLIOGRAPHY

The following is a select bibliography of material consulted in preparing this volume (in addition to that illustrated in the text):

Anderson, George and Peter	*Guide to the Highlands and Islands of Scotland*, Adam & Charles Black, Edinburgh, 1850.
Anon.	'Lomondwise', *Scottish Field*, July 1961, Glasgow.
Biggar, Joan	'Ardrossan – The Bunker Port', *The Scots Magazine*, January 1998, Dundee.
Brackenbury, Mark	*Scottish West Coast Pilot*, Stanford Maritime, London, 1981.
Brown, Alan	*Lymington: The Sound of Success*, Allan T. Condie Publications, Nuneaton, 1988.
Brown, R. L. and McKendrick, J.	*Cruising on the Clyde*, *Waverley* Steam Navigation Company, Glasgow, 1985.
Bruce, J. Graeme	'The Railways and Loch Lomond', *Backtrack*, July 1996, Penryn.
Charnley, Bob	*Over to Skye... Before the Bridge*, Clan Books, Doune, 1995.
Davies, Kenneth	*The Clyde Passenger Steamers*, Kyle Publications, Ayr, 1980.
Downie, R. Angus	*The Islands of the Clyde*, The Melven Press, Perth, 1982.
Duckworth, C. L. D. and Langmuir, G. E.	*Clyde River and Other Steamers*, Brown, Son & Ferguson, Glasgow, 3rd edition 1972.
Duckworth, C. L. D. and Langmuir, G. E.	*West Highland Steamers*, Brown, Son & Ferguson, Glasgow, 4th edition 1987.
Gunning, A.	*Ailsa Craig: A Milestone in the Clyde*, Glasgow Museums & Art Galleries, Glasgow, 1985.
Haws, Duncan	*Merchant Fleets: Britain's Railway Steamers*, TCL Publications, Hereford, 1994.
Hodgson, F. M.	*West Coast of Scotland Pilot*, Lords Commissioners of the Admiralty, London, 1958.
Hope-Moncrieff, A. R.	*Black's Guide to The Trossachs*, Adam & Charles Black, London, 1903.
McCrorie, Ian	*Clyde Pleasure Steamers*, Orr, Pollock & Co., Greenock, 1986.
McCrorie, Ian	*Steamers of the Highlands and Islands*, Orr, Pollock & Co., Greenock, 1987.
McGowan, Douglas	*Waverley*, Clyde and Bonnie (Publishers) Ltd, Kilchattan Bay, 1984.

MacGregor, Iain	*MacBraynes for the Highlands*, Turntable Publications, Sheffield, 1977.
McGregor, John A.	*All Stations to Mallaig*, D. Bradford Barton, Truro, 1982.
MacHaffie, Fraser G.	*Waverley*, Waverley Steam Navigation Company, Glasgow, 1980.
McKean, Charles	*The Scottish Thirties*, Scottish Academic Press, Edinburgh, 1987.
Mais, S. P. B.	*Isles of the Island*, Putnam, London, 1934.
Orr, Richard	*Queen Mary*, Caledonian MacBrayne Ltd, Gourock, 1976.
Osborne, Brian D.	*The Ingenious Mr Bell*, Argyll Publishing, Glendaruel, 1995.
Osborne, Brian D., Quinn, Iain and Robertson, Donald	*Glasgow's River*, Lindsay Publications, Glasgow, 1996.
Paterson, Alan J. S.	*The Victorian Summer of the Clyde Steamers (1864-1888)*, David & Charles, Newton Abbot, 1972.
Post Office Vehicle Club	*The Postbus Handbook*, British Bus Publishing, Wellington, 1998.
Preston, Robert	*Days at the Coast*, Richard Stenlake, Ochiltree, 1994.
Ransom, P. J. G.	*Scottish Steam Today*, Richard Drew, Glasgow, 1989.
Sanderson, Margaret H. B.	*The Scottish Railway Story*, HMSO, Edinburgh, 1992.
Somerville, Cameron	*Colour on the Clyde*, Bute Newspapers Ltd, Rothesay, 1970.
Storrie, Margaret C.	*Islay: biography of an island*, The Oa Press, Port Ellen, 1981.
Stromier, George	'The Vanishing Piers', *Scottish Field*, August 1965, Glasgow.
Thomas, John	*The Callander & Oban Railway*, David & Charles, Newton Abbot, 1990.
Thomas, John	*The West Highland Railway*, David & Charles, Newton Abbot, 1965.
Tindall, Jemina	*Scottish Island Hopping*, Sphere Books, London, 1981.
Walker, Fred	*Song of the Clyde*, W.W. Norton & Co., London, 1984.
Weir, Tom	*The Kyle Line*, Famedram, Gartocharn, 1974.
Whittle, John	*Speed Bonny Boat*, Saltire Communications, Edinburgh, 1990.
Widdows, Nick	*Ferries of the British Isles & Northern Europe*, Ferry Publications, Narberth, 1998.